BRITAIN
FROM
THE AIR

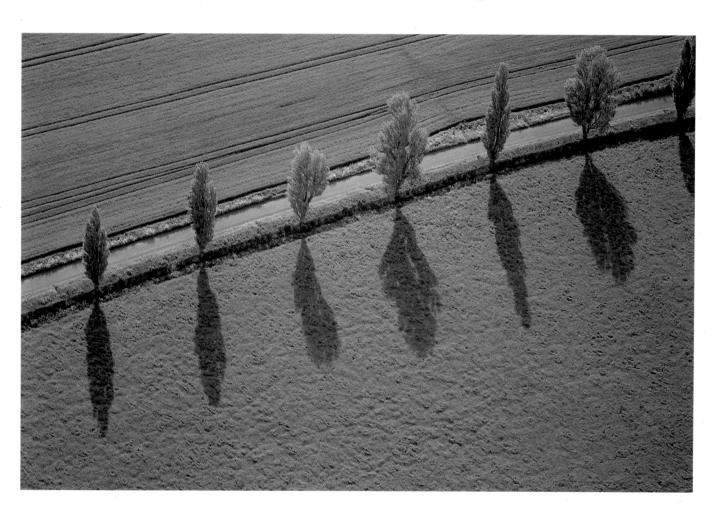

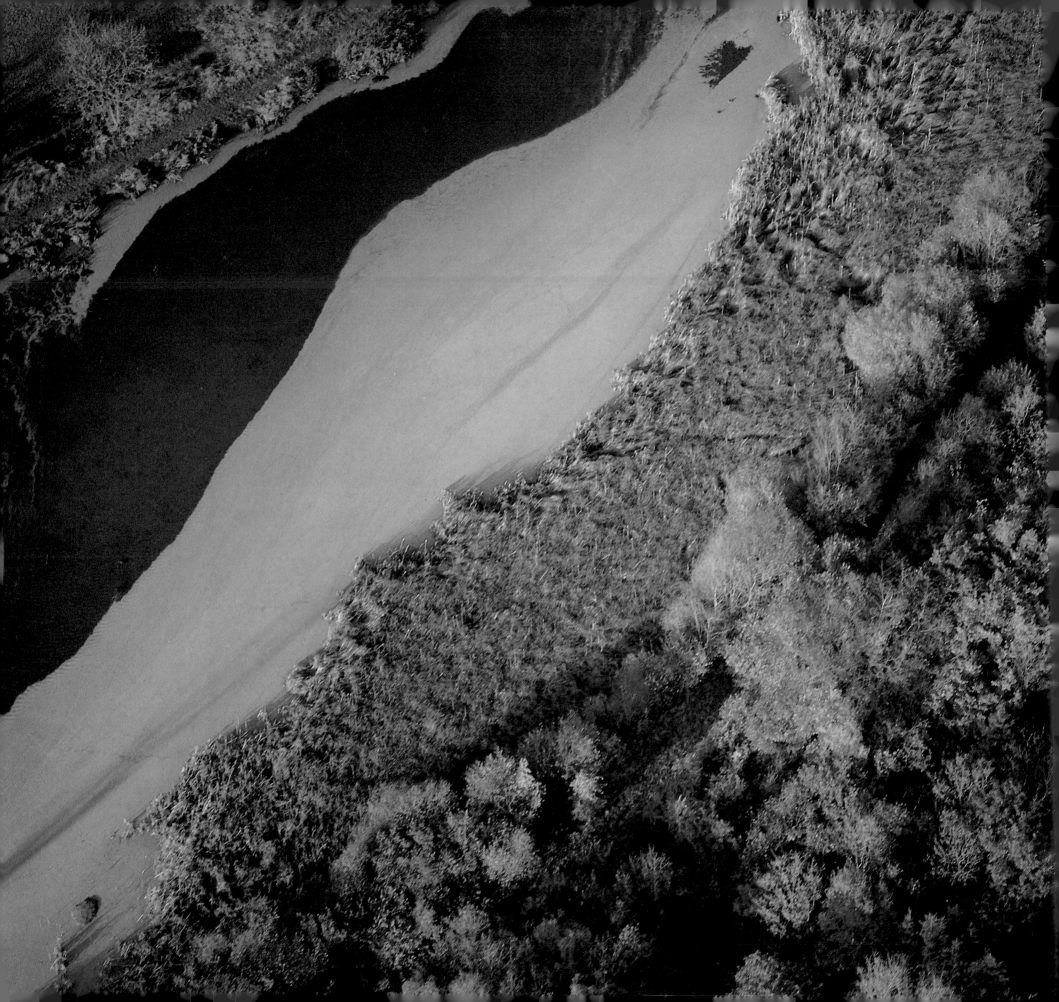

FRANCIS & HOLLAND
SCHOOL
·MILLENNIUM·LIBRARY·

This was donated BOOK by

Laura Edelshain

BRITAIN FROM THE AIR

Photographs by JASON HAWKES
Text by JANE STRUTHERS

EBURY
PRESS

Dedication from Tim to
TAMARIA

Acknowledgements: we would like to thank Julian Shuckburgh for all his support and help
and, on the flying side, all the CPLs and ATCs throughout the country.

First published 1993

5 7 9 10 8 6

Photographs copyright © 1993 Aerial Images Ltd
Text copyright © 1993 Jane Struthers

Jason Hawkes and Jane Struthers have asserted their right
under the Copyright, Designs and Patents Act, 1988, to be
identified as the authors of this work.

First published in the United Kingdom in 1993 by
Ebury Press
Random House, 20 Vauxhall Bridge Road, London SW1V 2SA

Random House Australia (Pty) Limited
20 Alfred Street, Milsons Point, Sydney,
New South Wales 2061, Australia

Random House New Zealand Limited
18 Poland Road, Glenfield
Auckland 10, New Zealand

Random House South Africa (Pty) Limited
PO Box 337, Bergvlei, South Africa

Random House UK Limited Reg. No. 954009

A CIP catalogue record for this book
is available from the British Library

ISBN 0 09 177175 7

Designed by David Fordham
Typeset by SX Composing, Rayleigh, Essex
Printed in Italy by New Interlitho S.p.a., Milan

Photographs on front cover, Burghley House; back cover, The Radcliffe Camera, Oxford;
on page 1, fields in Oxfordshire; page 2, a river bed in Berkshire.

Contents

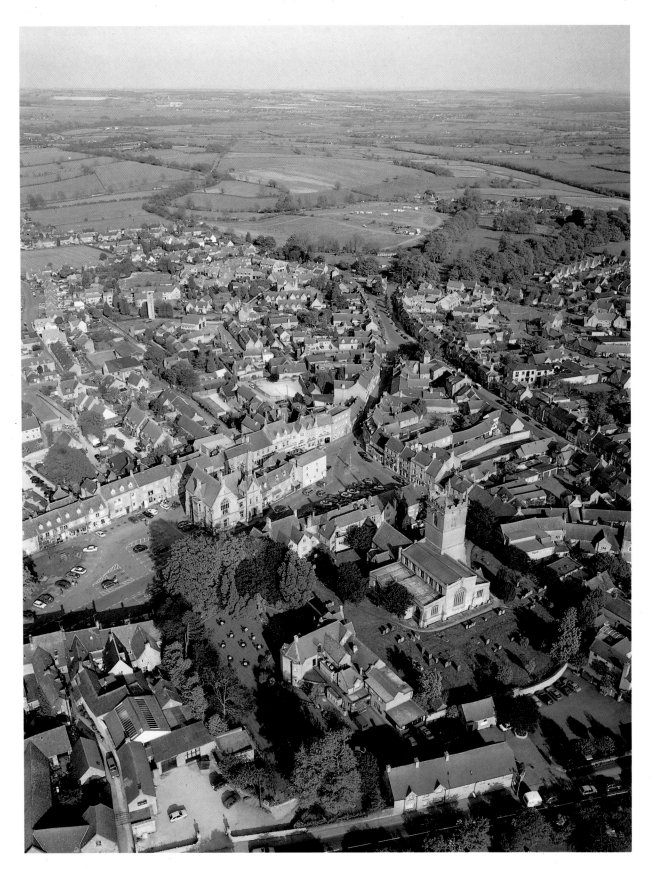

STOW-ON-THE-WOLD

The honey-coloured limestone buildings in the town of Stow-on-the-Wold gleam in the sunshine and show why this is one of the most popular tourist attractions in the whole of the Cotswolds. During the Middle Ages, Stow-on-the-Wold was an important town for the local wool industry, and its proximity to Cirencester (the capital of England's wool trade) increased its prestige and prosperity. The large market square stands in the centre of the photograph, with the parish church in front of it.

INTRODUCTION

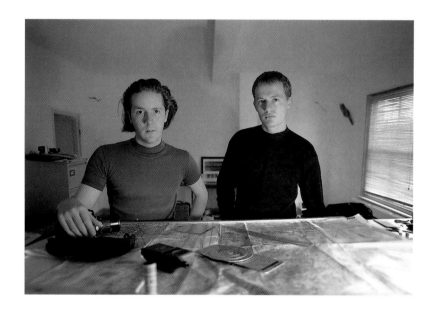

Jason Hawkes (*left*) and Tim Kendall of Aerial Images

IN HIS PREVIOUS BOOK, *London from the Air*, Jason Hawkes's roving camera provided stunning bird's-eye views and peered inquisitively into London's nooks and crannies to produce a book that was a source of fascination even for seasoned London-lovers. This time, he has taken his camera on a tour of Britain, to show the country in some of its many different faces, moods and colours.

There are surprises here, as well as much-loved images. Everyday places are revealed as objects of beauty in their own right. A footbridge over the M4, surely one of the most mundane images of late twentieth-century life that it is possible to find, becomes an elongated pair of tarmac-covered pince-nez when viewed from overhead. Shining new cars lined up on the forecourt of a car manufacturer's are diminished to miniature replicas by the distancing effect of an aerial view, and even gasometers along the Clyde look beautiful with their russet rings and flat grey tops. There are the vivid colours of Britain's countryside for which it is justly famous – the tapestries of lush fields, the delicate green tree tops of its forests, the rusts and ochres of its moors, and the combed stripes of its harvested hills. A field of lavender and one of poppies startle with their vivid colours. From the vantage point of a

helicopter, a flock of sheep look like tiny white insects, and a low-lying mist isolates the upper branches of trees, turning them into ghostly grey plants. The peaks of craggy mountains look like bare bones sticking up out of the surrounding landscape, from viewpoints normally confined to birds and climbers, and soft green valleys tuck themselves neatly into folds created by the surrounding hills. Seashores stretch for miles, and surf-washed bays appear to be camouflaged as white-painted rocks until they receive closer inspection.

Britain is also renowned for its buildings, which range here from the Elizabethan splendour of Burghley House to the shining glass of Canary Wharf tower. Stately homes are inspected as they never could be on foot, with the camera peering into courtyards and revealing formal gardens from the past in all their ornamental magnificence. The spires and buttresses of the great cathedrals of the Middle Ages can be enjoyed without getting eyestrain or cricks in necks. Cities are apparently taken in at a glance, yet with more than enough detail to be able to identify their bridges, churches, cathedrals, castles and other landmarks with ease. Oxford's dreaming spires continue to dream on in the sunshine of a perfect summer's day, and the ruins of St Andrews bear witness to the city's bloody past of religious persecution.

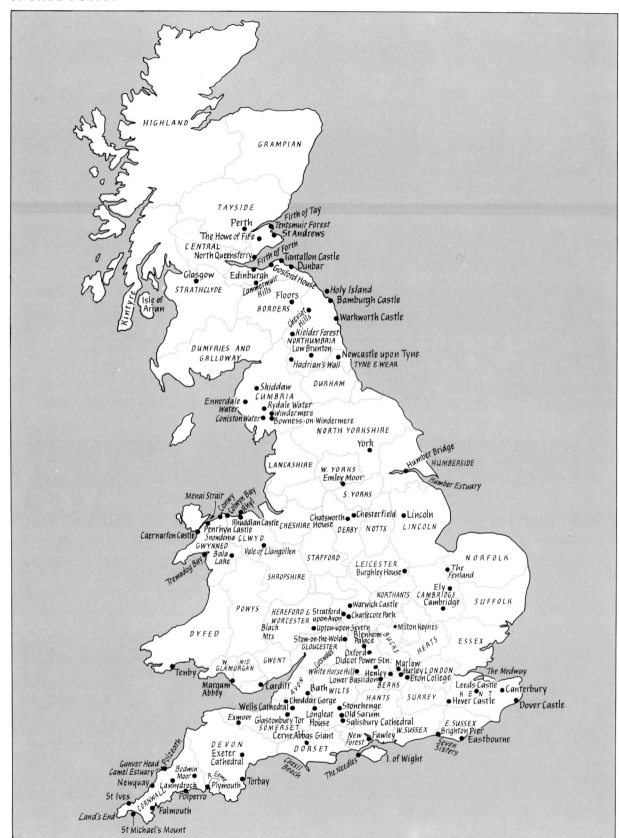

A map of Britain indicating the places illustrated in the book.

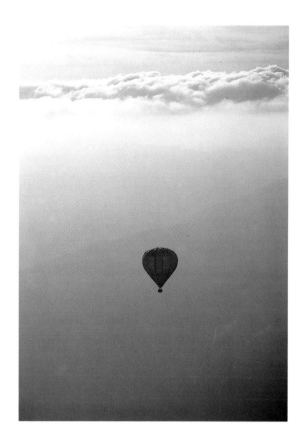

A hot air balloon, captured here high above the Lake District, evokes a previous, more gentle, age.

Of course, this book can only be selective. It would be an impossible task to include every city, range of mountains, stretch of coast, major bridge, stately home and rushing river. Each one is someone's favourite, yet it may not have been included in this book for a number of reasons. Britain is not a particularly large country by world standards, but it must rank as one of the most beautiful and photogenic, and so difficult decisions have been made about what to put in and what to leave out. One of the most pressing problems for aerial photographers is that some parts of Britain's air space are completely out of bounds to low-flying aircraft. Many royal residences are included in that ban for security reasons, and vast tracts of some of Scotland's most spectacular scenery are also no-go areas because of the military aircraft that practice manoeuvres there.

Anyone interested in the actual photography will want to know that Jason Hawkes used a Pentax 645 with an inbuilt light meter, 150mm and 45mm lenses, with an 80-160 zoom, and his film was Kodak 220 EPN. Tim Kendall, Jason's partner in Aerial Images, was the navigator and helped Jason on board the hired helicopter, as well as in choosing suitable sites and editing the final transparencies.

I should like to thank the friends and colleagues who helped me, often when I was sitting surrounded by maps and peering at transparencies, to identify some of the more obscure places shown in the photographs. Thanks are also due to Julian Shuckburgh and Mary Scott at Ebury Press, and to David Fordham.

JANE STRUTHERS
LONDON 1993

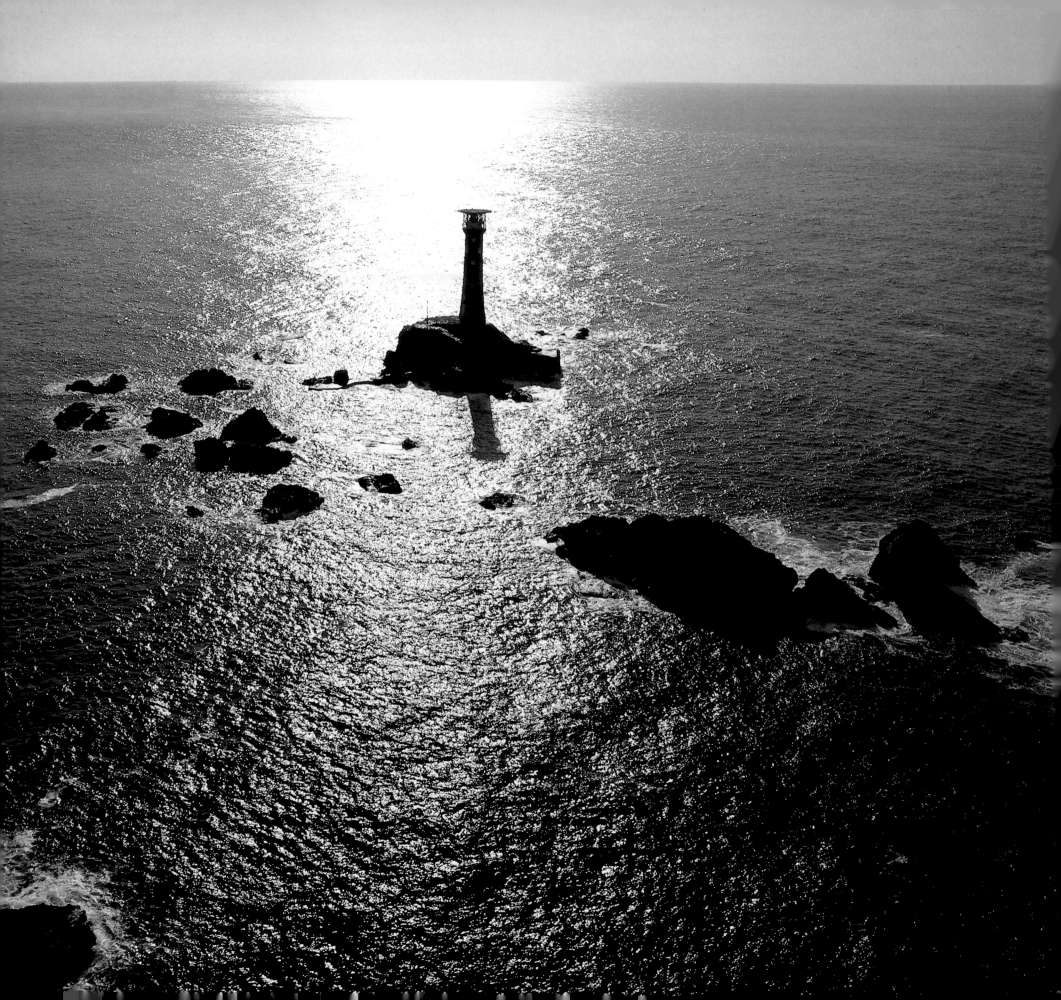

THE SOUTH WEST

Cornwall and Devon

NEWQUAY

Above Newquay, with its foaming white crested water, is Britain's best surfing centre.

LONGSHIPS LIGHTHOUSE

Facing page The Longships Lighthouse, sitting on its barren rock 1½ miles (2.5 kilometres) out to sea from Land's End, marks the westernmost point of the English mainland and the beginning of the vast Atlantic. During the eighteenth century there was a lighthouse just to the north at Sennen Cove, but in 1837 it was moved, stone by stone, to its present position on Longships reef. The granite rocks at Land's End are the remnants of a huge mountain chain that once ran from the Scilly Isles, through Cornwall, to Brittany.

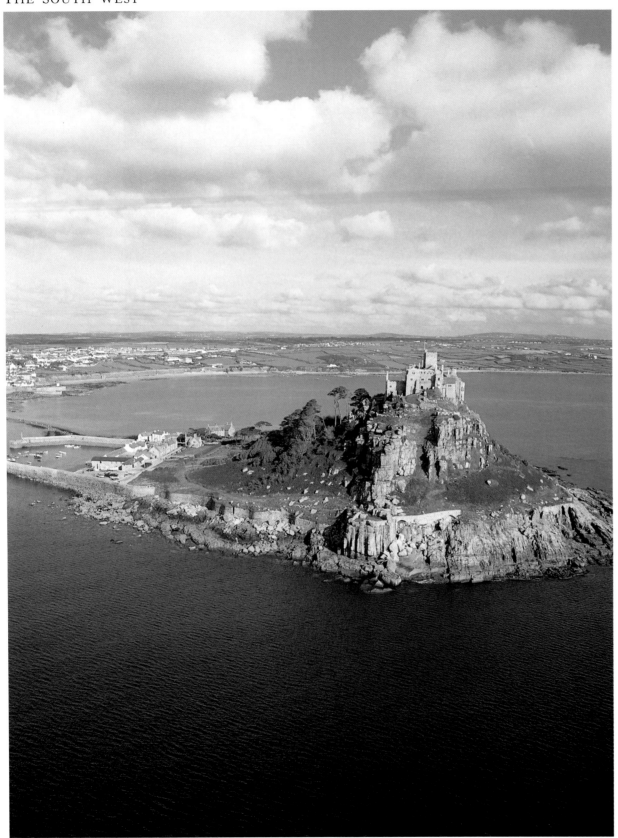

ST MICHAEL'S MOUNT

With its seemingly inhospitable granite rocks, a 300-foot (90-metre) perpendicular cliff and a windswept (and tidally controlled) position in the waters of Mount's Bay, St Michael's Mount looks like the ideal fortress, yet its origins are spiritual rather than secular. The Benedictine Abbot of the French foundation at Mont St Michel built a fortified priory here in 1135, and the two places were linked for over three centuries. After the Dissolution of the Monasteries the priory became the fortress that its spectacular vantage point had always suggested. Visitors to the island today can enjoy the magnificent views from Land's End to the Lizard and ponder on the chequered history of this lovely place. To give them further food for thought, Cornish folklore has it that St Michael's Mount is part of the vanished kingdom of Lyonesse (which spanned from the Scilly Isles to the westernmost point of Cornwall) and was known to the legendary King Arthur and his many gallant knights.

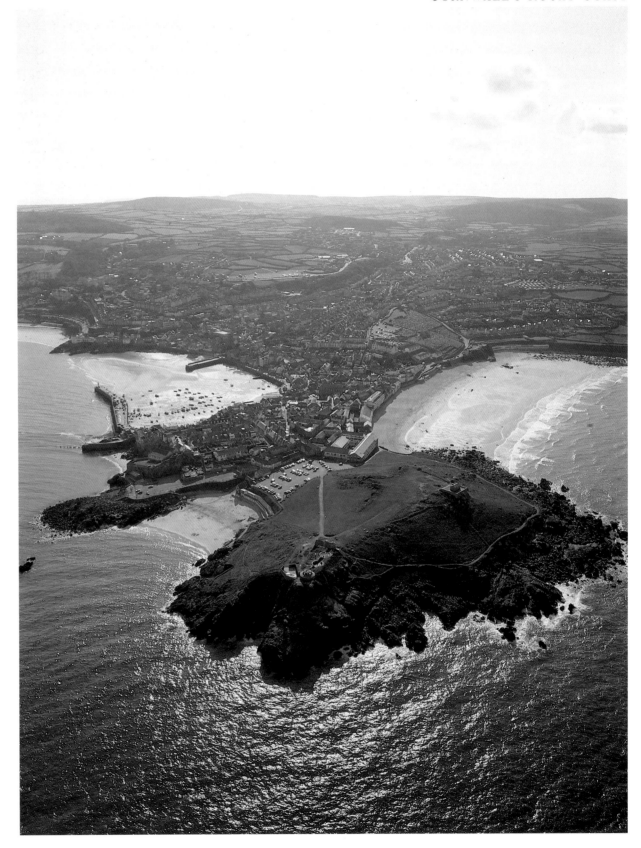

ST IVES

Travel north east from St Michael's Mount, across the narrow toe of Cornwall, and you will come to St Ives, a much-loved mecca for tourists and painters. Some come for the huge sandy bays, while others revel in the town's association with such notable modern artists as Bernard Leach and Dame Barbara Hepworth, and the Victorian painters Walter Sickert and James McNeill Whistler. St Ives Head, the massive grasscovered rock jutting into the sea, shelters the two beaches, Porthgwidden and Porthminster on the left of the photograph. As can be seen, the harbour dries out into a vast sandy bay at low tide, leaving boats stranded. The harbour walls themselves were designed by John Smeaton, who was also the creator of the third Eddystone Lighthouse; their efficiency enabled St Ives to become the biggest pilchard port in Cornwall during the nineteenth century. Porthmeor Beach, the bay on the other side of St Ives Head, has no protection from the elements and so is very popular with windsurfers.

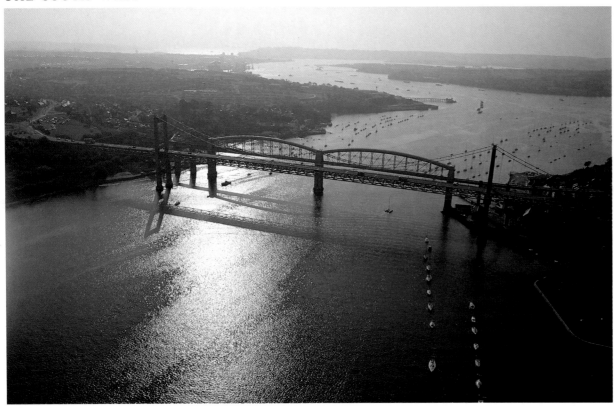

THE ROYAL ALBERT BRIDGE

Left The graceful swooping curves of the 1960s suspension road bridge echo the elliptical tubes of Isambard Kingdom Brunel's Royal Albert Bridge, which was completed in 1859. It was built to carry the, then new, railway over the River Tamar from Devon into Cornwall. In the photograph, Saltash in Cornwall lies on the left, and Plymouth in Devon lies on the right, with the Tamar forming the liquid boundary between the two counties. The flotillas of boats moored on either side of the mighty river serve as reminders of Plymouth's illustrious place in Britain's naval history.

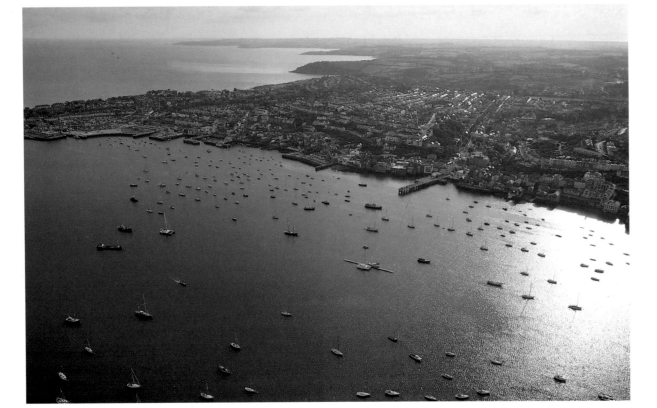

FALMOUTH

Left The first Britons to hear of Nelson's victory at Trafalgar in 1805 lived here at Falmouth – at that time the town was the first port of call for ships returning home from the east. The town's position on the south coast of Cornwall, with the shelter of the Fal estuary (known as Carrick Roads), ensured its success as a port for centuries and therefore was responsible for a good deal of the town's past wealth. Ships known as packets used to leave Falmouth carrying mail to Europe and as far away as the West Indies, but they stopped in 1852 when the Post Office introduced a steamboat service from Southampton instead.

TORBAY

Facing page Each year many thousands of holiday-makers flock to Torbay in Devon, yet any strangers trying to locate it on a road map will be mystified to find no sign of it. Instead, they will see a huge bay, marked Tor Bay, which encloses the three seaside towns of Torquay, Paignton and Brixham. This area first became a popular holiday resort at the end of the eighteenth century, continued to grow in the mid-nineteenth century with the coming of the Great Western Railway and is still trying to catch its breath. The photograph shows Torquay Harbour glittering in the sunshine, and the sprawl of the town itself spreading over to Babbacombe Bay (once a haunt of smugglers) on the other side of the point.

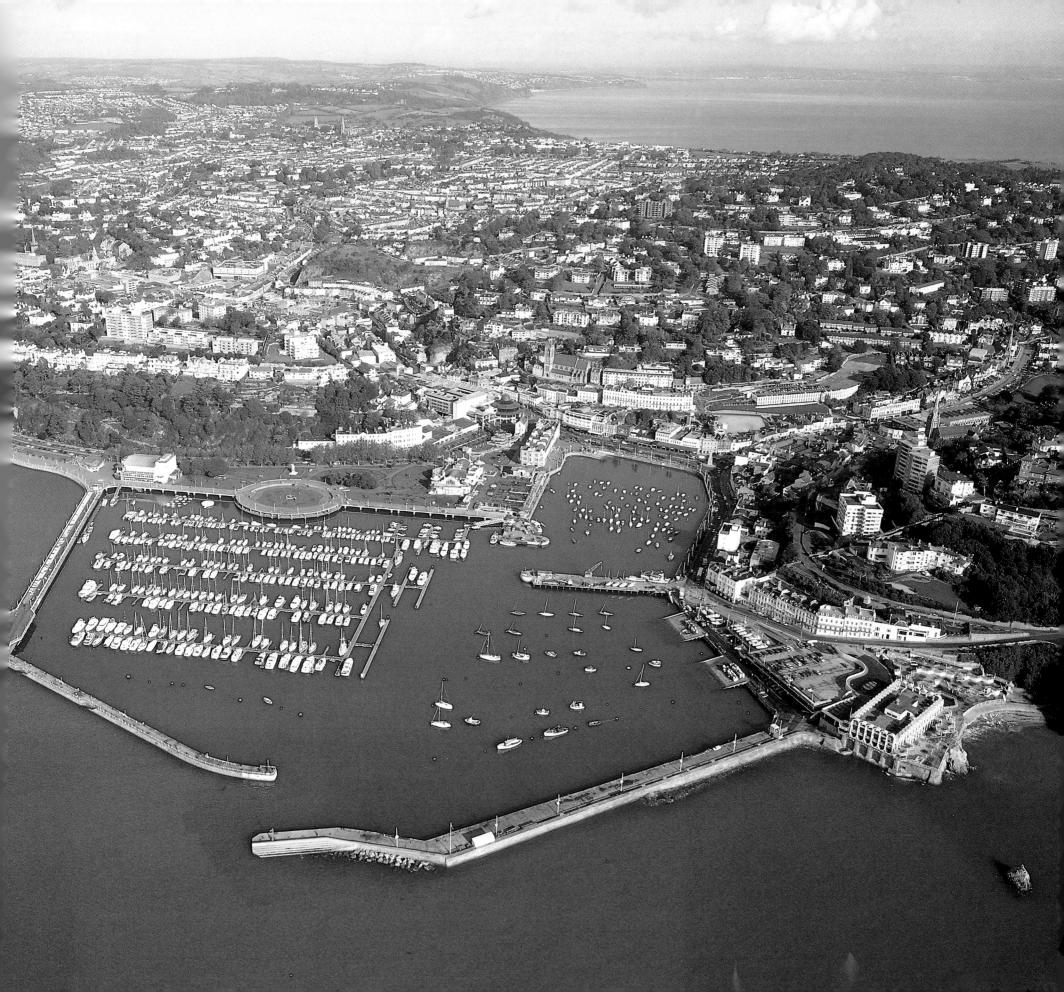

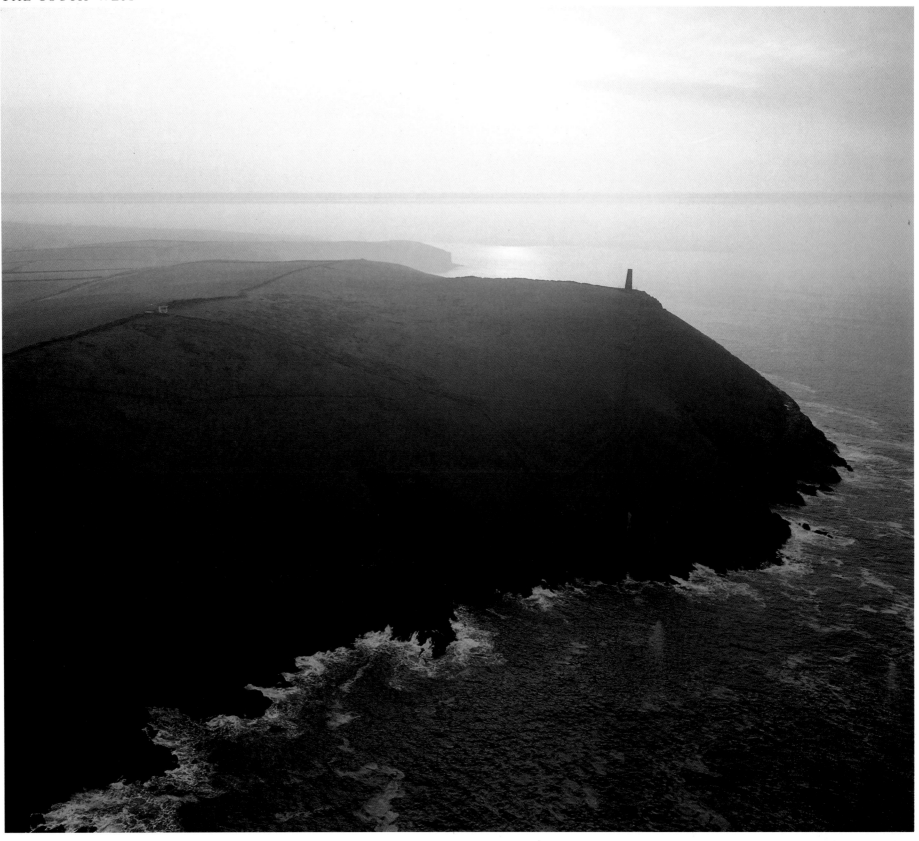

GUNVER HEAD

Facing page North-east of Padstow in Cornwall lies Gunver Head, looking here like a huge toe being washed by the surrounding sea. The craggy coast around here is whipped by strong currents, and it is easy to imagine ships' hulls being smashed into matchwood against these inhospitable rocks, or lured to their doom by wreckers, during Cornwall's famous seafaring days. To the east of Gunver Point at the mouth of the Camel estuary lies the aptly named Doom Bar, a massive sandbank that has spelled disaster to many an unwary ship over the centuries. Local legend has it that the treacherous sandbank was created by a vengeful mermaid after someone had shot her, and it has certainly served her purpose over the years. However, she was unable to prevent Padstow, which lies due south, becoming the most thriving port in northern Cornwall.

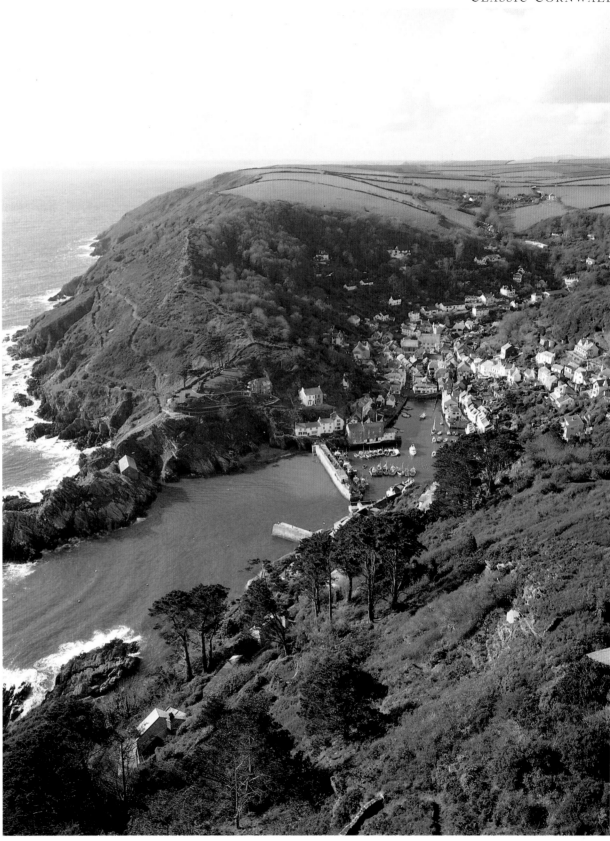

POLPERRO

Right For many people this is a picture of classic Cornwall, with enchanting white-washed cottages apparently tumbling higgledy-piggledy down into the tiny harbour at Polperro. What the photograph doesn't show are the huge numbers of tourists who are drawn here every year like moths to a flame, and who have taken over from the smuggling and fishing that were once Polperro's main money-spinners. Visitors wishing to stretch their legs can take the Cornwall South Coast Path that follows the coastline to either side of this pretty village, perhaps remembering as they go the plots of Daphne du Maurier's Cornish-based novels which make such dramatic use of this stretch of coastline.

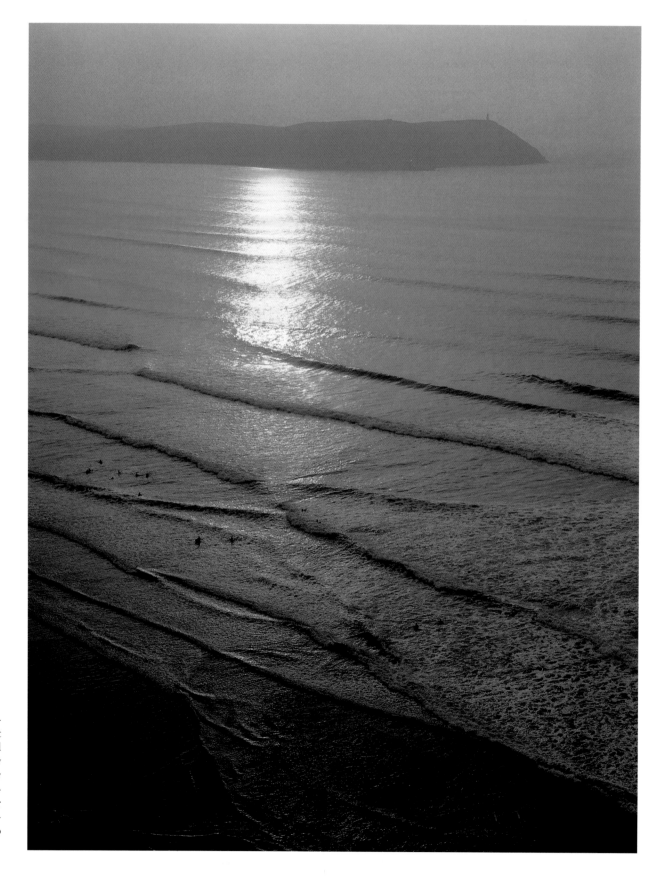

POLZEATH

Right It is beaches like these that help to ensure the popularity of Cornwall's coastline. Not only do they contrast vividly with the spectacularly rugged cliffs that abound here, but they are also paradises of soft sand and, very often, offer stunning views. Hayle Bay at Polzeath is very popular with surfers, thanks to the westerly winds that ruffle its waves. The headland in the background is Stepper Point. Its tower was built as a landmark for sailors, to protect them from the menacing Doom Bar sandbank and to mark the mouth of the Camel estuary.

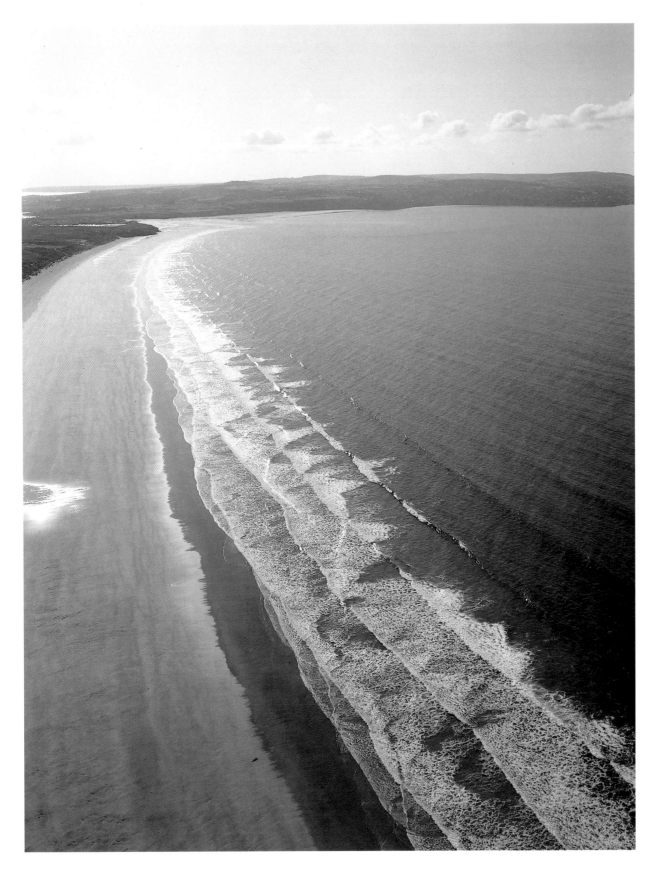

ST IVES BAY

Left The wonderfully sandy beaches at St Ives Bay curve round in a deep semi-circle from St Ives in the west to Godrevy Point in the east, and are very popular with windsurfers and surfers alike. Each summer they are thronged with holiday-makers enjoying Cornwall's enviably mild climate.

RIVER ERME AND CAMEL ESTUARY

Overleaf, left The thickly wooded banks at the mouth of the River Erme near Mothecombe in South Devon run inland for a couple of miles, enclosing thick pale golden sand, a few boats and plenty of birds. Wonwell Beach on the east side of Erme Mouth is sheltered, although Mothecombe on the west isn't always safe for bathing because of the strength of local sea currents. *Overleaf, right* From the vantage point of a helicopter, the rippling sands that line the Camel estuary in North Cornwall look to be part of a painting, full of squiggles, pleasing curves and little curlicues. Kenneth Grahame, author of *The Wind in the Willows*, spent happy holidays with his son in this part of Cornwall, and the sailing trips they took in the Camel estuary found their way into the book, with Ratty's enjoyment of 'messing about in boats'.

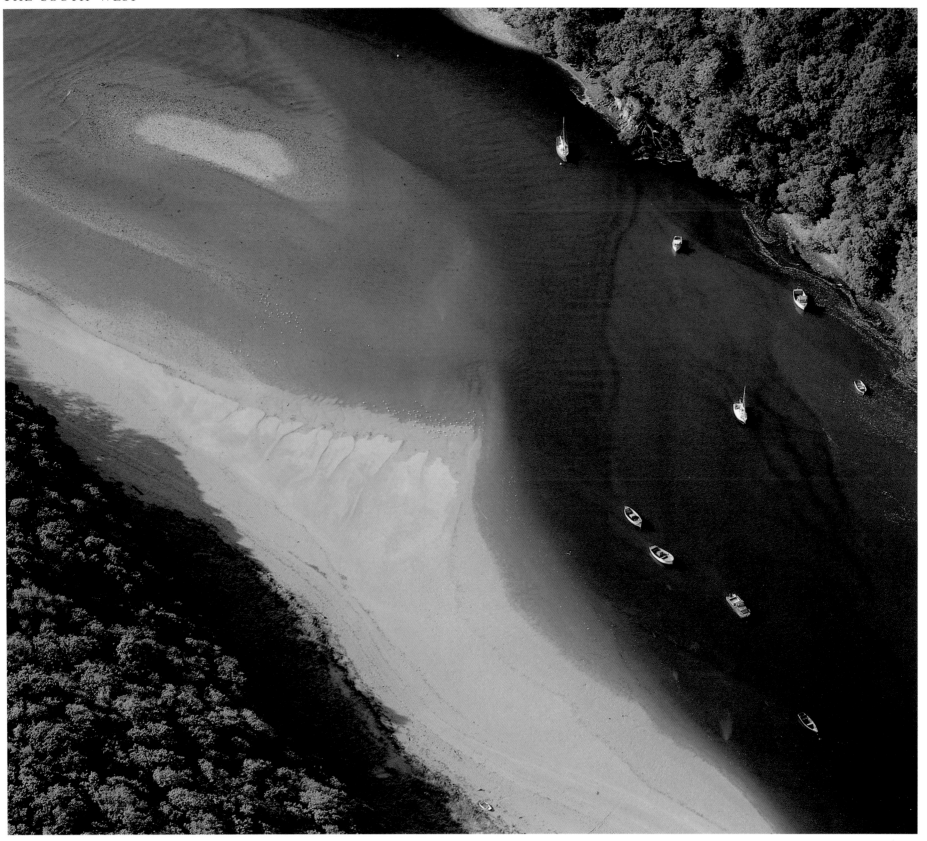

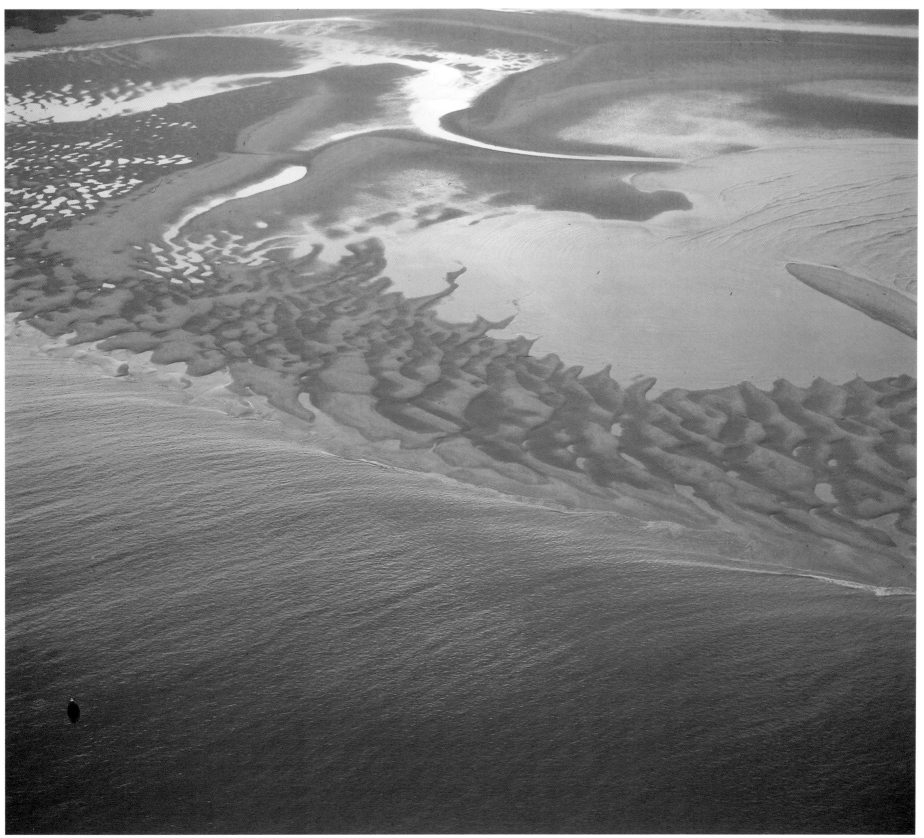

BODMIN MOOR

Now one of the most inhospitable parts of the south west of Britain, in prehistoric times Bodmin Moor was not only heavily wooded, but also the most densely populated part of Cornwall. As the settlers became more civilized, they cleared the land by chopping down trees for firewood and housing. There are still large areas of woodland today, especially around the edges of the moor, which help to soften Bodmin's uncompromising landscape.

BODMIN MOOR

Plantations of conifers grow on Bodmin Moor, as in many other parts of Britain, provoking heated arguments about the relative merits and demerits of conifer trees versus such broad-leaved trees as oaks and beeches. When viewed from this vantage point, however, the beauty of conifers is revealed, especially in their wide variety of colours, ranging from deep forest green to pure yellow.

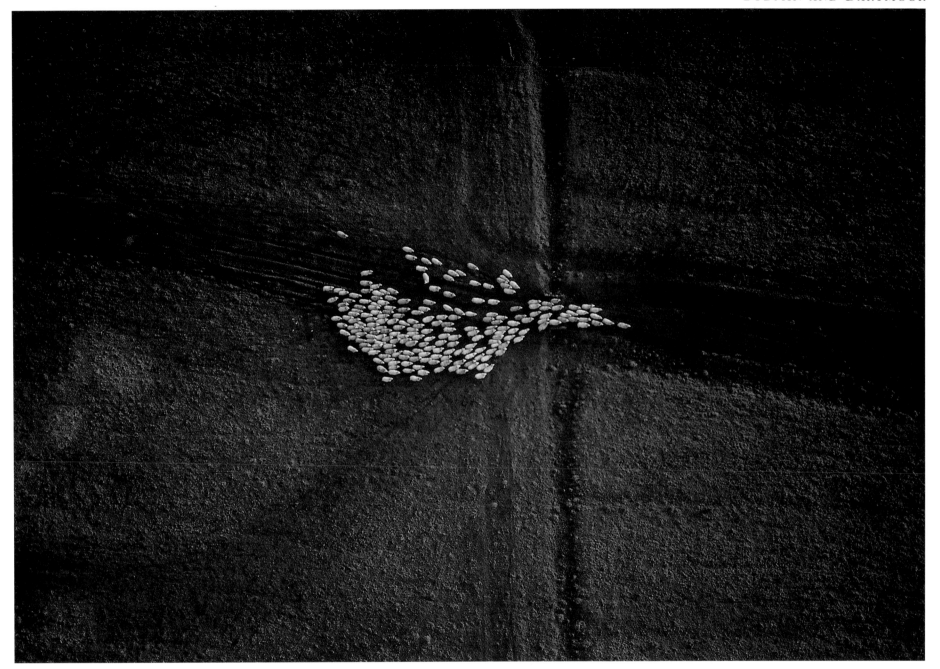

SHEEP FARMING

Sheep are still the main product of hill farms in Britain, and there are many to
be found here on Dartmoor, where they share the land with the resident shaggy
wild ponies and hardy cattle. The majority of the sheep here are Scottish Black-
face, though the Dartmoor Greyface and Whiteface breeds are also common.

BODMIN MOOR

The rocky, scarred landscape of Bodmin Moor extends for nearly 80 square miles (130 square kilometres), yet such is its barren, boggy and boulder-strewn nature that only one major road crosses it, linking the towns of Launceston in the north east and Bodmin itself in the south west. Bodmin's vast eerie bleakness has inspired many atmospheric novels that tell of travellers getting hopelessly lost, or even dying, in this treacherous landscape. Parts of the moor are still only accessible on foot or horseback.

EXMOOR

The soft green valleys of Exmoor, which stretches from Combe Martin in North Devon to Raleigh's Cross in Somerset, are in complete contrast to Bodmin Moor and have a much more benign air. Once a royal forest, this is now officially called Exmoor National Park and offers a mixture of heathland, moorland and impressively rugged cliffs. Pretty villages are scattered over its 265 square miles (690 square kilometres) although, like Bodmin Moor, there are some areas that can only be reached by pony, whether shanks's or otherwise. The area inspired R. D. Blackmore to write *Lorna Doone*, and the Doone Valley near Simonsbath is named after her.

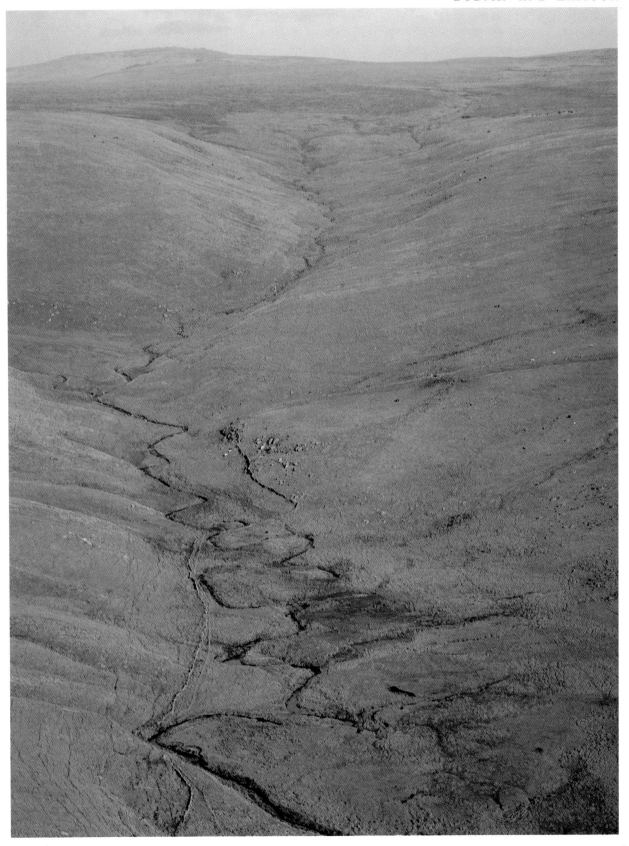

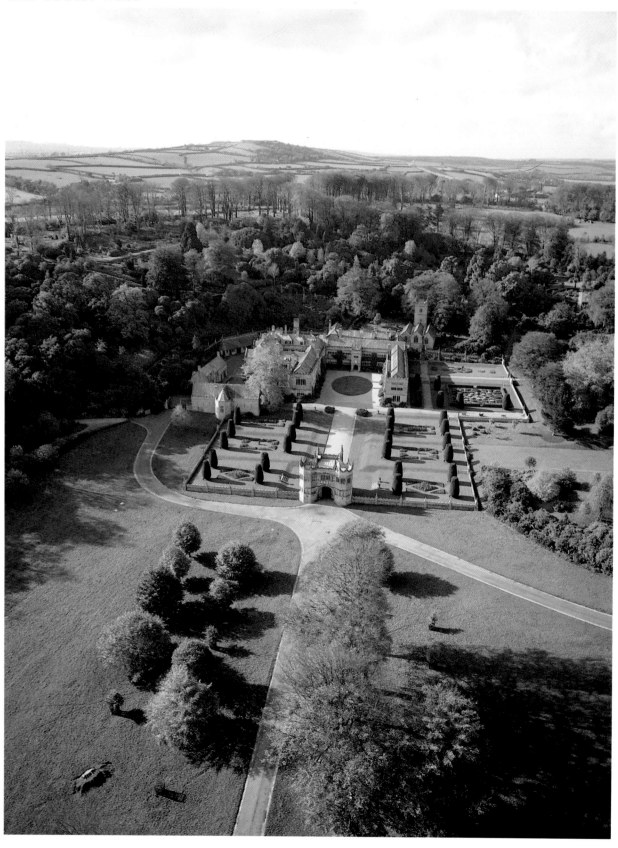

LANHYDROCK

Left Only 2½ miles (4 kilometres) away from the bleakness of Bodmin Moor lies the seventeenth-century splendour of Lanhydrock. A disastrous fire destroyed much of the house in 1881 but it was carefully restored by its then owner, Lord Robartes, who followed the original plans throughout the work. It is interesting to examine the house in the photograph in the hope of spotting the original parts and the later building work – only the north wing (on the right of the photograph) and the stunning gatehouse are original. Lanhydrock is also celebrated for its gardens, which were started in 1857 and whose formality is shown off to magnificent effect in this photograph. The richly planted parkland leads down to the River Fowey.

EXETER CATHEDRAL

Facing page The Cathedral Church of St Peter has graced the centre of Exeter for over 600 years, although parts of the magnificent building date from the twelfth century. An earlier cathedral once stood here, built as a church by King Canute in 1019; it became a cathedral in 1050 when Edward the Confessor enthroned the first bishop of Exeter. The history of the city dates back to the Romans, who arrived in AD 50. They called it Isca Dumnoniorum after the Celtic settlers, the Dumnonii, who had lived here before, and enclosed it in a city wall, parts of which are still standing. Also still standing are many of Exeter's medieval buildings, despite heavy air raids that took their toll in 1942.

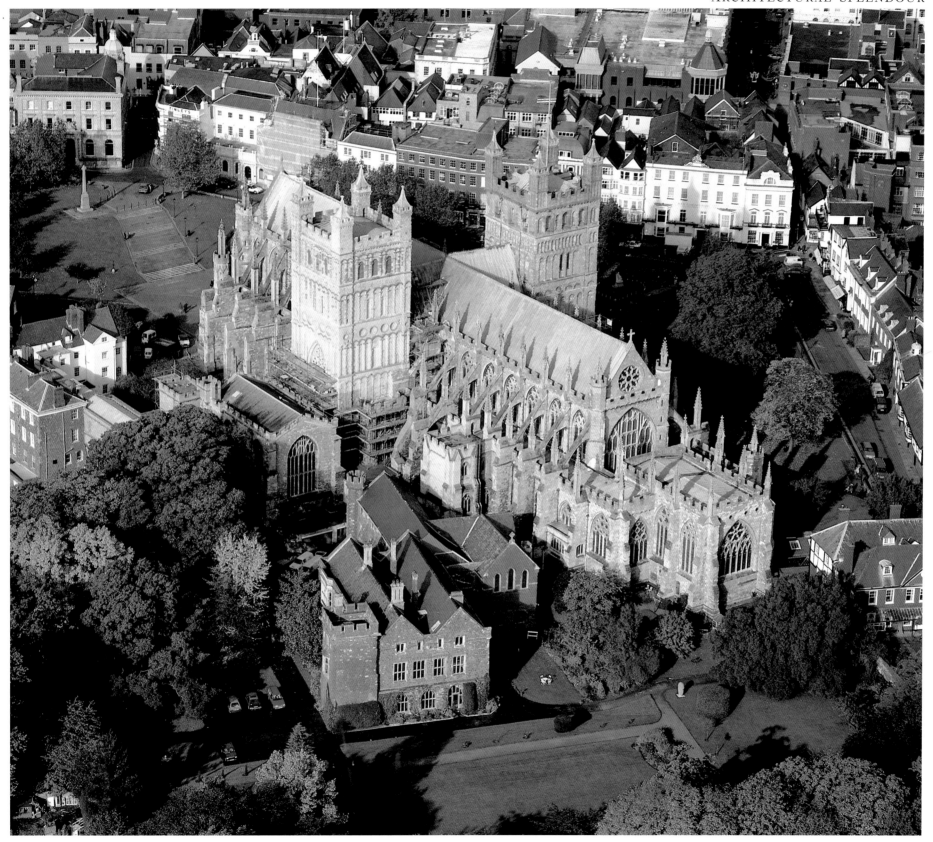

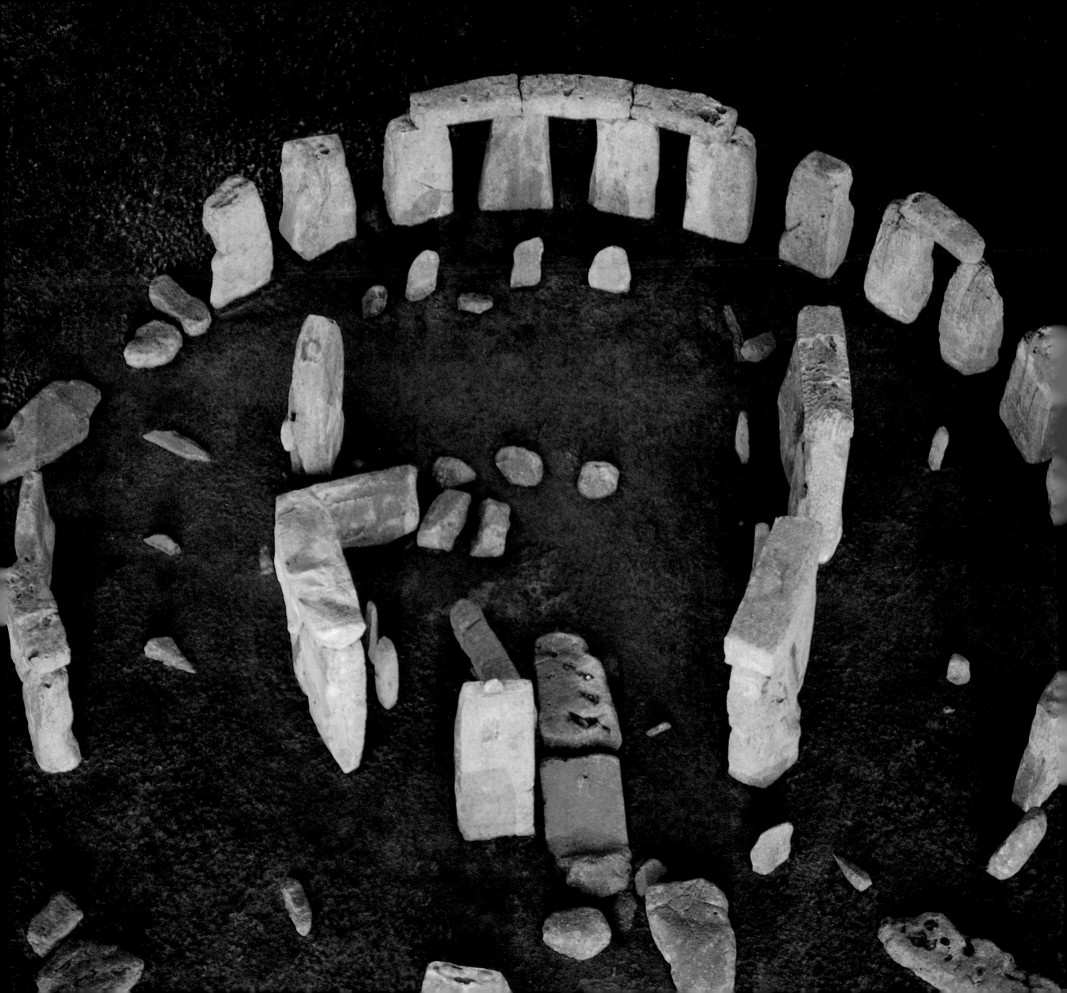

THE SOUTH AND WEST

HAMPSHIRE, WILTSHIRE, AVON, SOMERSET, OXFORDSHIRE AND ISLE OF WIGHT

THE NEW FOREST

Above It was William the Conqueror who called the dense woodland west of Southampton the New Forest, because to him it was precisely that – he ordered that the existing forest should be cleared away (taking 22 Saxon villages with it) and a new one replanted. The work was carried out so rapidly that by 1079 he was able to designate his forest a royal hunting preserve. By the seventeenth century, the forest's proximity to the important naval dockyard of Portsmouth meant many of the trees were grown specially for ships' timber. Today, those hectic ship-building days have gone and the deer roam free.

STONEHENGE

Facing page More mysterious than beautiful, Stonehenge offers an enigma that has yet to be solved. Viewed from above, the massive stones look like a collection of broken teeth, yet close to they are imposing and seem determined to keep their secrets.

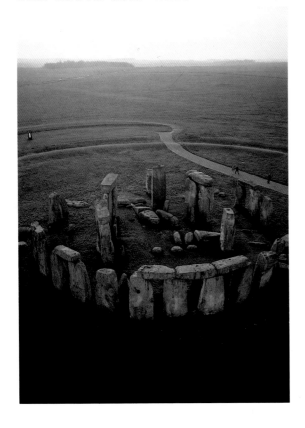

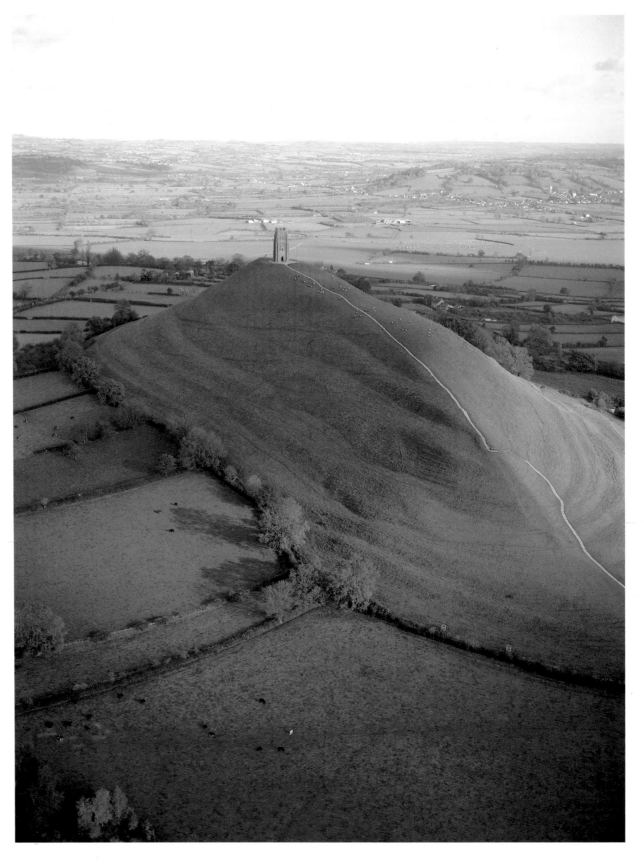

STONEHENGE

Above Pre-dating the pyramids of Ancient Egypt, Stonehenge has dominated Salisbury Plain since at least 3100 BC. No one knows why it was built, although the current belief that it was created by Druids as a temple is a fallacy because they only arrived in Britain in about 3 BC and were worshippers of the mighty oak tree. Other theories maintain that Stonehenge is a giant astronomical computer which was once used to calculate the positions of the stars and planets, and it has even been claimed that it was a storehouse of mystical energy.

GLASTONBURY TOR

Right Glastonbury is another part of southern Britain steeped in mystery and woven about with myths, this time concerning the semi-legendary King Arthur who is believed to have lived here during the fifth or sixth centuries. The ruins on the top of Glastonbury Tor are all that remain of the fourteenth-century St Michael's Chapel, which was a rich Benedictine priory until it was destroyed during the Dissolution of the Monasteries in 1539. The plain that surrounds the Tor was under water during King Arthur's time, and so the Tor is said to be the Isle of Avalon – the Celtic meeting place of the dead – where the injured Arthur was taken to die.

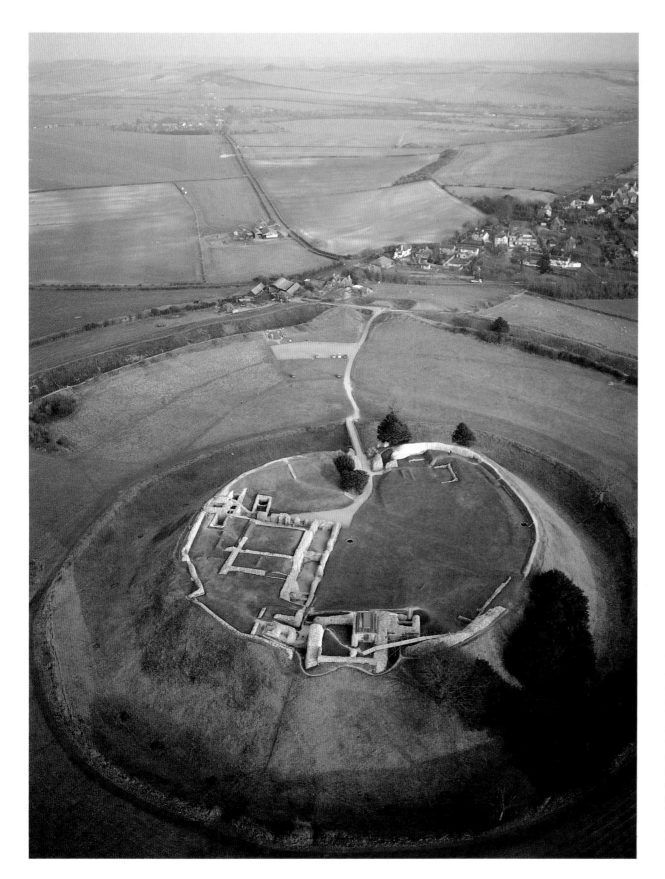

OLD SARUM

Today it is an intriguing ruin, but until the thirteenth century Old Sarum was a thriving town with a cathedral, and before that it had been an Iron Age camp. The rot set in when a combination of water shortages and squabbles between soldiers and the clergy led to the removal of the see down the valley to a place called New Sarum; today, we know it as Salisbury. Old Sarum deteriorated quickly and soon became derelict, and now only the foundations of its buildings remain. Students of nineteenth-century history will know of Old Sarum for a completely different reason – it was one of the so-called 'rotten' boroughs in which a mere handful of voters returned two MPs. In 1735 one of them was a youthful William Pitt, who was standing in his family borough and became Prime Minister 21 years later.

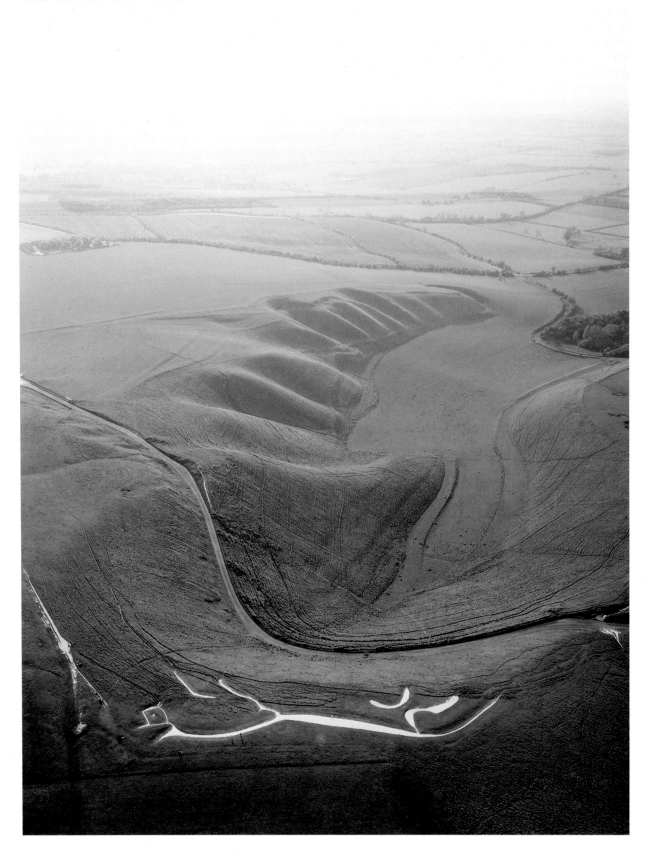

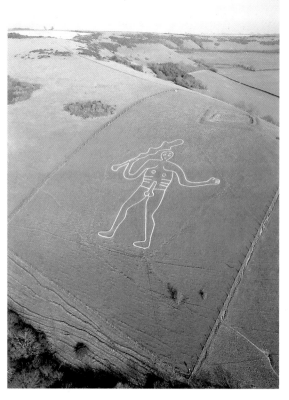

CERNE ABBAS GIANT

Above Regarded by local people as a fertility symbol, the Cerne Abbas Giant is the most notorious of Britain's hill figures. He is believed to have been carved on the chalk hillside above the village of Cerne Abbas at least 1500 years ago, but opinions vary about who and what he was – a Danish giant, a Celtic god or Hercules.

WHITE HORSE HILL, UFFINGTON

Left With its prominent position on the Ridgeway, the prehistoric track that runs from Dover in Kent to Ilchester in Somerset, there is no doubt that the ancient chalk White Horse at Uffington was once a very important hill carving. Where the great debates begin is in deciding why the horse was carved here and by whom. Some historians say it was created by the Iron Age Celts in honour of their goddess Epona. Local history maintains that the horse represents the dragon that was slain on nearby Dragon Hill by St George. Perhaps it is linked with Uffington Castle, the Iron Age hill fort that stands nearby, and is said to be Mount Bladon, where King Arthur won a mighty battle against the Saxons in about AD 518. Whichever version you wish to believe, the White Horse is well worth visiting, whether you stand on his eye and make a wish as folklore suggests you should, or just enjoy the grass-covered undulations of the Berkshire Downs spreading out before you.

HAMPSHIRE LANDSCAPES

Following pages The beautiful colours in this photograph (*left*) belie the fact that it shows a landfill site in Hampshire. The greeny-brown land consists of accumulated rubbish. The Hampshire scrubland (*right*) has a leathery appearance from this height and is dotted with ghostly trees.

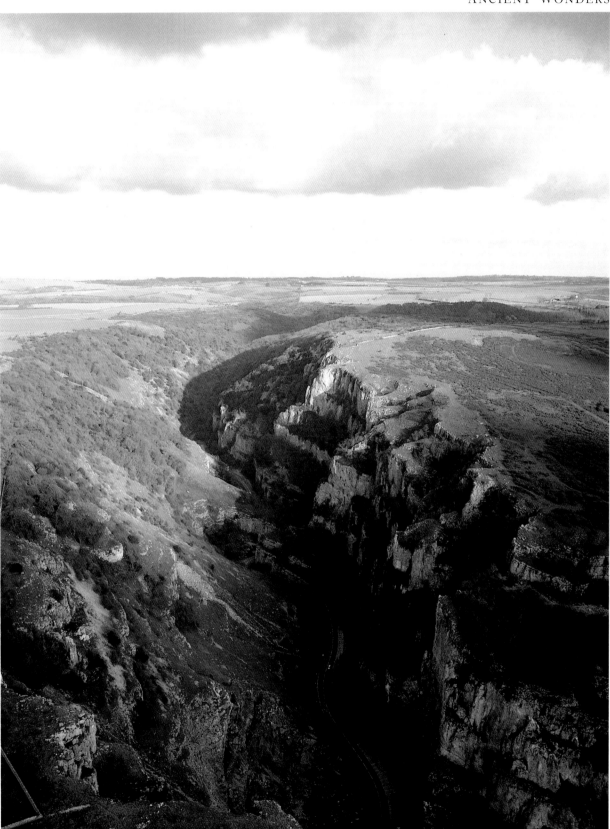

CHEDDAR GORGE

Right Standing almost 450 feet (135 metres) high, the limestone cliffs of Cheddar Gorge cut an irregular but very dramatic swathe through the Mendip Hills and completely dwarf the narrow road that twists along the bottom of the cleft towards the village of Cheddar. It seems hard to believe, looking at the vastness of the Gorge today, that it was formed by small streams weaving their way through the surface fissures of the limestone and eventually eroding it away. The area is still rich in little waterways and underground lakes. The Gorge is justly famous for its hundreds of caves, which vary in size from the modest to the massive, with Gough's Cave being the largest. It was in here, amidst the stalagmites and weird rock formations, that a 10,000-year-old skeleton, known as the Cheddar Man, was found in 1903, in caves that were believed to have been occupied at least 35,000 years ago. He is now on show, for anyone wishing to see him, in an adjoining museum.

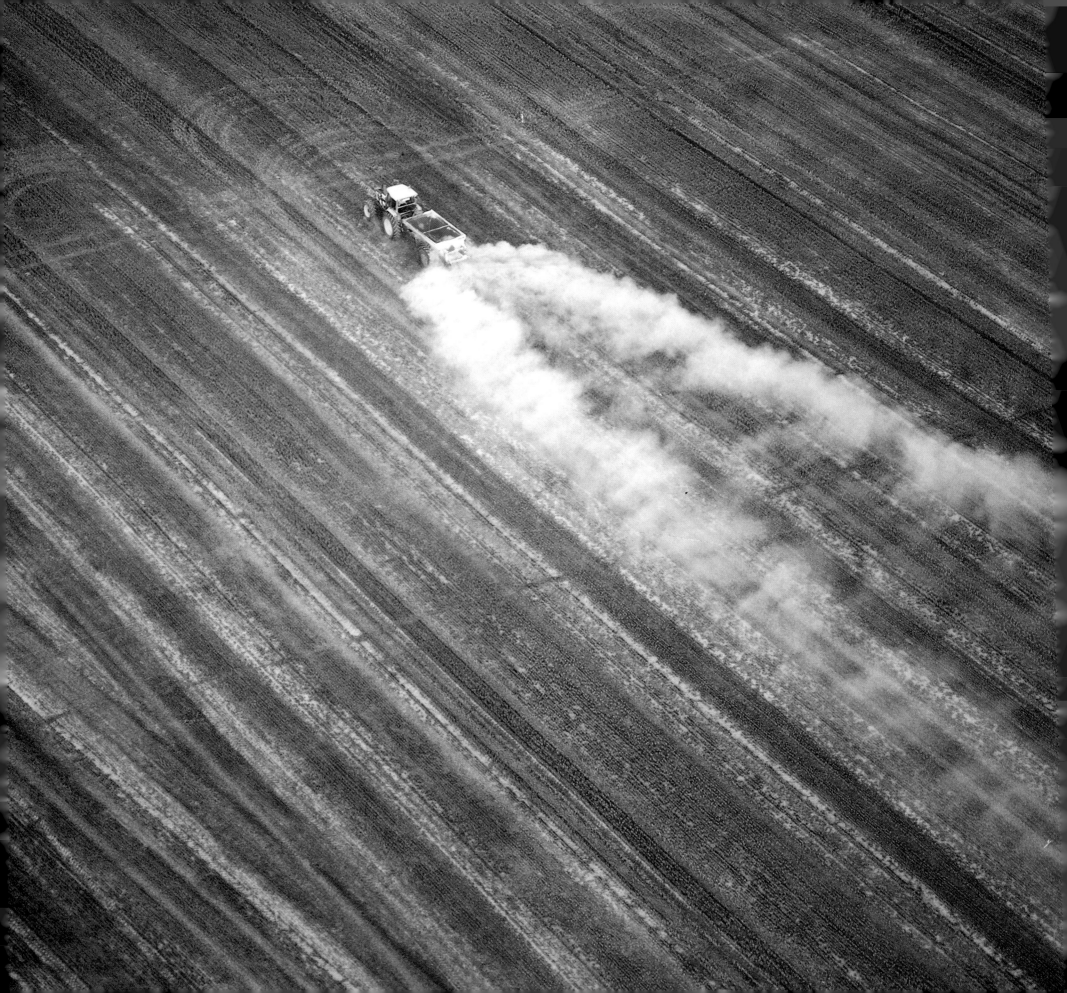

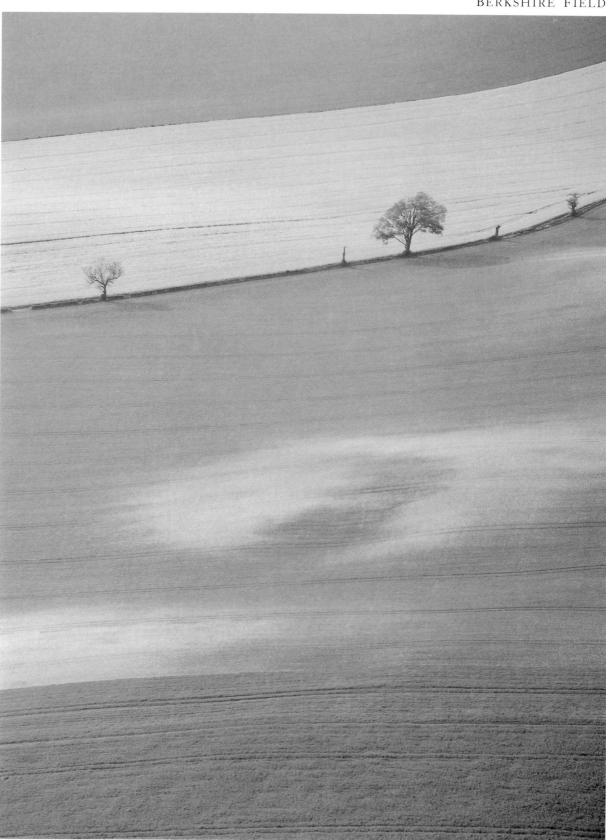

ARABLE FARMING

Facing page Arable farmers are doubtless too caught up in EC regulations and their toils to appreciate to the full the visual effect they have on the countryside; it is up to painters, photographers and walkers to do that. Some artists, such as Eric Ravilious, become so closely associated with a particular stretch of countryside (in his case, the Sussex Downs) that the landscape in question can look like one of their paintings, rather than the other way round. This Berkshire field, arrayed in stripes of russet and brown, is crying out to be painted.

MODERN FARMING TECHNIQUES

Right Not everyone appreciates the colour schemes of modern farming techniques. Each spring and summer, crops of rape, which farmers began growing in large quantities here in the early 1970s, transform the country-side with their bold splashes of yellow flowers against the surrounding green fields. The rape plant is a relative of the cabbage family, and one variety is grown to feed cattle and sheep over the winter, while another (oil-seed rape) is grown for food oil and bio-diesel. The field shown in the photograph is undeniably beautiful, yet this new addition to our fields has aroused much controversy and complaint, as it is claimed that rape's thick powdery pollen causes hay fever.

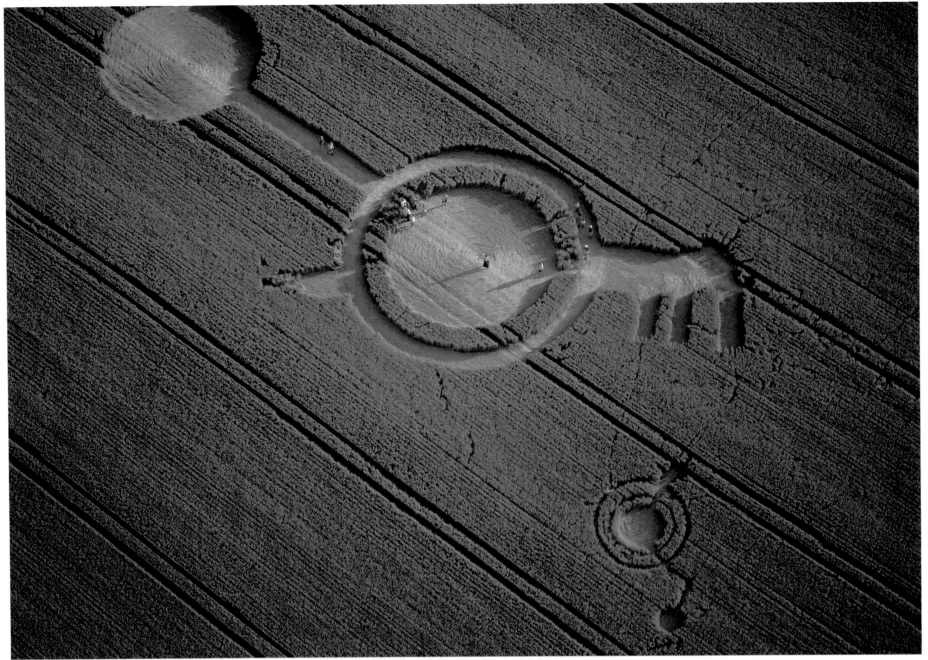

CROP CIRCLES

Man-made mischief, signs of extra-terrestrial life or a natural phenomenon? The debate about crop circles is still raging and is as heated as ever, yet, like the circles themselves, somewhat regulated by the seasons. Come the summer, strange things happen in fields, and the public and photographers arrive to inspect the mystery, then by harvest-time everyone forgets all about them and prefers to huddle indoors over the fire. What many people don't realize is that crop circles are nothing new, and farmers have known about them for hundreds of years. Some current examples are certainly fakes and admitted to be so, but many are genuine. So the question remains, how did they get there?

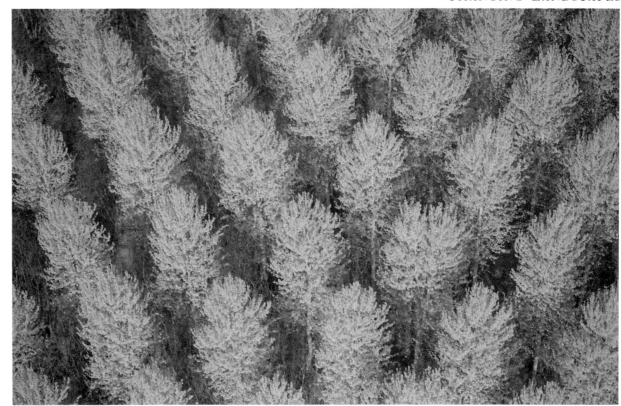

SEASONS IN THE FORESTS

When seen from the air, the seasonal changes in Britain's landscape can be even more spectacular than they appear on the ground. Forests full of young trees (*top*) are decked out in their spring finery of lush pale green leaves, yet what is even more striking is the pleasingly regular pattern in which they have been planted, giving them an added beauty. The bare trees of late autumn (*bottom*) stand guard over rows and rows of tiny saplings, looking rather like white polka dots from this height. The soft bark of each one is covered by a protective tube that allows the light and rain in but keeps away hungry predators.

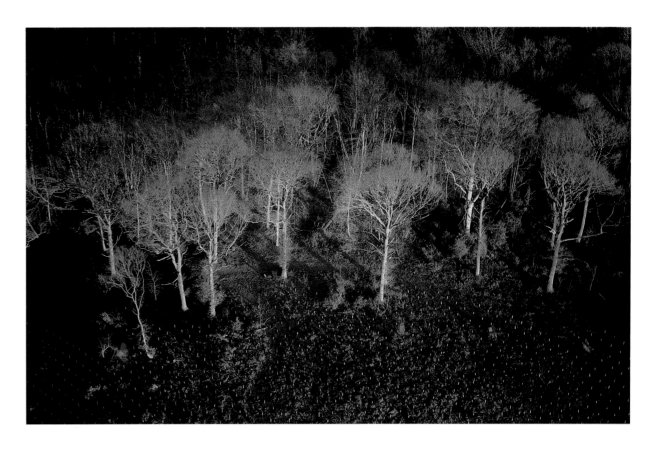

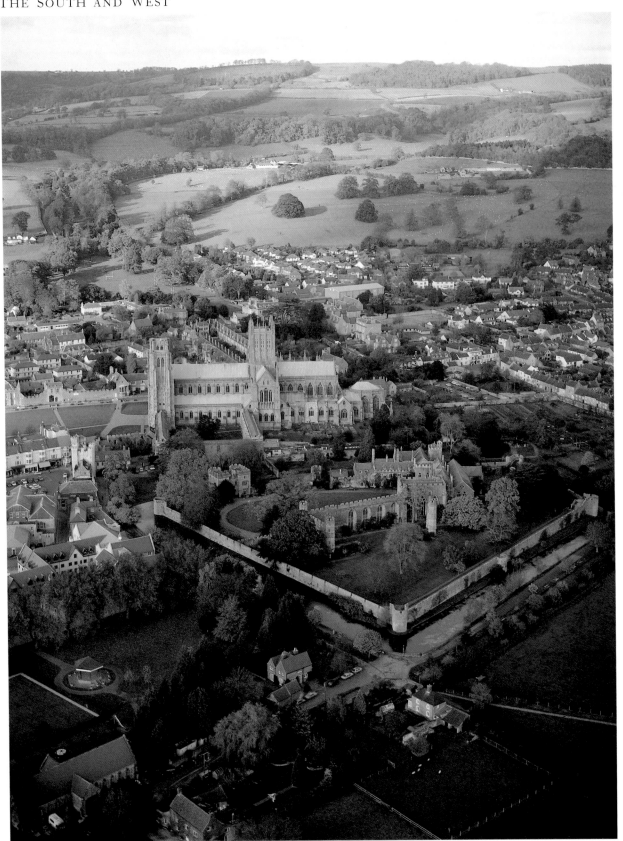

WELLS CATHEDRAL

Wells, though one of the smallest cities in Britain, is rich in beauty, atmosphere and architectural treasures. The cathedral is a magnificent gallery of medieval sculpture and the west front once bore statues of over 400 saints and angels, although many of them were destroyed during the seventeenth century. In the foreground of the photograph stands the moated Bishop's Palace which is one of the oldest inhabited houses in Britain (the castle-like outer walls were built in 1206), although parts of it, such as the pink-stoned banqueting hall facing the camera, are in ruins. Directly behind the banqueting hall stands the gateway, built in 1450, which is known as the Bishop's Eye. Thirsty visitors can walk through it into the Market Place and then make for the seventeenth-century Crown Inn, where William Penn is supposed to have preached his Quaker beliefs from one of the windows. Directly to the left of the cathedral's tower runs the Vicars Close, which consists of terraced houses and is believed to be the oldest fourteenth-century street in Europe.

SALISBURY CATHEDRAL

The compact thirteenth-century cathedral looks out over modern-day Salisbury and away to Old Sarum where the city, and some of the cathedral's stones, originally stood. Unlike most English cathedrals, which are a patchwork of different architectural styles because of the building work or restoration that has progressed over the centuries, Salisbury is virtually a complete example of Early English Gothic. Only part of the tower and its spire (which, at 404 feet (123 metres) is the tallest in England) were added in 1334, about 50 years after the rest of the cathedral was completed. The cloisters are the largest in England. Much of the cathedral was built from creamy Chilmark stone, quarried locally in the village which bears its name. Of course, Salisbury isn't just known for its cathedral, but also for its beautiful Cathedral Close. It contains houses dating back to the thirteenth century, and the historic atmosphere is enhanced by the medieval gateways that lead into it. The River Avon flows through the city, having already passed the discarded and ruined Old Sarum on its journey, before meeting up with the Nadder, Wylye and Bourne rivers on their voyage south.

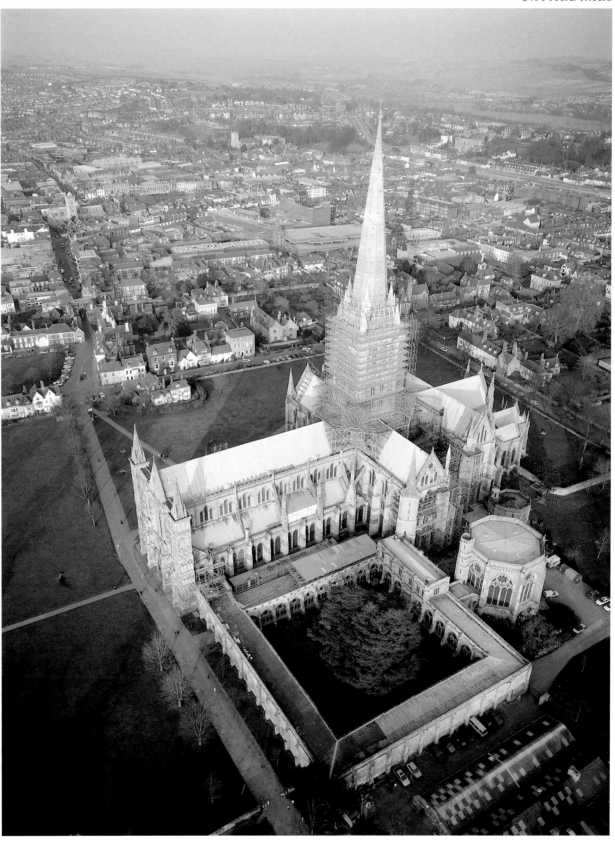

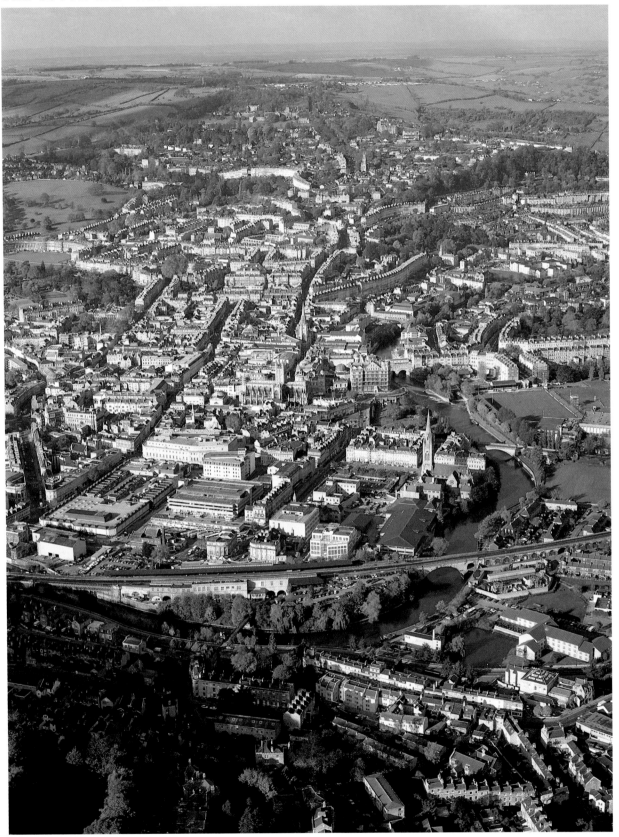

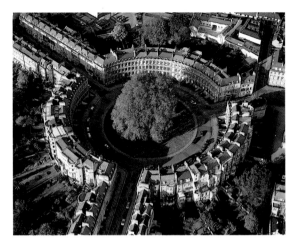

BATH

Left The River Avon curves its way round the centre of Bath, gliding swiftly through a city rich in history. The story of Bath runs from its Celtic beginnings, when it was revered as a healing spa, through its Roman occupation in AD 44 to its apotheosis as a Georgian spa, when the dandy, Beau Nash, was master of public ceremonies. Modern-day Bath has retained much of the elegance and style that made it so fashionable in the eighteenth century, and many of the buildings have been meticulously preserved. If visitors find Pulteney Bridge (the topmost bridge on the right-hand side of the photograph) reminiscent of the Ponte Vecchio in Florence, it would be because it served as Robert Adam's inspiration for this bridge in 1770. A short distance to the right of the bridge is Bath Abbey which was built in the Perpendicular Gothic style in gradual stages over four centuries. Bath is, of course, world-famous for its magnificent Georgian architecture, exemplified by the Circus and Royal Crescent, which were designed respectively by John Wood the elder and his son, John Wood the younger. *Above* The Circus was designed as a perfect circle, but sadly building work only started when its architect, the elder John Wood, died.

LONGLEAT

Facing page The elaborate splendour of Longleat House owes much to Elizabeth I's desire to visit her most powerful subjects each summer; she always expected the best accommodation and hospitality from them, and would not have been disappointed here. Sir John Thynne owned the land here and ordered that a mansion be built on it. Unfortunately the first house was quickly destroyed in a fire, but this second mansion has survived and was enjoyed by the Queen on her royal progress through the country. During the eighteenth century the grounds were landscaped by Capability Brown, and today are just as well known as the home of the wildlife safari park.

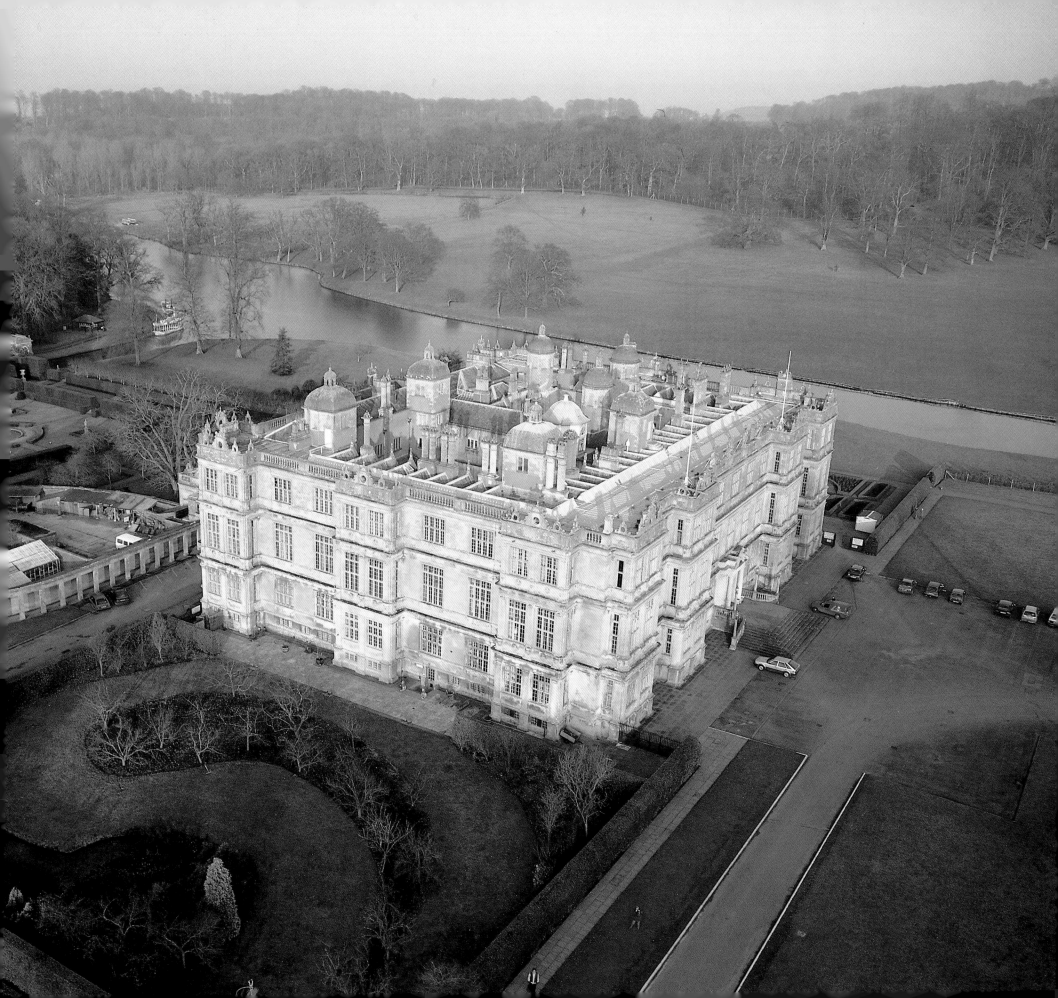

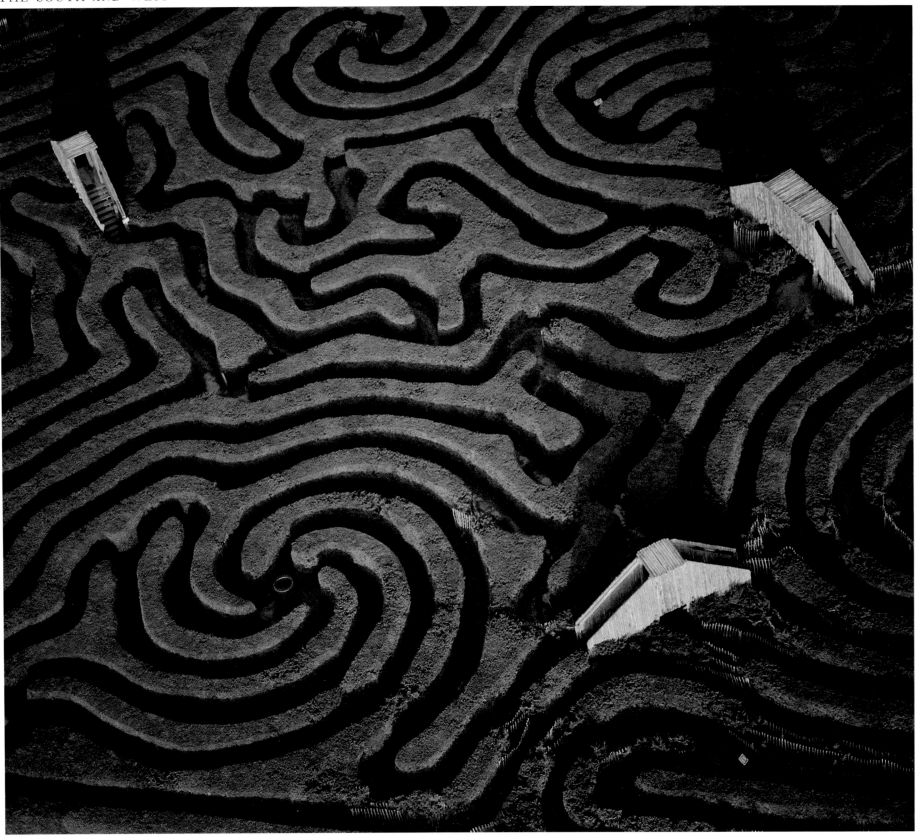

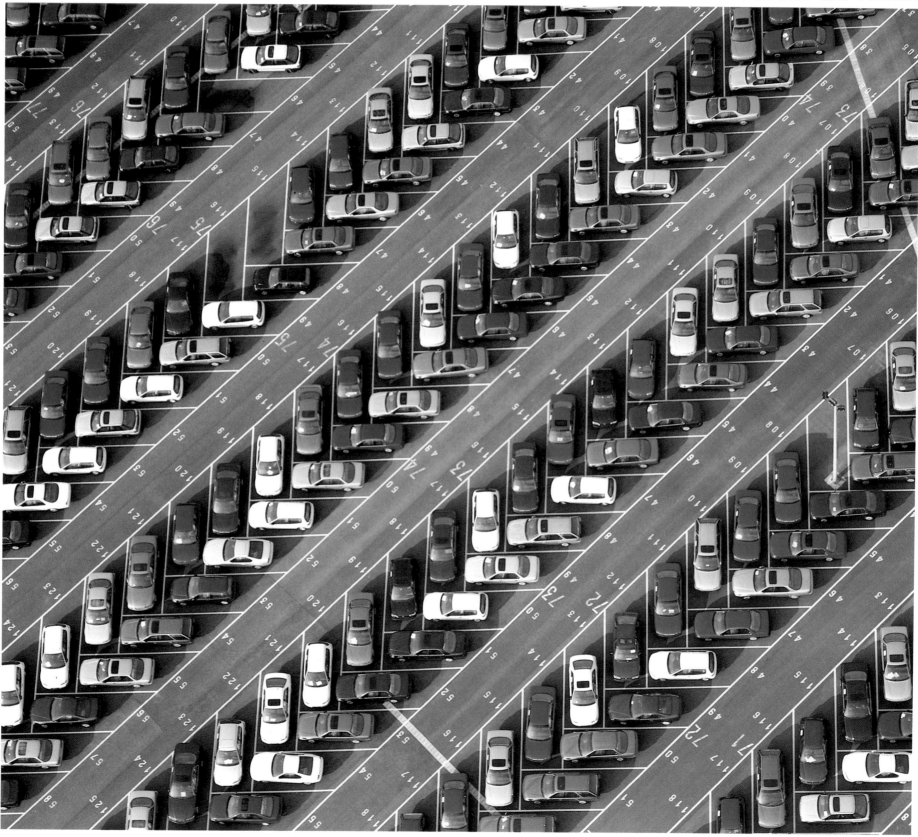

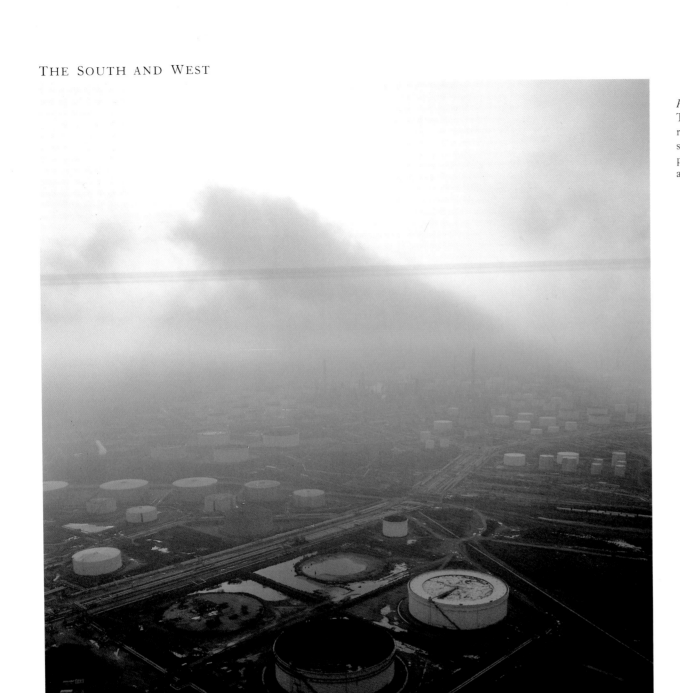

LONGLEAT AND CAR PLANT

Previous pages Here are patterns from the past and present. The maze at Longleat (*left*) twists and turns in a seemingly random series of patterns, occasionally interrupted by strange wooden bridges. The cars at the Austin Rover plant, however (*right*), are laid out in very precise patterns and look like Dinky cars carefully arranged on the fore-court of a large toy garage.

FAWLEY OIL REFINERY

Left These round pale towers belong to Fawley Oil Re-finery on the west side of Southampton Water. There are piers for servicing oil tankers sticking out into the sea, and the huge sprawling mass, though it resembles a disused wasteland, is fully operational.

DIDCOT POWER STATION

Facing page The looming grey towers of Didcot Power Station make a striking twentieth-century landmark because they are visible for miles around in their native Oxfordshire, and even in neighbouring Berkshire and Wiltshire. Even when the curved towers themselves are not visible, the smoke that issues from them certainly is.

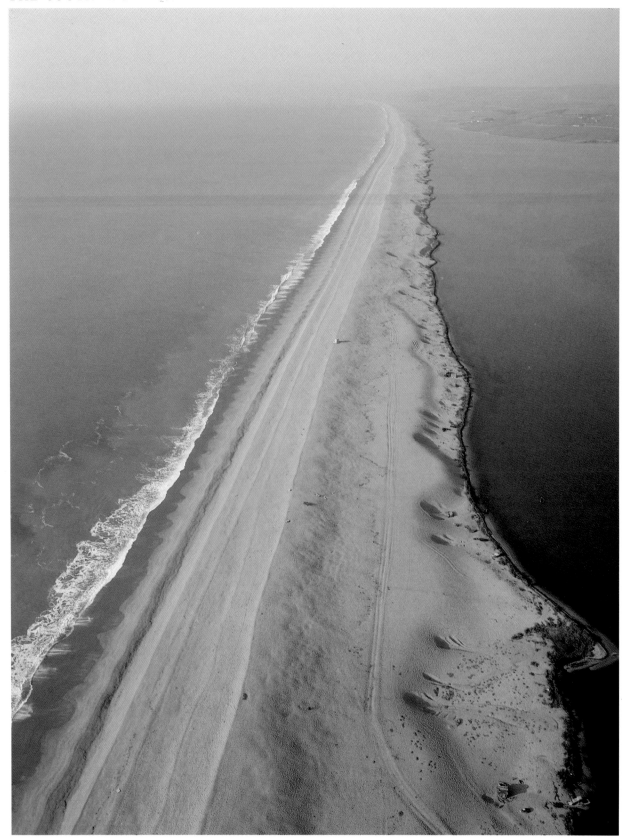

CHESIL BEACH

The 10 miles (16 kilometres) of Chesil Beach contain a geological mystery that has yet to be unravelled. Why are the countless pebbles that cover this massive bank of shingle graded according to size, with the smallest near Abbotsbury in the west and the largest lying in the east at the Isle of Portland? The stones also change colour along the way, being browny-yellow in the west and grey in the east, which is another riddle waiting to be solved. In some places Chesil Beach, which lies on a blue clay reef, is over 40 feet (12 metres) high, and so acts as a natural sea wall for the lagoon, known as the Fleet, that lies behind it. In the past, the height of the beach has spelled disaster for many a ship swept helplessly on to the rocks in the teeth of a violent storm. One notable example occurred in 1824, when a sloop was saved from the turbulent sea by being pushed into the Fleet but two other ships went down, with all hands lost. The storm was so violent that it also destroyed a good part of the village of East Fleet. Beachcombers can have fun exploring Chesil Beach on foot but swimming would be dangerous because of the strong currents, despite the inviting appearance of the sea.

THE NEEDLES

Only three chalk pinnacles, known as the Needles, protrude from the sea like jagged teeth, but once an unbroken ridge of chalk joined the Isle of Wight with the mainland. As chalk is so soft and the sea so rough, the Needles will one day vanish completely beneath the waves, but until that happens they are one of the most popular tourist attractions on the Isle of Wight. Of course they also pose a danger to ships, so the lighthouse was built in 1859 to replace one that sat on the clifftop, which is also being eroded by the sea. What does still occupy the clifftop is Old Needles Battery, a nineteenth-century fort which houses an exhibition of the fort's history. In the far left of the photograph is Alum Bay, noted for its multi-coloured cliffs and equally bright beaches created by such minerals as red iron oxide, white quartz and yellow limonite. Over the years, many thousands of children holidaying on the Isle of Wight have proudly borne home small glass lighthouses filled with layers of the different coloured sands. The cliffs themselves, so different from the white chalk normally associated with the Hampshire coastline, were formed underwater, before the Isle of Wight emerged from the sea about 50 million years ago.

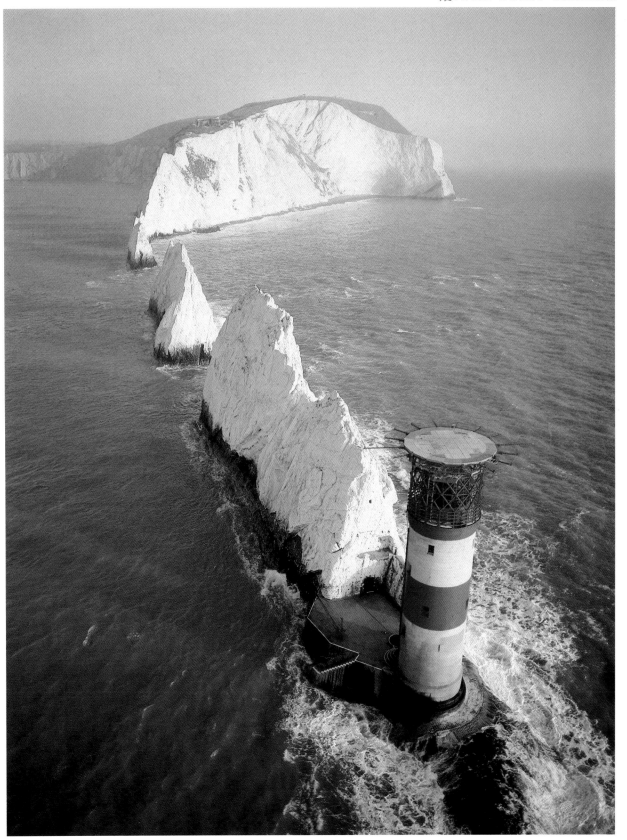

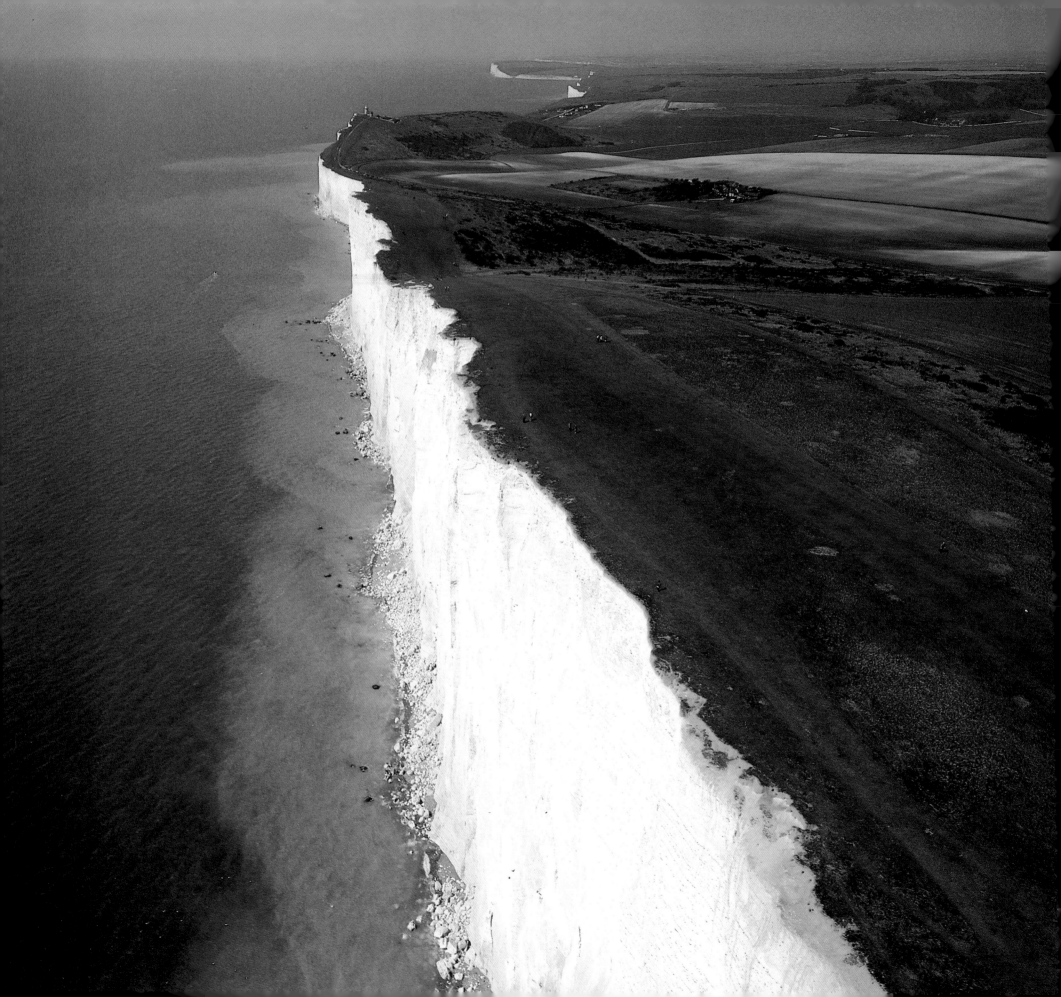

THE SOUTH AND SOUTH EAST

EAST SUSSEX, WEST SUSSEX AND KENT

Above Rivulets of cool golden sand are a sight enticing to holiday-makers, and they certainly flock in their droves to the Isle of Wight. There are generously sandy bays and beaches all around the island, and many of them seem to link up to form a continuous fringe of sand, especially around the south coast of the island. The south coast offers a range of beaches, from vast stretches of sand, such as at West Wittering, to the pebbly beaches of Brighton and Seaford or the rocks that are revealed at low tide to the west of Eastbourne.

EASTBOURNE

Facing page The coast between Eastbourne and Brighton, including the Seven Sisters, may not be able to offer any sandy beaches, but it more than compensates for that with its glorious chalk cliffs and stunning views of the undulating South Downs countryside. This photograph is taken looking west from Beachy Head (which is the highest point of the south-east coast) towards Seaford and Newhaven. Belle Tout, Eastbourne's original lighthouse, can be seen standing on the headland known, appropriately, as Lookout Hill.

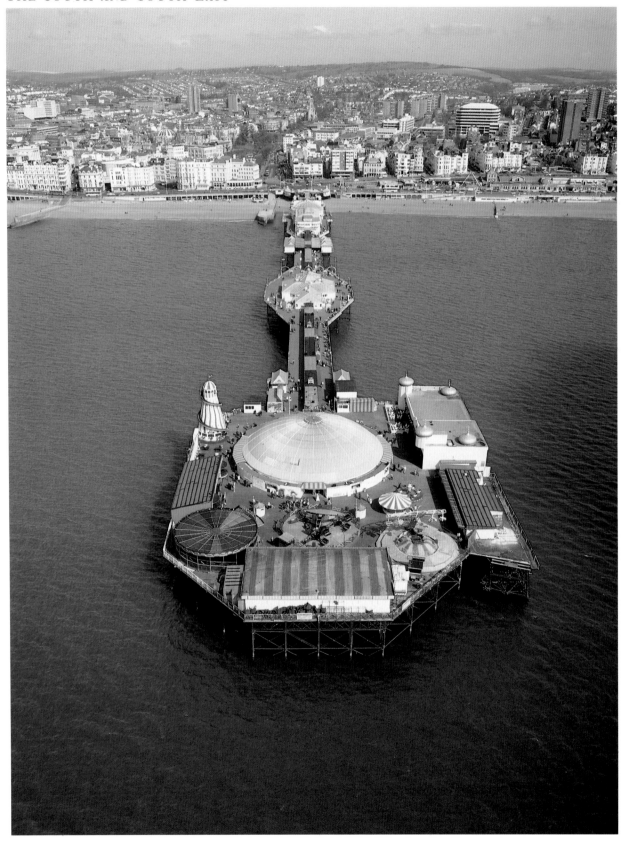

BRIGHTON PIER

Piers are an essential part of the British seaside, with their associations of cheery good humour, slot machines, McGill postcards and bracing sea breezes. Nineteenth-century Brighton obviously had such a respect for piers that it built two, although the once-elegant West Pier is now rapidly collapsing into the sea – a deterioration that was hastened by the violent storms of 1987 and 1990. The merrily-named Palace Pier, on the other hand, is a thriving monument to enjoyment and conjures up all the bustling, colourful jollity of Brighton in summer.

BRIGHTON

The Palace Pier, laden with all the fun of the fair, stretches out into the sea with the seaside town of Brighton lying behind it and the smooth curves of the South Downs rolling away to the horizon. Originally a small fishing town called Brighthelmstone, Brighton owes its initial popularity to the Prince Regent (later George IV), who first visited the town in 1783 and found he just couldn't stay away. He even set up home there, in a Regency extravaganza of a house that is now world-famous as the Royal Pavilion. Two of its minarets, looking like pointed green onions, can be seen here pointing skywards, to the left of the pier. After George IV's death, subsequent members of the royal family didn't share the late monarch's love of his fantastic palace (and the activities that went on in it), and a disapproving Queen Victoria sold it to the town in 1850; visit the Pavilion today and you'll realize that Brighton definitely had the better bargain. The arrival of the railway in 1841 set the seal on Brighton's fame and fortune as a seaside resort, and it has thrived ever since, developing its unique atmosphere of faded royal splendour mixed with a generous dash of boisterous seaside fun, shabby seediness (the atmosphere of Graham Greene's *Brighton Rock* still persists) and artistic curiosity (there are many intriguing antique shops and plenty of famous faces to be seen).

EASTBOURNE

Twenty miles (32 kilometres) along the coast, Eastbourne has a very different atmosphere from Brighton and prides itself on being a sedate and elegant resort. The 3 miles (4 kilometres) of promenade are lined with huge white-painted hotels on one side (shops and restaurants are not allowed to spoil this elegant esplanade) and flower beds on the other. More exuberant flower beds, known as the Carpet Gardens, are the two long rectangles lying just beyond the pier, where thousands of bedding plants are laid out in the formal Victorian patterns that are either loved or loathed. The begonias and sempervivens thrive in Eastbourne's plentiful sunshine, earning it the soubriquet 'Suntrap of the South'. The green part of the promenade jutting out into the sea is known as the Wish Tower, after the martello tower that stands on it. This is the 73rd tower to have been built along this stretch of coast during the Napoleonic Wars – originally 103 towers ran down from Aldeburgh in Suffolk to Seaford in Sussex, although only 45 now remain. The small blue-roofed building lying halfway between the pier and the Wish Tower is the bandstand. In the photograph it barely seems to extend into the sea at all, but in rough weather the sea beats against its walls and has even been known to drown out the music of the band – and flood the surrounding Grand Parade with shingle and sea water.

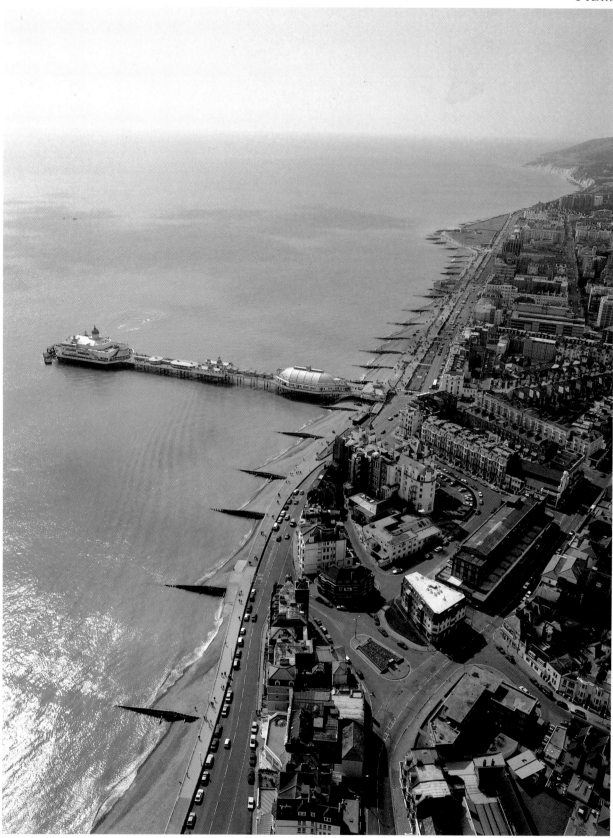

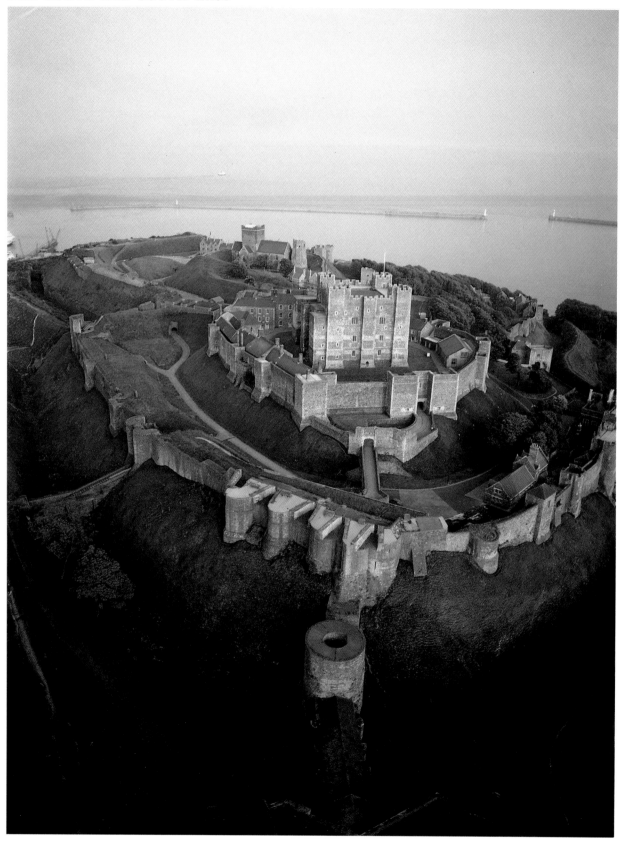

DOVER CASTLE

Left Sitting on the Eastern Heights, Dover Castle looks as imposing today as it must have when its massive keep was built by Henry II in the 1180s. Unfortunately, even after the curtain wall was built, the castle wasn't as impregnable as had been hoped, and Prince Louis of France managed to besiege it during the reign of King John, causing considerable damage. By the time of the Napoleonic Wars a few lessons had been learned in fortress-building and the tops of many of the towers were sliced off to provide artillery platforms, as can be seen in the photograph. The Romans also thought the Eastern Heights were a superb vantage point, and part of their building work remains in the shape of the church, St Mary in Castro, and the octagonal bell tower that stands to the right of it. This was originally the bottom of a massive Roman lighthouse, or *pharos*, and is one of the tallest Roman remains in Britain. With the huge harbour walls illuminated by several small lighthouses, the cross-channel ferry on the far horizon has no need of this primitive method of guidance in and out of the harbour.

HEVER CASTLE

Facing page In complete contrast to Dover Castle and its military associations, Hever Castle sits dreamily surrounded by a moat and formal gardens in one of the prettiest parts of Kent. Built for prestige, not defence, the castle is perhaps best known as the childhood home of the ill-fated Anne Boleyn, who was wooed and won here by an ardent Henry VIII. The castle fell into disrepair after her father died, and was only rescued in 1903 by the American millionaire William Waldorf Astor. He restored the existing buildings to their original Elizabethan splendour and also enhanced the rest of the grounds by building the mock-Tudor village in the bottom right-hand corner of the photograph and creating a series of magnificent landscaped gardens. The work took four years to complete and employed the services of one thousand men, using many trees from nearby Ashdown Forest in its construction. Anyone wishing to visit Hever Castle and impress their friends by swiftly reaching the centre of the maze need only study this photograph to discover most of its secrets.

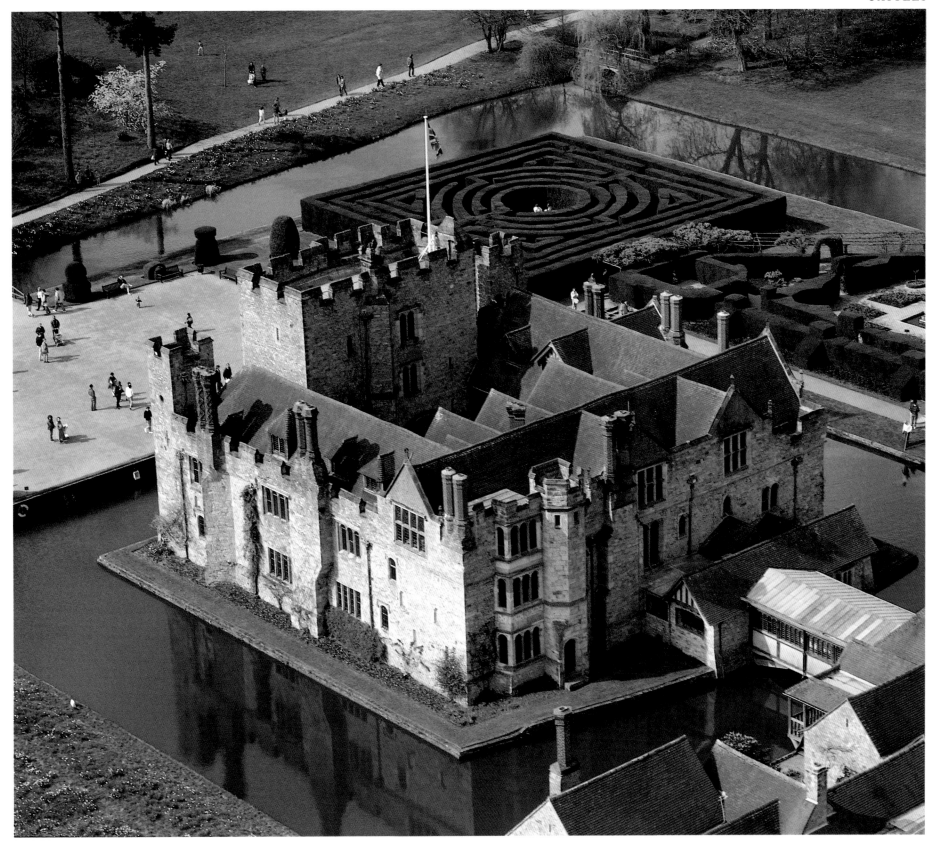

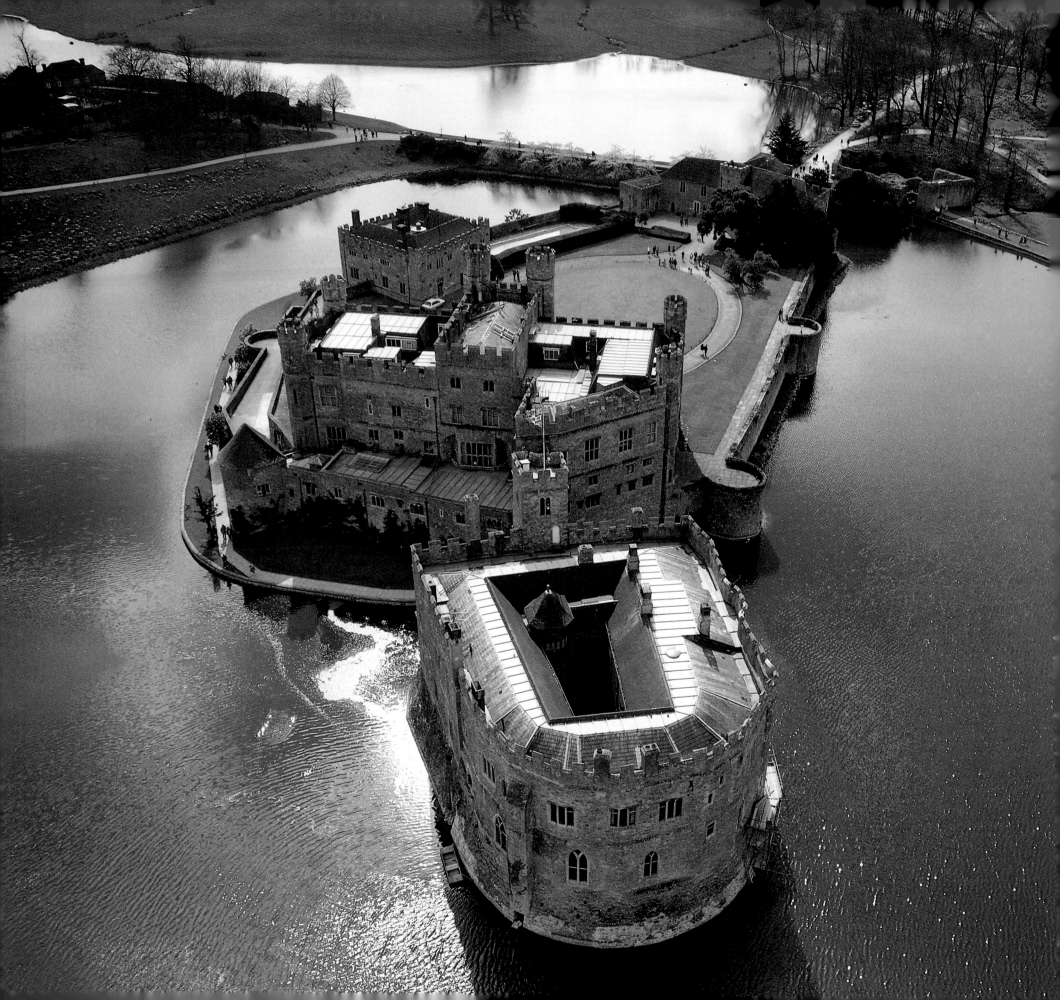

LEEDS CASTLE

Facing page This bird's-eye view shows Leeds Castle off to magnificent advantage. The castle stands on two islands in a lake that is fed by the nearby River Len. The main part of the castle is connected to the gloriette, which stands nearest the camera, by a two-tier bridge. Its first royal owners, the great castle-builder Edward I and his first wife, Eleanor of Castile, regarded Leeds as defensive and so greatly increased its fortifications, but when it passed into Henry VIII's hands several centuries later he fell in love with its glorious surroundings and turned it into a palace. Today it is owned by the nation, and is one of the most beautiful tourist attractions in the south east.

CANTERBURY

Right Medieval splendour contrasts sharply with modern buildings in Canterbury, but the soaring spires of the cathedral dominate the scene. Canterbury Cathedral is the mother of the Anglican church throughout the world, and in that role has been visited by millions of pilgrims over the centuries, the most famous being those immortalized in Chaucer's *The Canterbury Tales*. Large parts of the old walls that originally encircled the city still remain and can be walked on – they are clearly visible standing out in sharp relief against the road in the left of the photograph. Below them are the vertebrae-like ruins of St Augustine's Abbey, which was founded in 598 by St Augustine who had come here from Rome to spread the Christian Gospel. His first convert was King Ethelbert of Kent, who in turn converted his subjects, so his journey was not in vain. Other visitors' attractions include the Old Weavers House, the Roman Pavement, Eastbridge Hospital and a museum and art gallery. The horizon stretches out, past the sprawling suburbs of Canterbury, towards Ashford and the Kent-Sussex border.

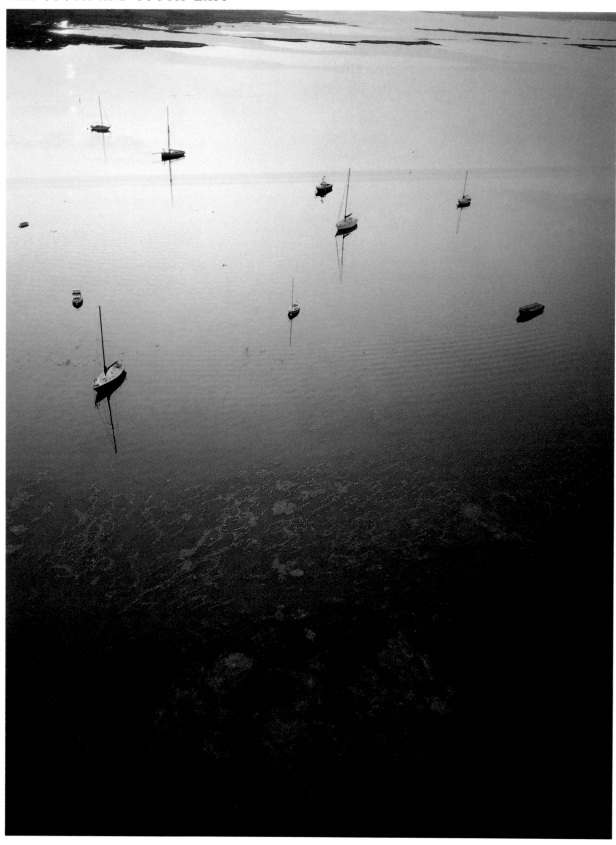

RIVER MEDWAY

Over the centuries the Medway has seen the rise and fall of
the naval dockyards at Chatham, and with them the story
of Britain's maritime history. The closure of the working
dockyards means that most of the boats that sail up and
down these waters now are built on a much smaller scale,
like these yachts sitting peacefully in dead calm water.

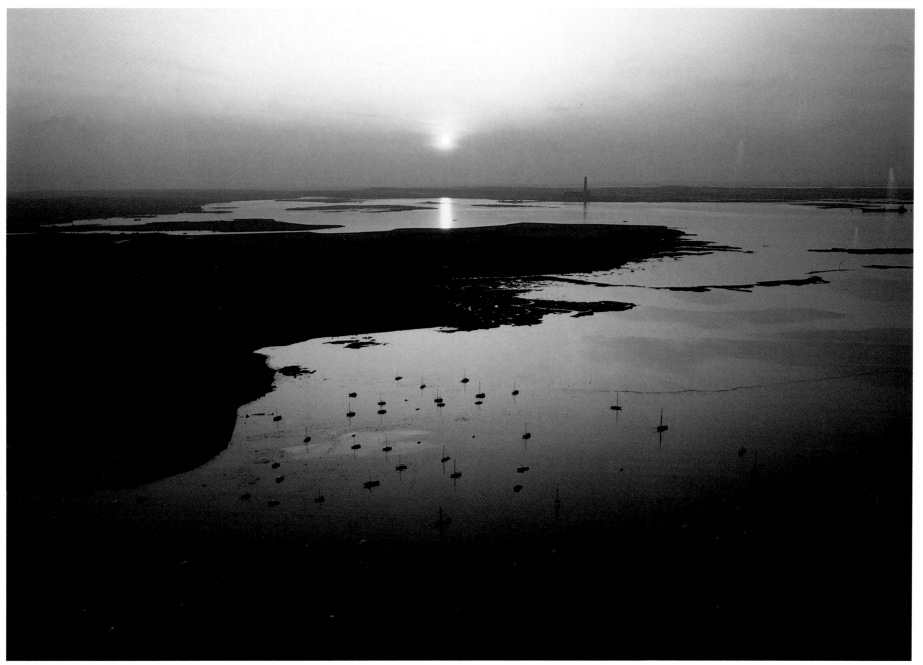

THE MEDWAY ESTUARY

There are still some parts of the South East of England that are quite unspoilt, while others have been completely overtaken by the urban sprawl of the twentieth century. Parts of the Medway, as here, remain untouched although others have become industrialized, such as the Isle of Grain, which has an oil refinery and power station.

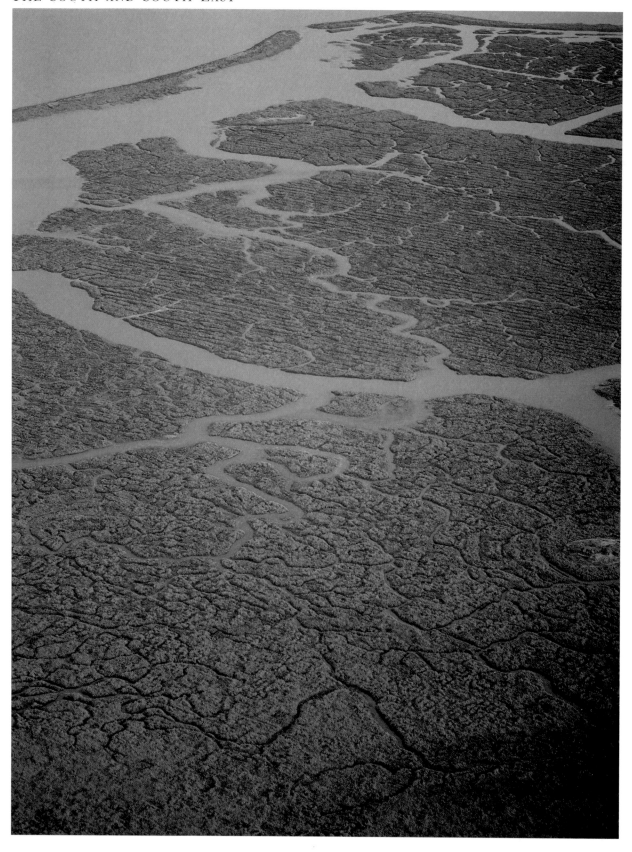

RIVER MEDWAY

Left Much of the Medway is muddy and littered with creeks and mudflats. There are also little islands, including one called Deadmans Island, which sounds as though it has stepped straight out of *Treasure Island*. After the terrible outbreak of plague in 1665, any passengers on foreign ships coming into the Medway who were suspected of suffering from the plague were put into quarantine on special ships anchored off this island. If they lived, they were allowed to leave, but if they died they would be buried on Deadmans Island.

COUNTRY FIELDS

Facing page A Sussex field (*top left*) has been invaded by telegraph poles, while this field in Kent (*top right*) has been bisected by a main road, and an intersection of the M25 (*bottom right*) criss-crosses its way through what were once open fields. Only a Kentish apple orchard (*bottom left*) remains untouched.

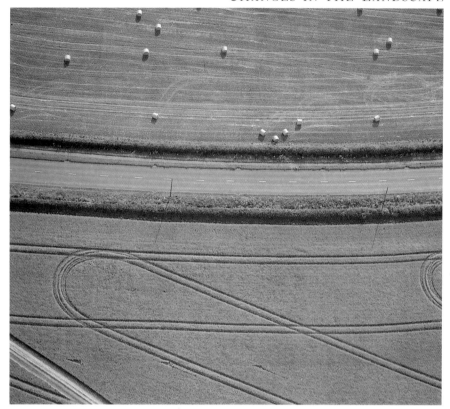

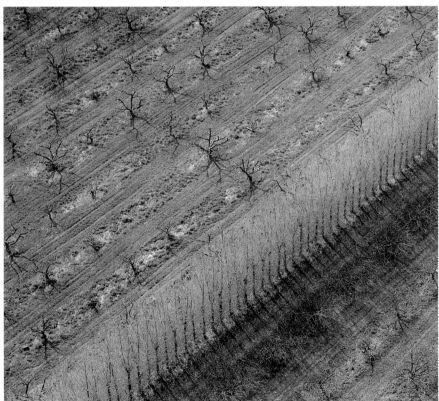

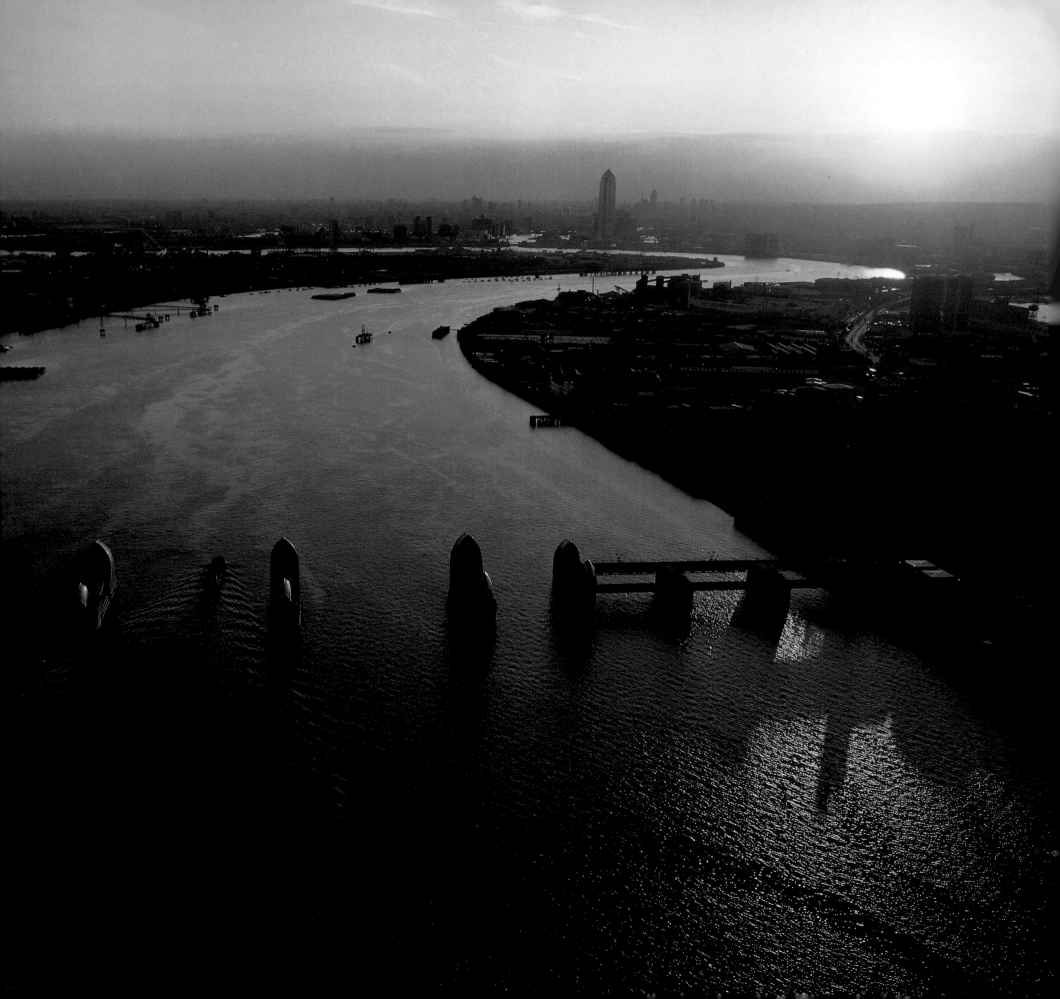

LONDON AND THE THAMES VALLEY

London, Surrey, Berkshire and Oxfordshire

WATERLOO STATION

'The most perplexing railway station in London' is how Waterloo Station was described at the end of the nineteenth century, when it had grown so much that it became two stations (which it still is today – Waterloo and Waterloo East). To add to the confusion, the London Necropolis Company ferried its funeral traffic from its 'Necropolis station' next door to Waterloo and ran a daily funeral express back and forth to their cemetery. The new station was built on the site of the old one between 1900 and 1922, with 21 platforms arranged in a crescent. The Necropolis station was destroyed in the Second World War.

THE THAMES BARRIER

Facing page The Thames Barrier at Woolwich was completed in 1982, yet similar flood prevention schemes had first been discussed over 100 years before. These plans never came to fruition, but the devastating flood of 1953, in which 300 people in East Anglia and the Thames estuary drowned, underlined the need for action, and work finally began on the Barrier in the 1970s.

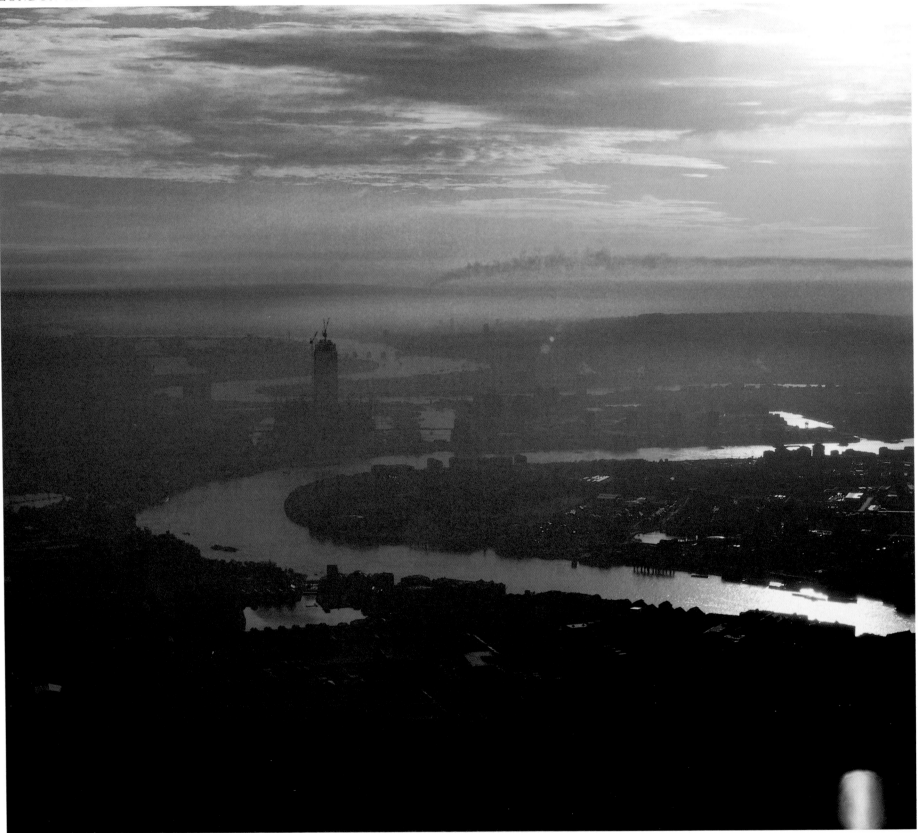

THE ISLE OF DOGS

Facing page As the Thames flows down from the centre of London on its way to the sea it forms a series of loops, one of which swoops round the north bank and encloses the Isle of Dogs in a long peninsula. During the Middle Ages this area was known as Stepney Marsh and was home to a small community, but the river reclaimed the land in 1448 and no further serious attempts were made to develop it until the early nineteenth century, when the West India Docks were created. It was these docks, and others like them, that helped London to become such a successful and wealthy port. The West India Docks were closed in 1980, and the Isle of Dogs is gradually being redeveloped, with its own overground railway (the Docklands Light Railway) and a complex of futuristic office blocks intended to house many of the large companies that first operated in central London. Canary Wharf tower stands out tall and proud, and marks the centre of West India Docks itself.

TOWER BRIDGE

Right Although the old docks have gone and the Docklands Development has arisen in their place, the Thames is still a working river. Tower Bridge forms the unofficial dividing line between the river's twin functions of commercial waterway and beautiful tourist attraction. Now one of the most famous bridges in the world and an international symbol of London, Tower Bridge was only completed in 1894. It had to be built in Gothic style to complement the nearby Tower of London, and its span had to open up so tall ships could sail through it. HMS *Belfast*, the largest cruiser ever built for the Royal Navy and now open to the public, is permanently moored upriver from Tower Bridge. The other bridges in the photograph, going up from Tower Bridge, are the new London Bridge (1973 – the old nineteenth-century version was sold and re-erected in Arizona, Texas), Cannon Street Railway Bridge (1866), Southwark Bridge (1919) and Blackfriars Railway Bridge (1886), with Blackfriars (road) Bridge (1899) standing just behind it. On the north bank of the Thames, Telecom Tower (formerly the Post Office Tower) emerges above the skyline – it caused a sensation when it was opened in 1965.

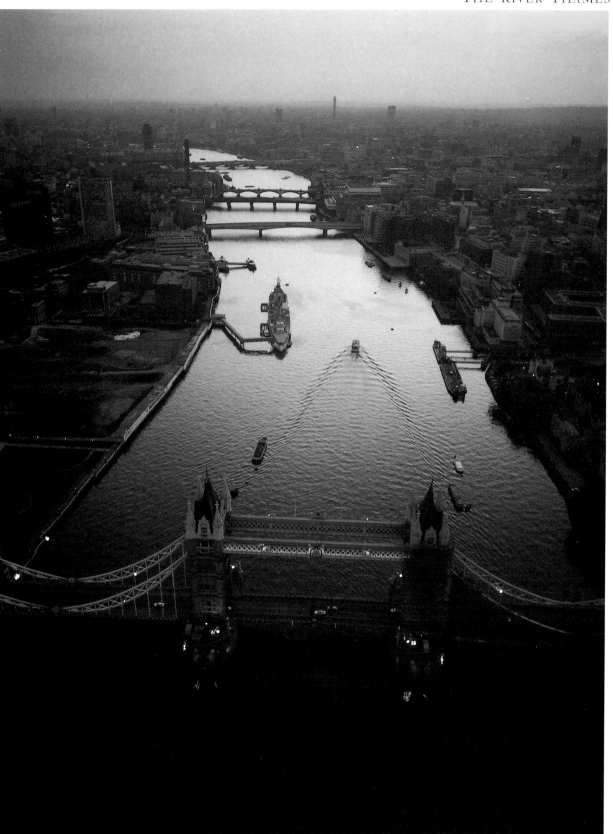

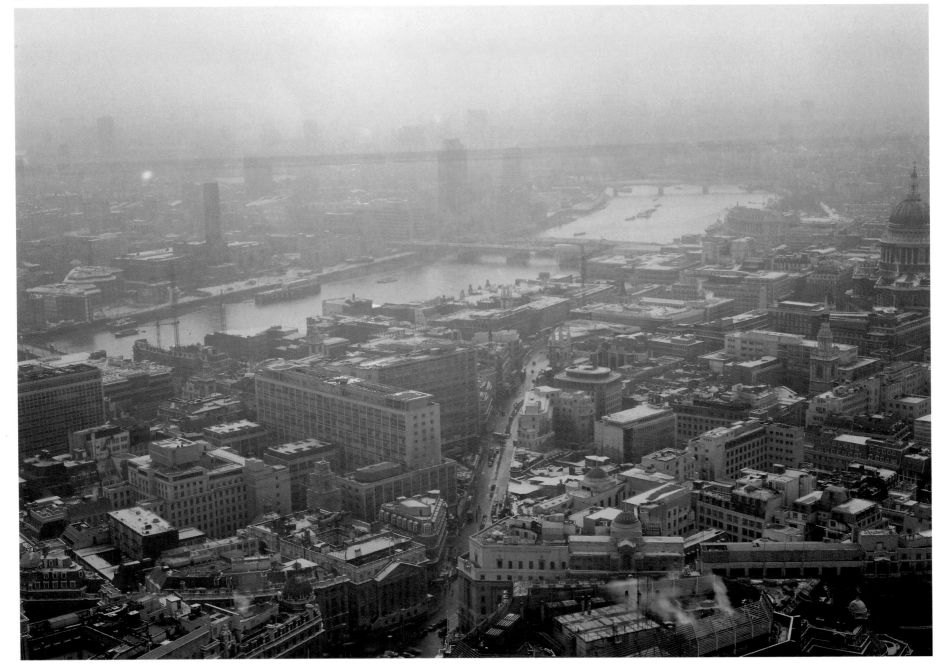

THE CITY OF LONDON

The air raids of the Second World War destroyed many old buildings in the City, paving the way for a preponderance of modern office blocks. Wren's masterpiece, St Paul's Cathedral, completed in 1709, on the right of the photograph (*above*), still looks over the City, shown here after a snowfall, but the photograph on the facing page shows how modern architecture is crowding out the City's historical buildings. The arcaded building on the Thames (centre left) is the old Billingsgate Fish Market, and the elegant building to its right is the Custom House. Wren's Monument of 1677, commemorating the Great Fire of London, stands proudly to the left of Billingsgate Market.

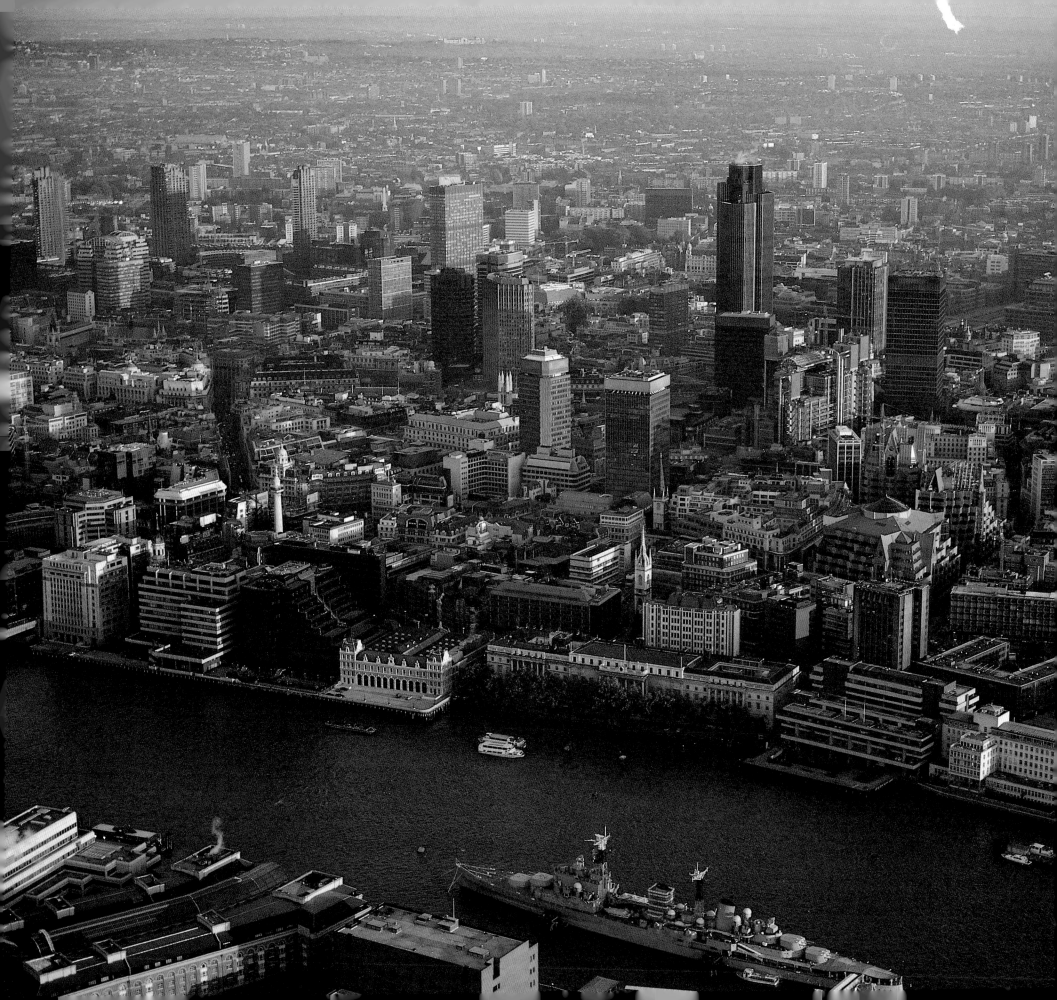

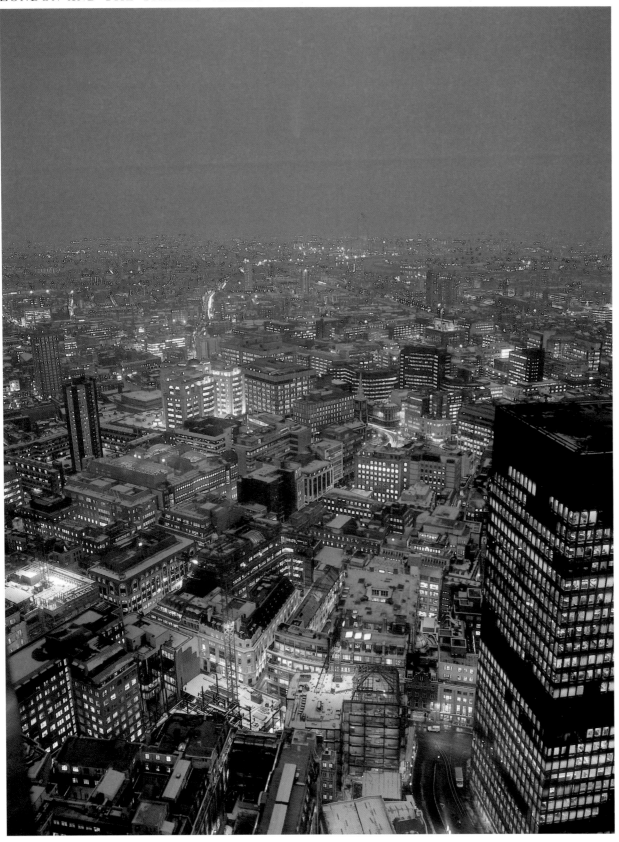

ALBERT BRIDGE

Facing page, left At night in Chelsea the illuminated spans of Albert Bridge glitter through gaps in buildings. This photograph was taken looking west, with Chelsea and Fulham on the right and Battersea and Wandsworth on the left. The dense patch of trees in the bottom left of the photograph is the edge of Battersea Park, and stretching to either side of Albert Bridge on the opposite bank is one of the most prestigious addresses in London – Cheyne Walk. The famous, the historic and the plain notorious have lived in its lovely Queen Anne houses, including Dante Gabriel Rossetti, Algernon Swinburne, Isambard Kingdom Brunel, Mrs Elizabeth Gaskell, George Eliot, James Whistler, Thomas Carlyle and, during the late 1960s, Mick Jagger and Keith Richards. The next bridge along is Battersea Bridge, with the towers of a gas works and Lots Road Power Station beside the small inlet in the river known as Chelsea Creek.

LONDON AT NIGHT

Left It is fascinating that a city so full of grey stone buildings during the day should become a mosaic of green and gold at night, and the beauty of the scene is further enhanced here by the purity of the snow lying on top of the buildings; snow in London is usually soon rendered black or ochre yellow by the general grime. This photograph is taken looking east, from St Mary Axe in the City down to the Isle of Dogs, and beyond into Essex. It is already history, because on the right-hand side of the photograph is the Baltic Exchange building which was badly damaged by an IRA bomb in the spring of 1992. The ribbon of white and red lights in the centre of the photograph shows a stream of cars going up and down Commercial Road, which is one of the busiest roads leading into the City.

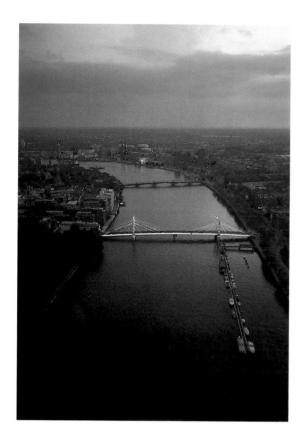

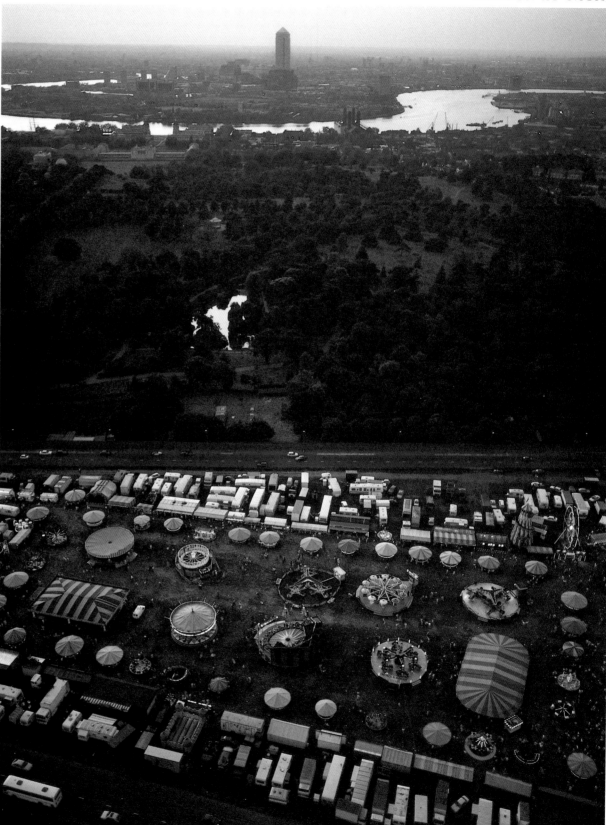

BLACKHEATH

Right Viewed in the dusk, the sideshows at this fun fair at Blackheath look like the patterns seen in Caithness paper-weights and colourful boiled sweets. Behind the fair is Greenwich Park, with its lake clearly visible; the green dome of the former Royal Observatory is poking through the trees to the left. Behind that is the Palladian splendour of the National Maritime Museum. Two of the three masts of the *Cutty Sark*, a nineteenth-century tea clipper now in dry dock at Greenwich, can be glimpsed further to the left and outlined against the Thames. The Isle of Dogs, with the ubiquitous tower of Canary Wharf, sprawls on the north bank of the river. From here the Thames becomes ever wider, passing through Woolwich to the right of the photograph, on past the Thames Barrier and out to sea.

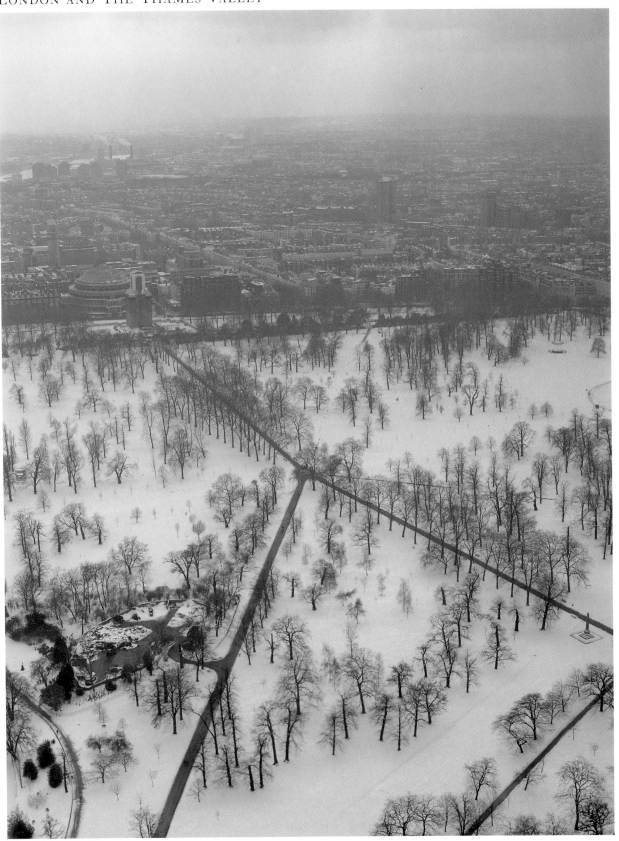

HYDE PARK

Left A fall of snow can change a landscape completely. Most people think of Hyde Park as a vast sea of green grass and pleasantly leafy trees, yet this photograph reveals its bare bones of skeletal trees and arterial paths. In the far right of the photograph in the Park is the edge of a very frozen Round Pond, with the green copper roof of the Bandstand apparently floating in mid-air above it. On the left, at the edge of the Park, is what seems to be a huge green and white sentry box, which actually encloses the Albert Memorial while its repair work continues. On the opposite side of this section of Kensington Road, known as Kensington Gore, is the circular Royal Albert Hall and, behind that, the Royal College of Music and Imperial College. The streets of South Kensington, Earls Court and Chelsea stretch away towards the Thames beyond.

THE EMBANKMENTS

Facing page Many stretches of the Thames, as it flows through central London, are bordered by embankments which give a clear and uninterrupted view of the river. The biggest are the Albert, Chelsea and Victoria Embankments, and parts of them are bordered by gardens laid out with paths, formal flower beds, statues and plenty of seats. They are usually thronged with workers eating their lunches, tourists having a rest from sight-seeing, dogs, sandwich sellers, buskers (the section of Victoria Embankment Gardens to the east of Embankment tube station even has a bandstand) and thousands of pigeons. It is rare to see any of these embankments blanketed, as here, in a fall of pristine and unmuddied snow. Although London is under snow here, the Thames still flows freely; the old days of frost fairs being held on a frozen Thames have gone forever. This is not because of global warming but because the old London Bridge (which was demolished in 1831) slowed down the flow of the Thames and allowed it to freeze over in prolonged bitter weather, to such an extent that oxen were roasted on the ice and people could drive their carriages across it.

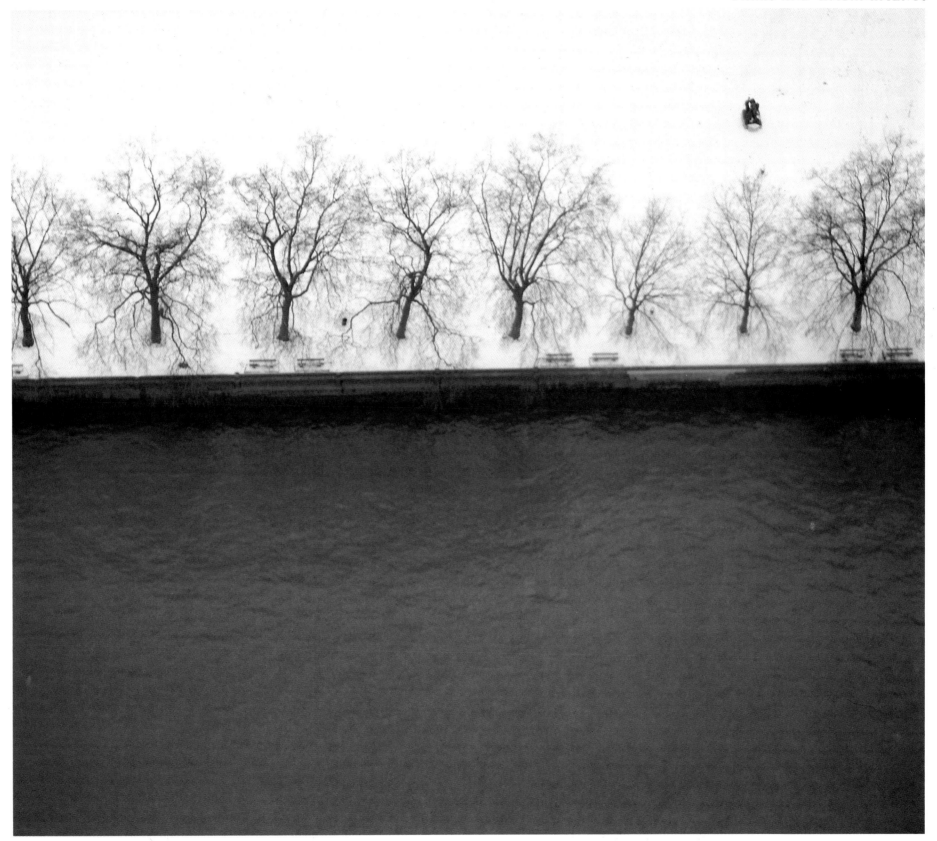

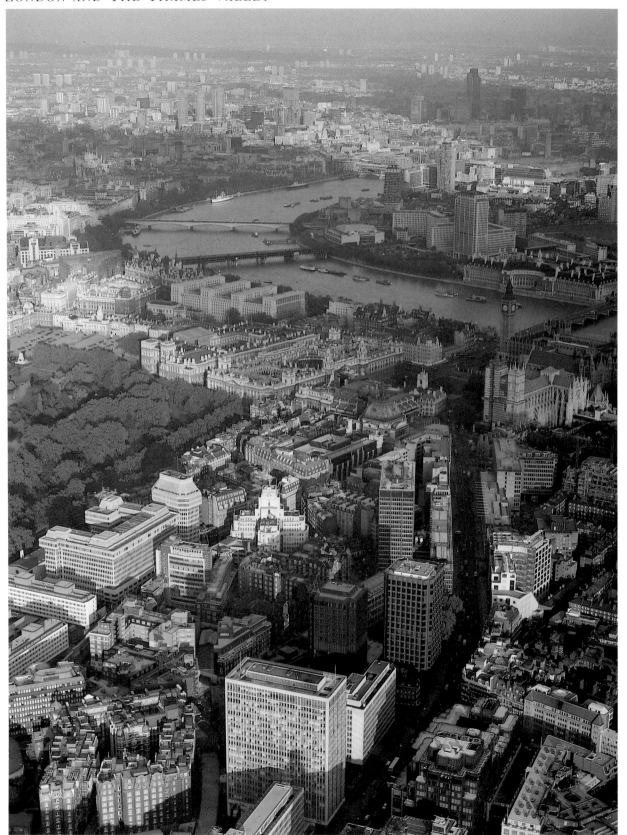

WESTMINSTER

The beauty of St James's Park, the oldest of London's royal parks, belies the fact that it takes its name from a hospital for female lepers. It has had a chequered history, going from a favourite royal retreat and hunting ground in the seventeenth century to a notorious haunt of prostitutes less than a hundred years later. Early in the nineteenth century various improvements were made to the park and it has continued to prosper ever since, now being home to over 30 species of birds. Horse Guards Parade is at the end of the park on the left of the photograph and beyond that, on the Embankment, is the Ministry of Defence which extends far below ground level. Victoria Street runs up the left of the photograph and leads to the pale Gothic beauty of Westminster Abbey and the golden Houses of Parliament beyond it. The bridges (right to left) are Westminster Bridge (1862), Charing Cross Railway Bridge plus footbridge (1864) and Waterloo Bridge (1942).

RICHMOND

The London borough of Richmond started life as a cluster of fishermen's cottages around a manor house, and it was only in the sixteenth century that it began to grow under the protective eye of Henry VIII, who pulled down the manor house and built a palace in its stead. The palace has long gone, but its few remains lie by Richmond Green in the bottom right of the photograph. Richmond, in itself a leafy area, is surrounded by some of London's most lovely open spaces. The vast expanse of Richmond Park begins on the brow of Richmond Hill, further away past the bottom right of the photograph, but the beginnings of the Old Deer Park can be seen on the south bank of the Thames (middle right in the photograph), bordered by Twickenham Road Bridge and the smaller Richmond Railway Bridge. A close look at the bridge slightly further downriver, and the turbulent water lying beyond it, will reveal its true function – it is a footbridge over a lock which controls the tide. Nineteenth-century improvements to the Thames in central London meant that low tide often left Richmond with nothing but a stretch of mud for a river. The sluice gates, which are raised or lowered to control the tidal Thames, are just visible in the photograph. The bridge itself leads into St Margarets and on into Twickenham; Hounslow and Isleworth fade away towards the north.

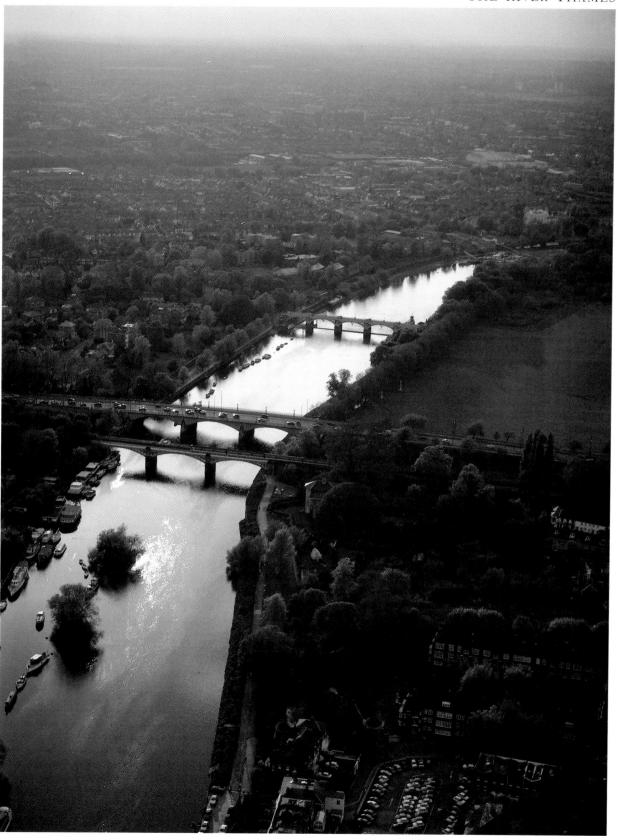

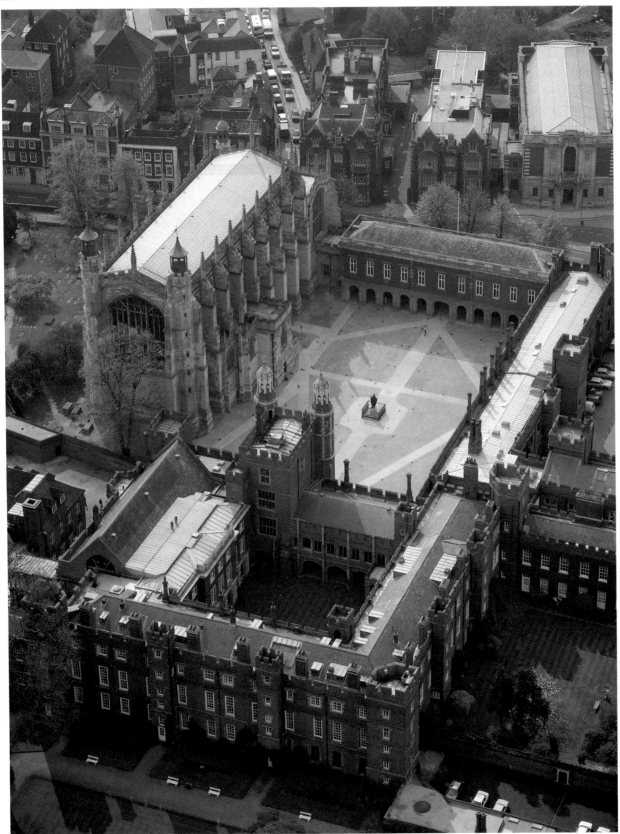

ETON COLLEGE

Left Eton College began its scholarly history when it was founded by Henry VI in 1440, though some of his ambitious plans for the place were abandoned when he was imprisoned (and then beheaded) in the Tower of London. For example, the huge chapel on the left of the photograph was originally intended to be part of an even larger church. Nevertheless, building continued during the sixteenth century, when such important parts of the college as the twin-turreted Lupton's Tower (overlooking the school yard) and the cloisters to the right of it were built. The statue standing in the middle of the school yard is of the deposed Henry VI.

RICHMOND HILL

Facing page Invalided or incurable soldiers living at the huge red-brick Neo-Georgian Star and Garter Home (built on the site of the old Star and Garter Hotel and completed in 1924 to a design by Sir Edwin Cooper) high on Richmond Hill not only have the constant pleasure of dwelling in an elegant and gracious building, but are also treated to fantastic panoramic views. Below the grassy terrace and the green treetops of Petersham Common, the land drops down to Petersham Meadows and one of the most beautiful of all stretches of the Thames, as the river curves around the bend of Marble Hill on the opposite bank. On either side of Richmond Hill itself is a wonderful collection of Queen Anne and Georgian houses, with the two standing on the left of the Star and Garter Home of especial note. The Wick, with its huge bow windows at the back of the house, was built in 1775 by Robert Mylne, and the house next to it, Wick House, was built for Sir Joshua Reynolds in 1772 by Sir William Chambers. Past the Star and Garter Home to the right is Richmond Gate, one of the entrances to the 2000-acre (810-hectare) expanse of Richmond Park.

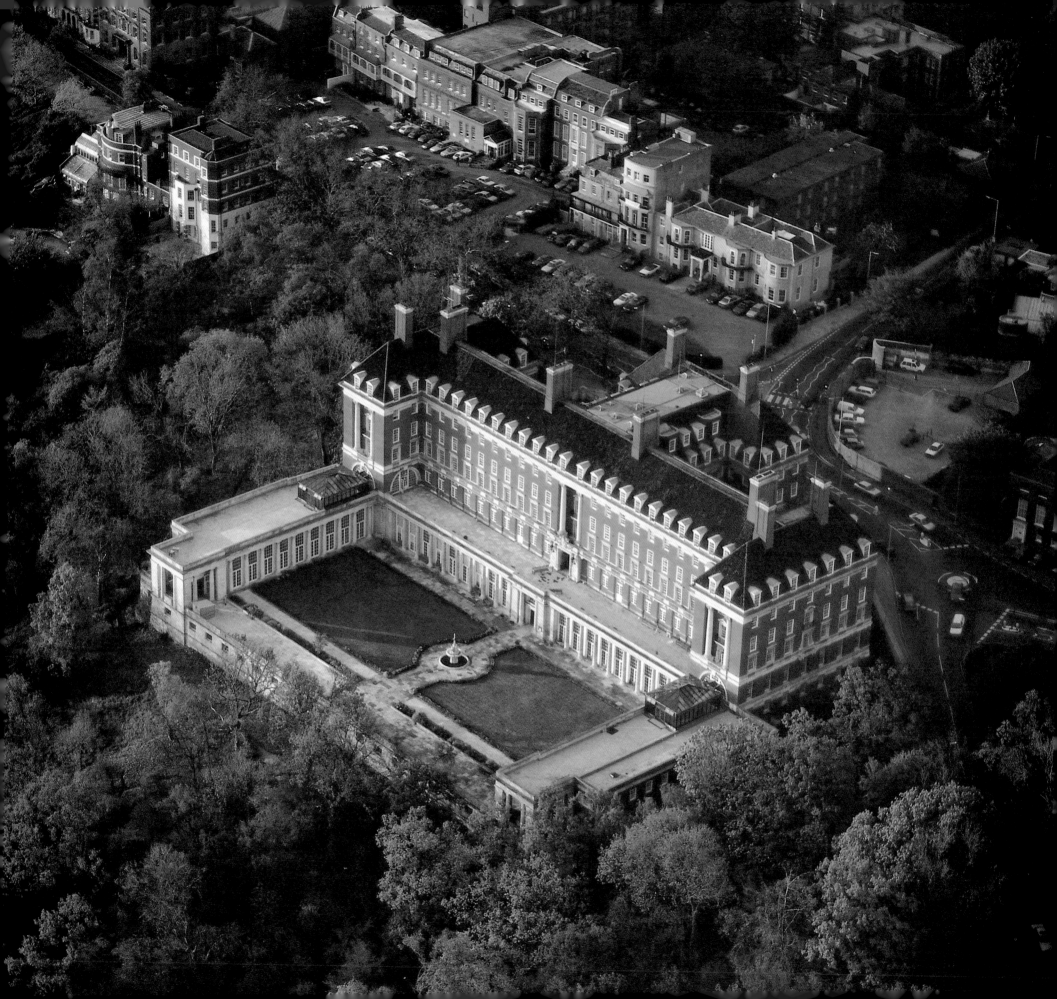

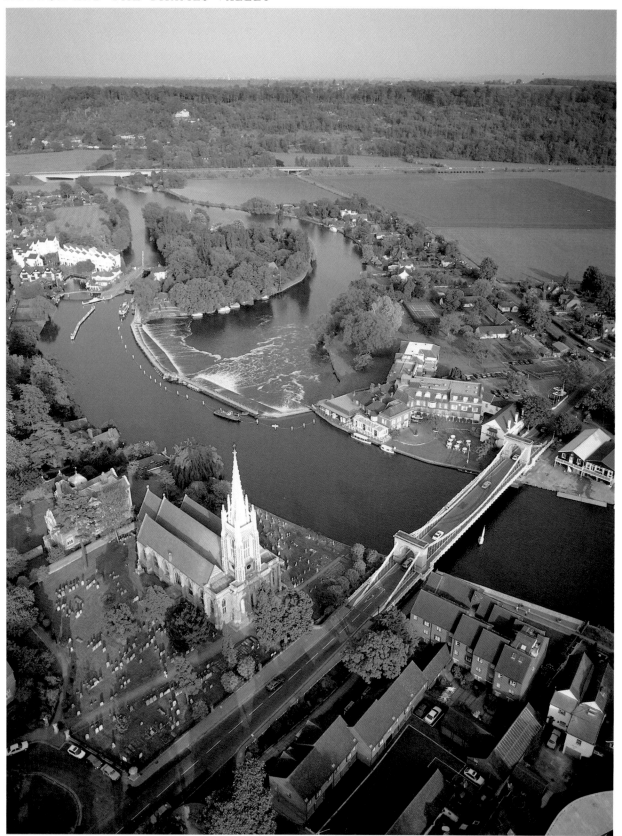

MARLOW

The Henley Regatta is world-famous, but it isn't the only regatta to take place on this stretch of river, as Marlow has one too. To most people, however, Marlow is best known for The Compleat Angler Hotel, which stands on the opposite bank from All Saints Church. It used to be called The Anglers Rest, but the change of name was to commemorate the book written by Izaak Walton in 1653 on the joys of fishing. As he particularly enjoyed fishing at Marlow, and *The Compleat Angler* took him 40 years to write, naming a hotel after the book seems a fair tribute to Walton's industry. There are new buildings in Marlow, too, such as the white clapboard houses down by the lock, built to blend in with the existing architecture; its sloping roofs were inspired by traditional mill buildings. The hills of Quarry Wood, which form part of the area known as Cookham's 'Little Switzerland', rise up in the background.

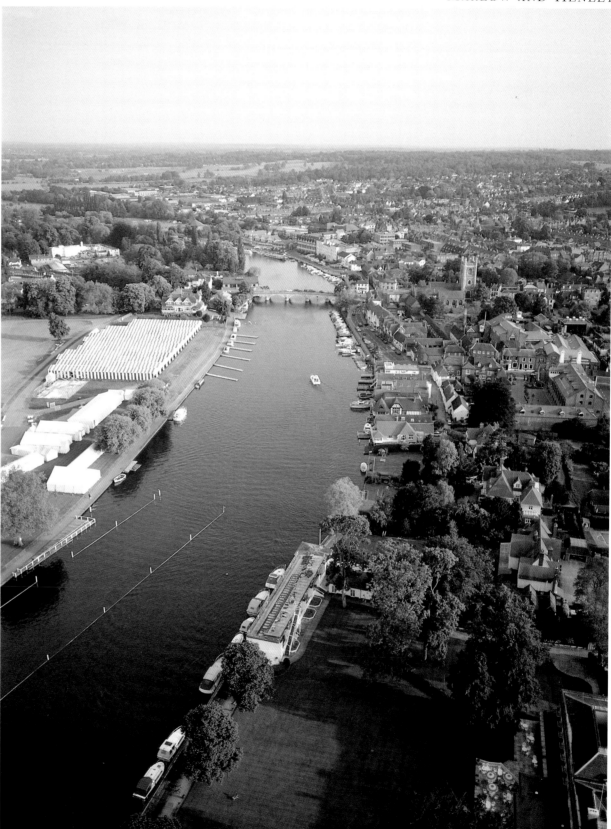

THE HENLEY REGATTA

Above For five days during late June and early July each summer the peaceful riverside town of Henley in Oxfordshire becomes the focal point of the English social calendar, when teams of international oarsmen race each other up and down the river and thousands of spectators sip champagne, enjoy a few strawberries and watch the races with one eye while they spot old chums with the other. *Right* Preparations are underway here for the forthcoming regatta. The pretty five-arched bridge was built in 1786 and is decorated with sculptures of the heads of Thames and Isis (the other name by which the river is known, especially in Oxfordshire). Immediately after the Regatta ends each summer the riverscape changes – the modern rowing boats vanish and are replaced by Edwardian canoes, 1920s slipper launches, Deep South paddle-steamers and other gems from the boating past, in the Thames Traditional Boat Rally.

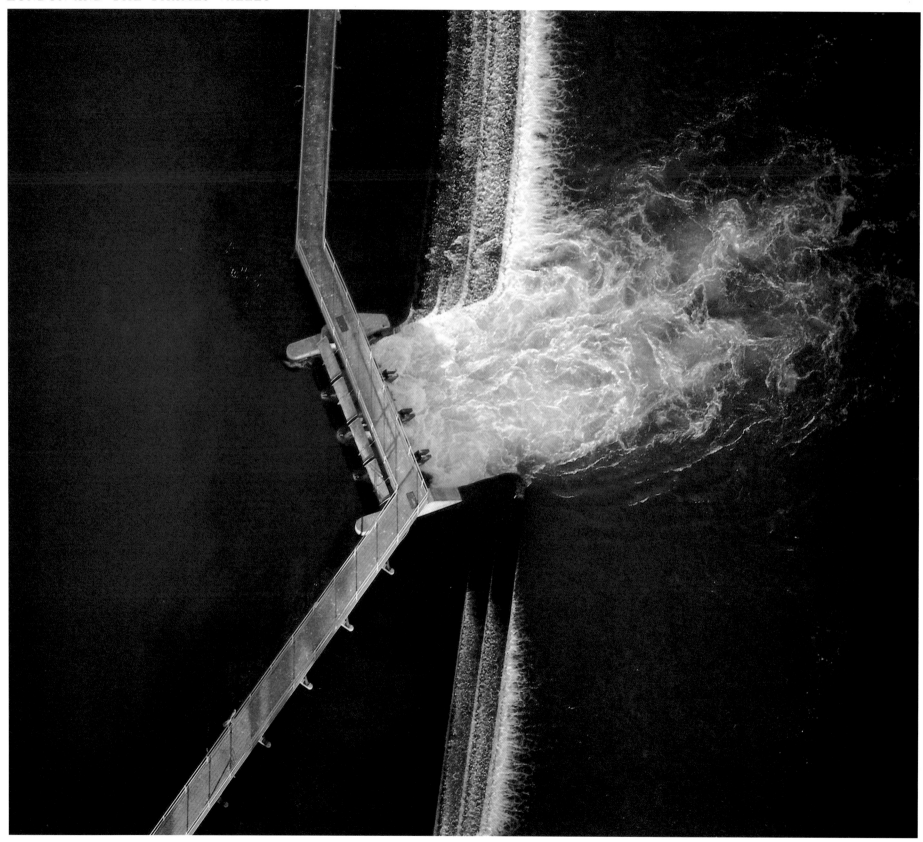

MARLOW WEIR

Facing page Anyone sailing through the lock at Marlow is well-advised to steer clear of the weir because the pull of the water is very strong. One of the best places to observe the weir, with its rushing, gushing water, is from the suspension bridge. There are marvellous walks along the whole of this stretch of riverbank, with plenty to see. Marlow is associated with other writers as well as Izaak Walton, but perhaps the most interesting ones are Mr and Mrs Percy Bysshe Shelley, who lived in West Street during the early years of the nineteenth century. While Shelley was writing his poem 'The Revolt of Islam', his wife Mary was working on her Gothic novel *Frankenstein*.

MARLOW BRIDGE

Right One of Marlow's most outstanding features is the elegant suspension bridge, which was designed by William Tierney Clarke and built between 1831 and 1836. In the 1960s there were plans to pull it down and build a new bridge, but they came to nothing; instead, the bridge was completely renovated in 1966 and is still going strong. The riverbank graveyard of All Saints Church is shown in more detail beside the bridge at the bottom of the photograph, with part of the gardens of The Compleat Angler Hotel visible on the opposite bank.

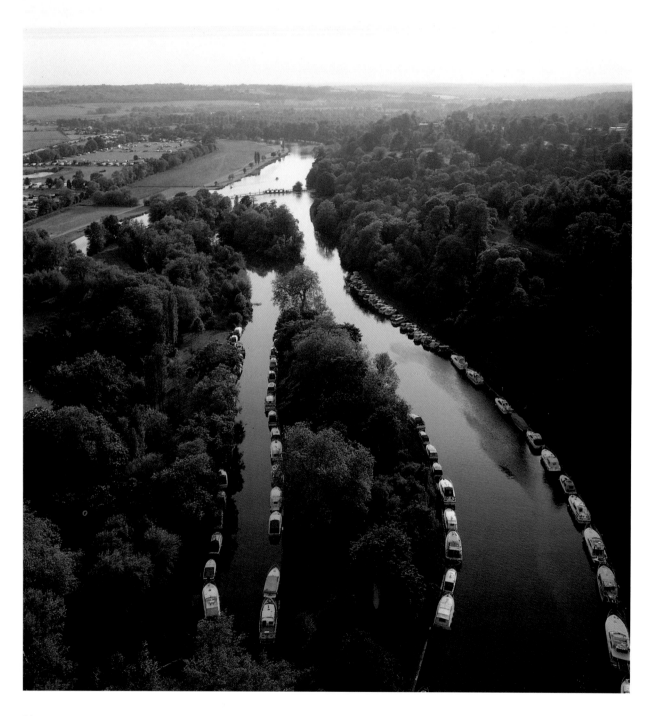

HURLEY

A few miles upstream from Marlow is the quiet village of Hurley. Large fields lead the way down to the river, with a massive caravan site sprawling over the east bank. The number of boats moored along the riverbank, and on either side of the wooded islands (known as ayots or aits) past Hurley Lock, illustrates just how popular boating is on this stretch of the Thames. On summer weekends the river is full of passing craft, with picnickers sitting on the banks and walkers exploring the many woods around here. However, this part of the Thames hasn't always been so tranquil, for a few river bends upstream to the left is Medmenham Abbey. It looks innocent enough today, but during the eighteenth century it was the summer headquarters of the notorious Sir Francis Dashwood and his dissolute Hell Fire Club. Their motto was 'Do what you will' and, if the stories are to be believed, they put it into practice at every opportunity, with orgies and black magic rites featuring high on the list of activities.

LOWER BASILDON

Right As it meanders through Berkshire, the Thames passes some spectacular scenery. Here, it has just snaked round a bend from the picturesque villages of Goring and Streatley into a heavily flooded Lower Basildon, and the beginning of the Chilterns Area of Outstanding Natural Beauty. It is not surprising that this stretch of the river is popular for holiday cruising, because the surrounding landscape is so pretty. The four-arched railway bridge in the foreground is Gatehampton Railway Bridge, which was built by Isambard Kingdom Brunel in the nineteenth century. An ancient earthwork, known as Grims Ditch, can be seen running like a scar through the wooded land rising up behind the bend in the river, a reminder that this part of the river has been an important crossing point since pre-Roman times.

READING TOWER AND M4 FOOTPATH

Following pages One of the most interesting aspects of walking through the British countryside is the strong chance you have of happening on the unexpected. It could be a hill figure carved out of the chalk downs, a breath-taking view across several counties or a strange building that stands in the middle of nowhere and seems to serve no purpose at all. This folly is near Reading (*left*), and its dilapidated appearance, with bricked-up windows, tells its own story. It was probably once a prospect tower – a tall building sited on the highest part of a landowner's grounds so it would not only be visible from miles around but also provide a wonderful view from its top storey. Some people would say that motorways are modern follies (*right*), but there is something very pleasing about the curves of this footpath over the M4. Footpaths like these can look unremittingly ugly when seen from a motorway, but this aerial view transforms them into an attractive abstraction.

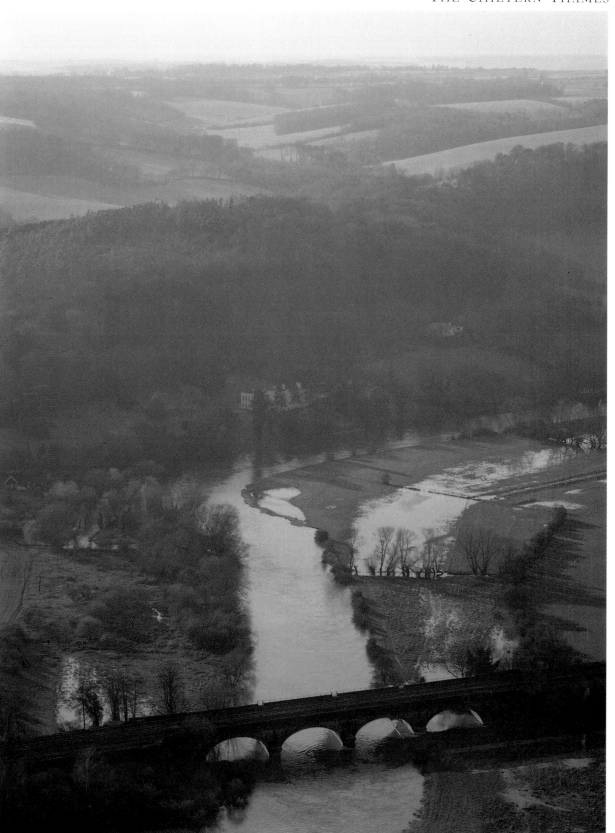

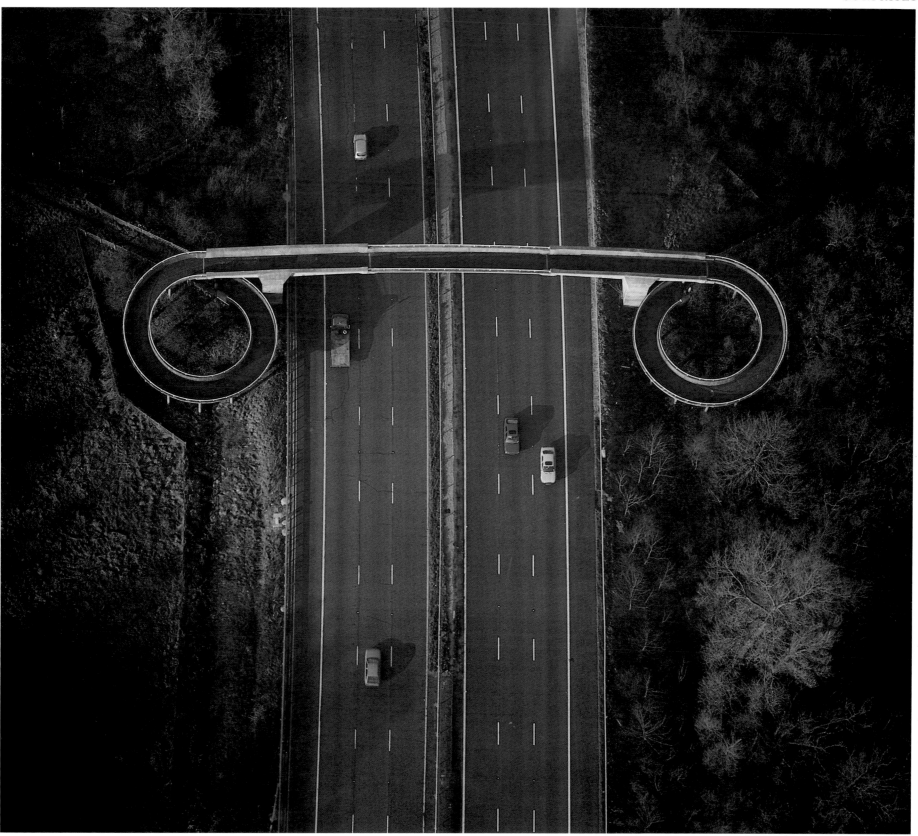

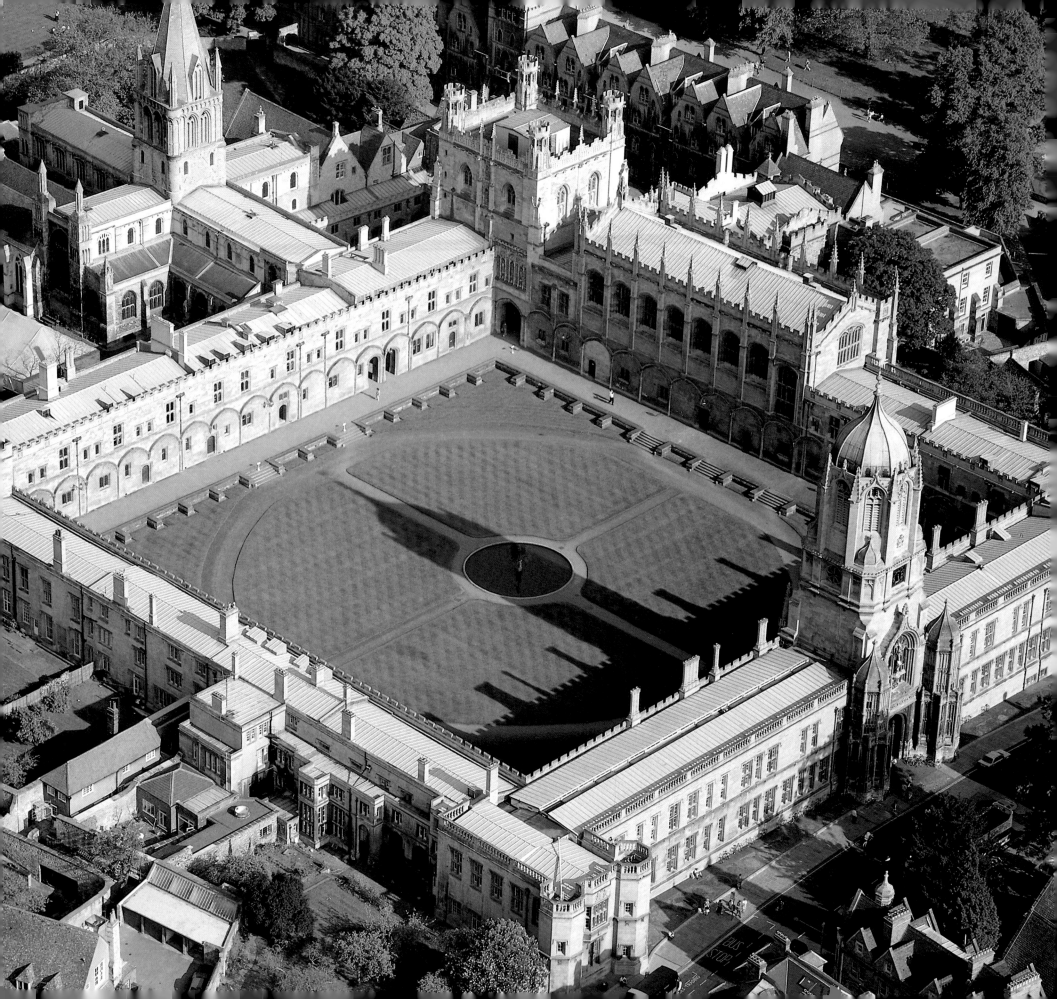

OXFORD AND THE MIDLANDS

OXFORDSHIRE, WARWICKSHIRE AND BUCKINGHAMSHIRE

Above This thick green carpet of grapes was spotted in Worcestershire. When the Romans invaded Britain the climate was warm enough for them to plant grapevines, and it seems that now, after a mini ice age in the Middle Ages, the climate is warming up again. English wine used to make wine buffs shudder with horror, but now it is gaining respect and recognition.

OXFORD

Facing page The college of Christ Church in Oxford was founded (as Cardinal College) by Cardinal Wolsey in 1525 on the site of St Frideswide's nunnery, the foundation around which the whole city grew. However, Wolsey soon fell from grace and the college was refounded, under its present name, by Henry VIII in 1546. Its quadrangle is the world-famous Tom Quad, with its equally famous statue of Mercury standing in the lake at the centre. Tom Quad gets its name from Tom Tower, built by Wren, which is the gateway into Christ Church on the right of the photograph. The cathedral (the smallest in England) is on the opposite side of Tom Quad.

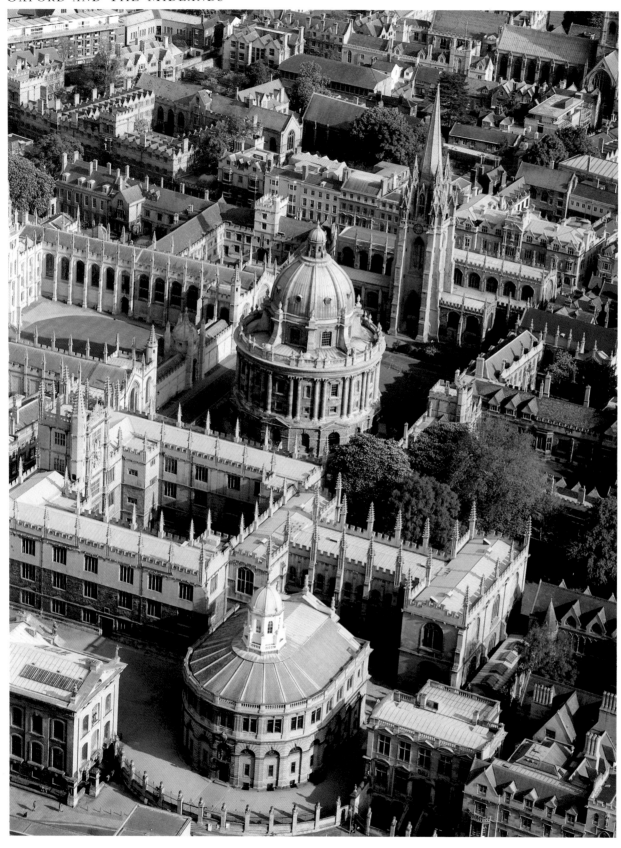

THE RADCLIFFE CAMERA

The unmistakeable dome of the Radcliffe Camera, set in Radcliffe Square, rises above the many beautiful buildings that surround it in the heart of Oxford. One Dr Radcliffe left £40,000 in his will for a building to house his library, and this lovely Italianate rotunda, designed by James Gibbs and built in 1737, was the result. It is now home to part of the Bodleian Library, the rest of which is to be found in the green-roofed buildings directly in front of the Radcliffe Camera. The Bodleian, which was formally opened in 1602, is one of the most important libraries in the world and contains a priceless collection of manuscripts and ancient books, as well as a copy of every new book published in Britain. The semi-circular building in front of the Bodleian and nearest the camera is the Sheldonian Theatre. It was the first full-scale building to be designed by Sir Christopher Wren, who based it on the Theatre of Marcellus in Rome. The theatre was built at the request of the Archbishop of Canterbury, Gilbert Sheldon, who disapproved of plays being performed in the church of St Mary the Virgin (seen in the photograph behind the Radcliffe Camera) and wanted Oxford to have a secular theatre instead. The cupola on the roof affords breathtaking views.

THE HIGH, OXFORD

First-time visitors to Oxford are faced with a difficult dilemma – what to see first? Perhaps the answer is to take a leisurely stroll up the High Street (known simply as 'the High' to Oxford's residents), guide book in hand, making detours whenever a promising-looking building is spotted. Here, the High curves away to the right and into the distance, lined with a fascinating collection of old buildings. Some are the exteriors of the colleges, while others contain shops, restaurants and cafés. The story goes that when the poet Shelley was a student here at University College in 1810 one of his favourite pastimes was hanging about in the High swapping babies from one pram to another, then making a dash for it when indignant nannies discovered they were gazing at bogus babies. In the photograph, the church of St Mary the Virgin is seen clearly to the right of the Radcliffe Camera. Directly opposite it on the other side of the road is Oriel College and a little further up the High is Shelley's old college, University College, which is one of the oldest in the city. Further up on the left is Queen's College, with New College to the left of it behind the high stone walls. Magdalen College, with its lovely tower, stands at the end of the High on Magdalen Bridge, above the River Cherwell.

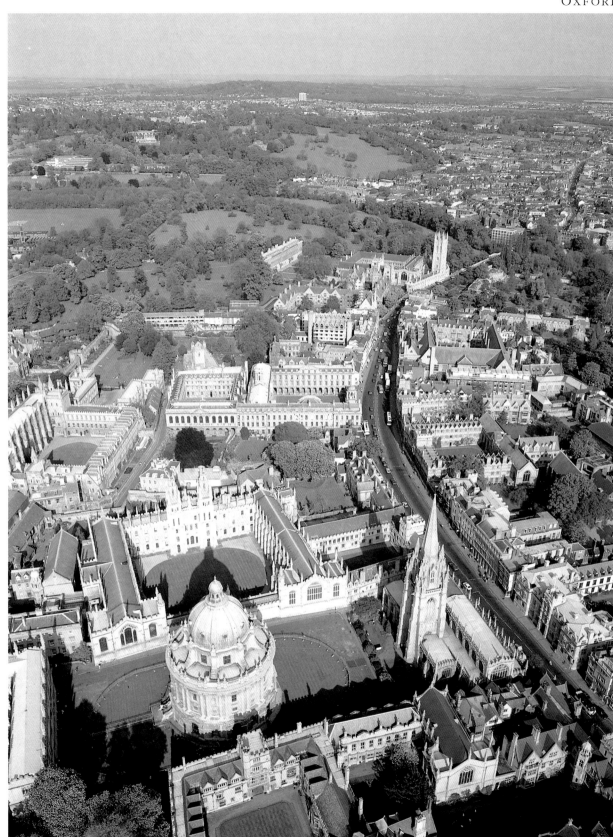

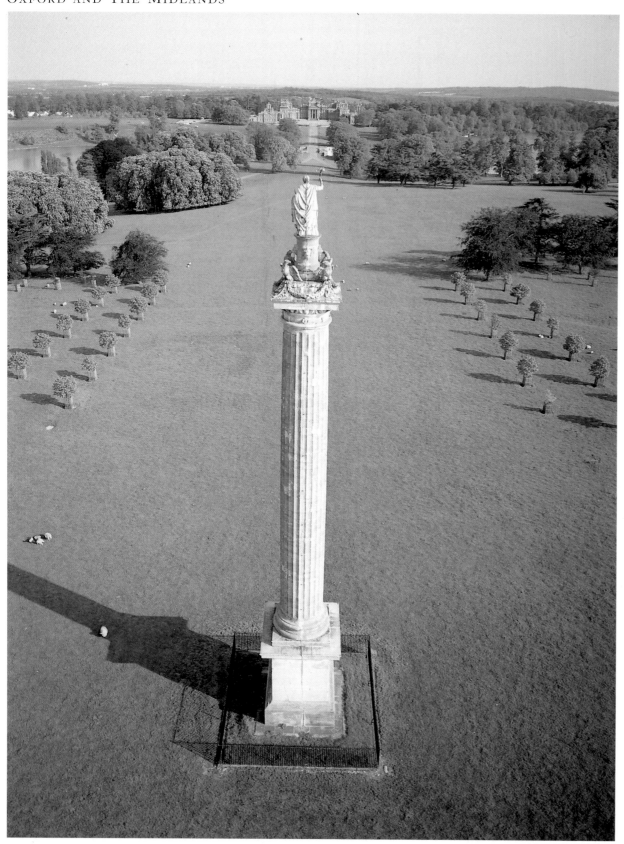

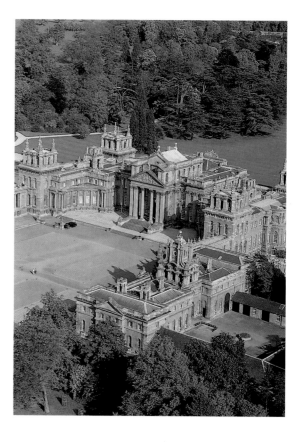

BLENHEIM PALACE

Left and above Blenheim Palace is set in 2200 acres (890 hectares) of beautiful parkland which over the centuries has received the attentions of such notable gardeners as Henry Wise and Capability Brown. Facing the palace and in a commanding position overlooking the grounds and the huge man-made lake to the left is the Column of Victory (*left*), topped with a statue of the 1st Duke of Marlborough, to commemorate his role in the successful Battle of Blenheim and his subsequent heroic standing.

CHARLECOTE PARK

Facing page A county away from Blenheim, in Warwickshire, is the classic Elizabethan beauty of Charlecote Park, built in the 1550s for Sir Thomas Lucy. The deer park was later landscaped by Capability Brown who obeyed the request not to destroy the avenue of stately elms; now sadly destroyed by Dutch elm disease. The deer themselves are supposed to have posed an irresistible temptation to a young William Shakespeare who was caught poaching them; today they still roam free across the grounds, mingling with the resident Jacob's sheep. The stone steps on the right lead down to the River Avon which flows sweetly through the grounds.

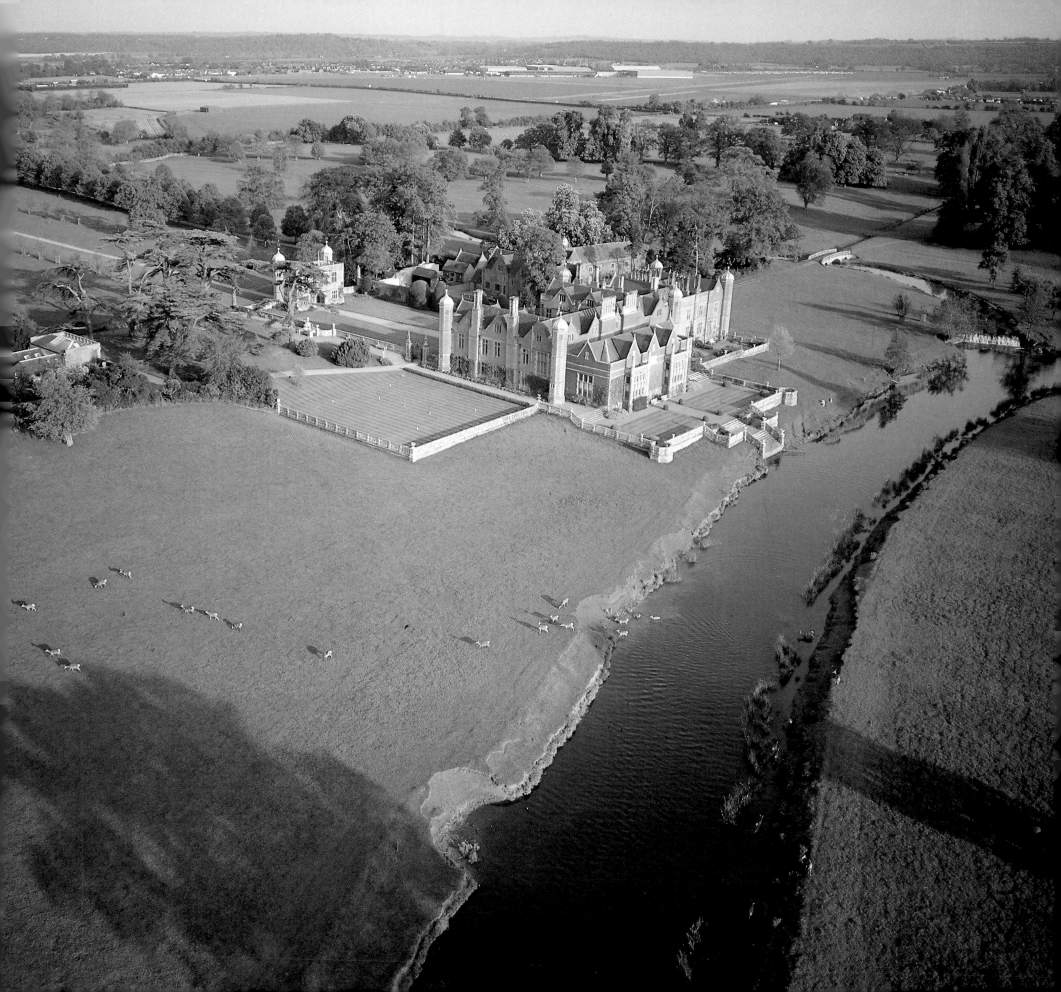

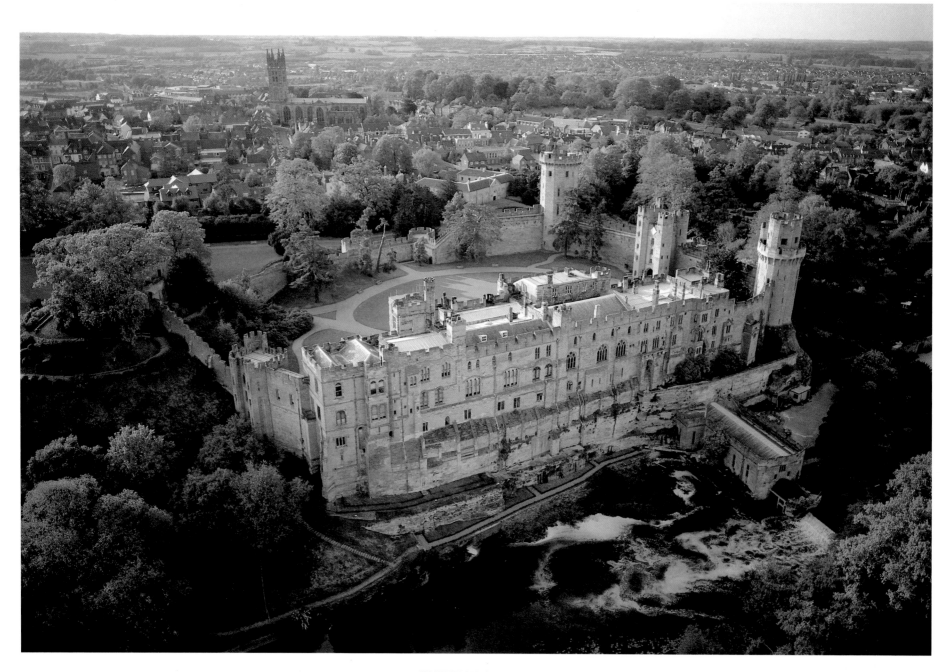

WARWICK CASTLE

Above Peacocks strut in the grounds of Warwick Castle, whose beautifully preserved battlements stand out against a background of leafy trees. It is the second castle to stand on this site, and was built in the fourteenth century by Thomas Beauchamp. The castle was converted into a house three centuries later. Caesar's Tower, on the right, is notable for its double parapet and is one of the most remarkable wall-towers in Britain. *Facing page* Warwick Castle stands in extensive, beautiful, grounds, and sits on a sandstone bluff beside the River Avon. This view admirably shows off the work of Capability Brown in the grounds, especially the Scots pines growing on the lawns, and the formality of the parterre in the foreground.

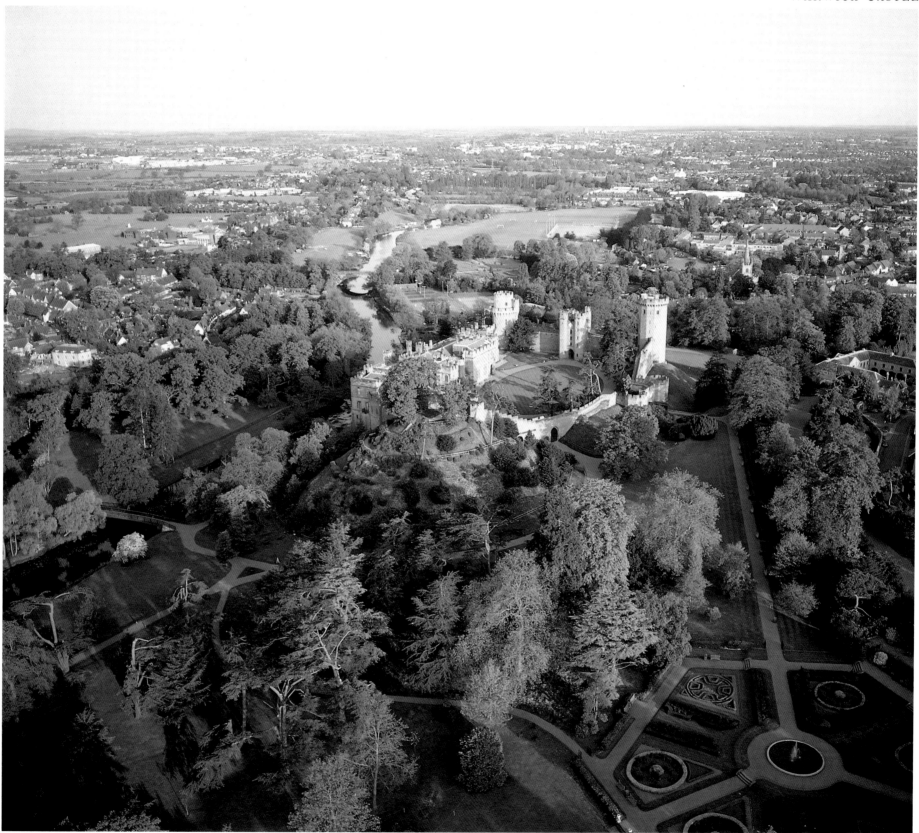

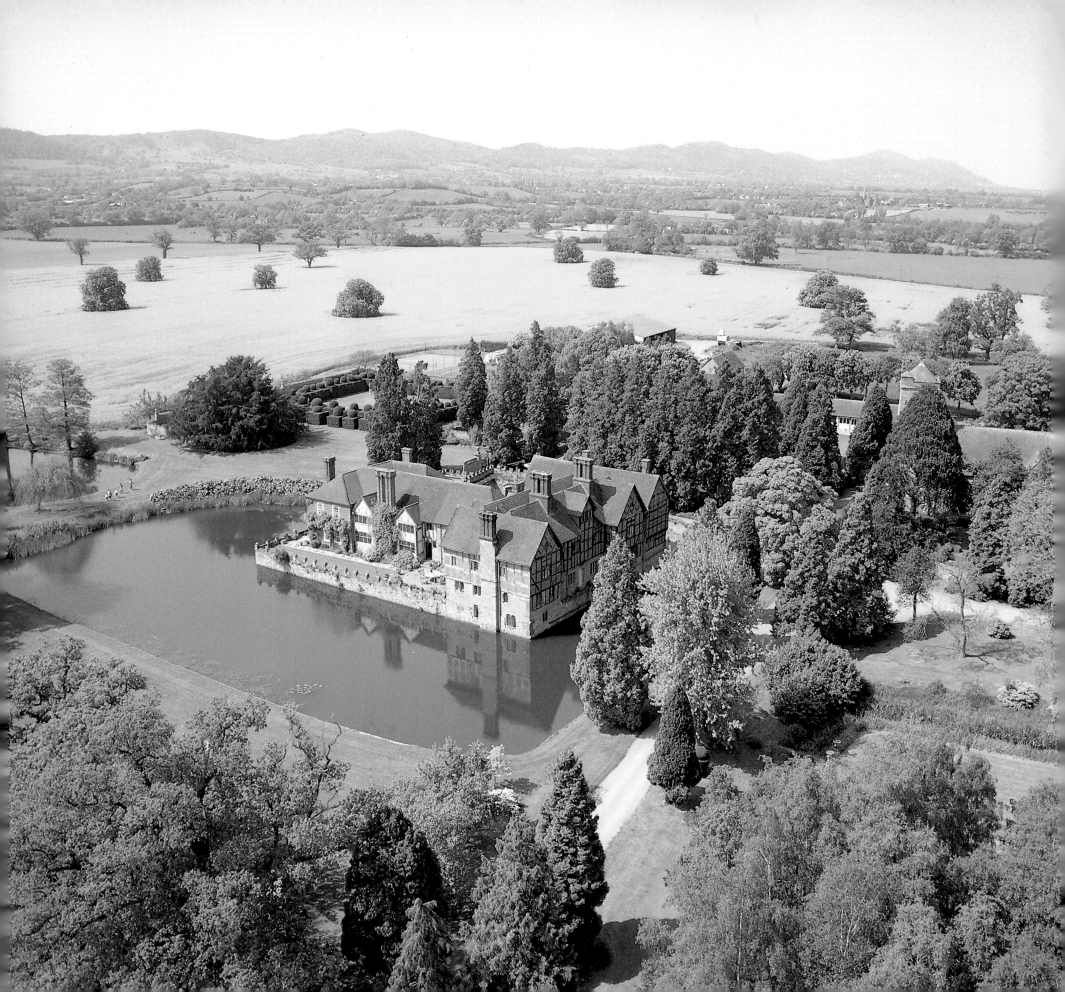

BIRTSMORTON COURT

Facing page With its backdrop of the Malvern Hills and the rolling landscape of Worcestershire, Birtsmorton Court is the perfect example of an English moated fortified manor house. A stone ball decorating the fourteenth-century archway is just visible on the side of the house furthest from the camera. The surrounding garden is as beautiful as the house, with a large pool to the west of the moat (on the left of the photograph), a topiary garden of box and ball yew trees and long herbaceous borders (hidden from the camera) planted in the space between the topiary and surrounding brick wall. The roof and tower of a chapel can be seen through the trees on the right side of the photograph.

STRATFORD-UPON-AVON

Right Tourists are attracted like homing pigeons to Stratford-upon-Avon each summer, whether they want to explore the medieval market town where William Shakespeare was born, enjoy the chocolate-box prettiness of the cottages and houses associated with his life, watch some of the Bard's plays at the tiered red-brick Royal Shakespeare Theatre on the banks of the Avon, or photograph the arches of nearby Clopton Bridge reflected in the stillness of the river. The Avon is considered virtually inseparable from Shakespeare's memory, and although it flows from Naseby in Northamptonshire down to Tewkesbury in Gloucestershire, Stratford must surely mark its most famous stretch of water. The river forms another link with Shakespeare by flowing past the lovely church in the foreground of the photograph – Holy Trinity Church, where Shakespeare was baptised in 1564 and buried in 1616.

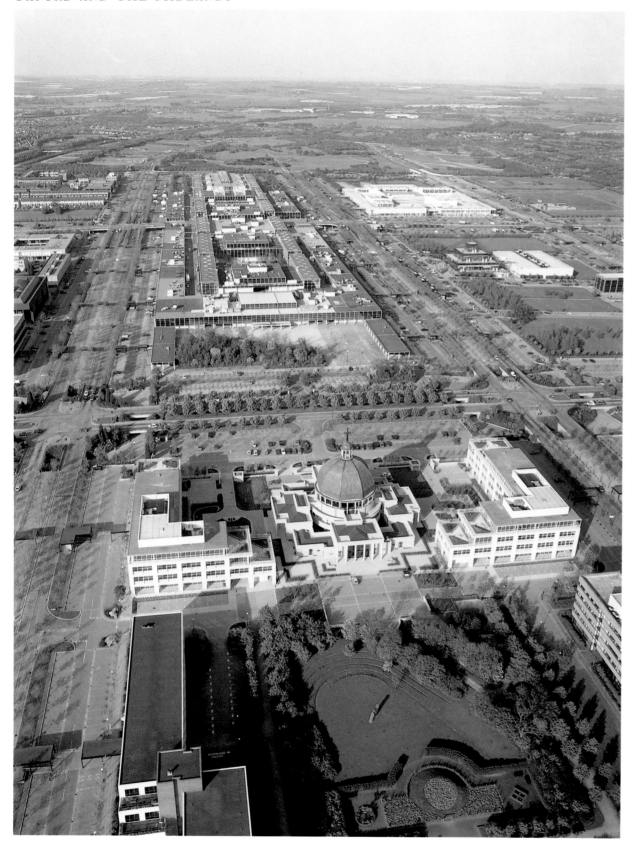

MILTON KEYNES

Begun in 1967, Milton Keynes is one of the country's newest industrial towns, built on a grid pattern that is shown off to good effect here. Debates about its relative merits and demerits rage hot and strong, with some hailing its business opportunities and others being less than complimentary. The fake sheep adorning the fields, to create the impression of rural bliss, don't help the town's credibility. The Grand Union Canal runs along the background.

MILTON KEYNES

The planners of Milton Keynes had obviously taken a leaf or two out of the books of the seventeenth- and eighteenth-century landscapers of formal gardens. This is a park in its infancy, whose trees will take a few years to achieve their full splendour. With its serpentine paths, strange quasi dew ponds and apparent earth works, it is certainly full of interest. This shows the same view as that on the facing page, but from the opposite direction, with the Grand Union Canal behind the camera lens here.

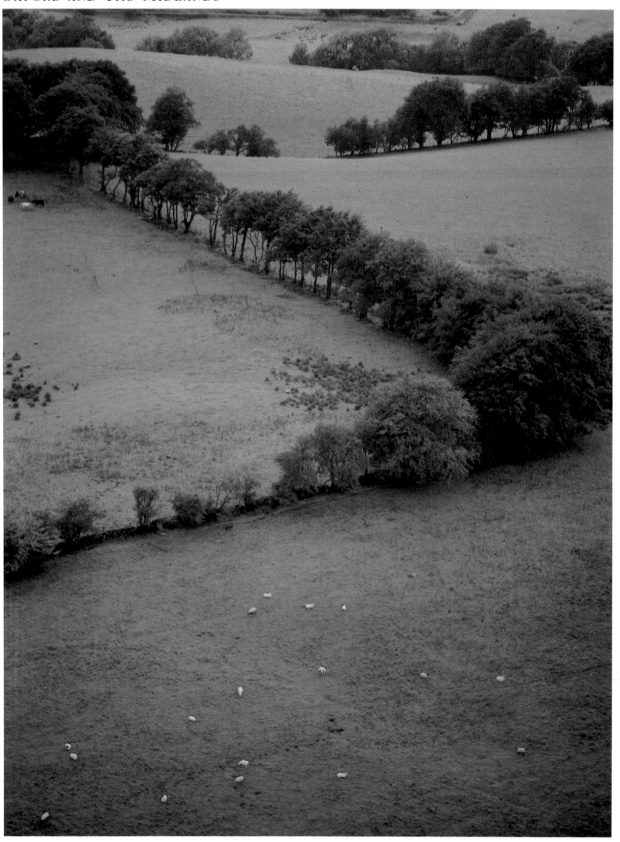

THE COTSWOLDS

Left This photograph is a visual explanation of how the Cotswolds got their name – 'cots' comes from an ancient Saxon word for sheepfolds, while the 'wolds' part of the name means high, open uncultivated land. Sheep have been reared here for centuries, with some Cotswold towns specializing in sheep markets and others becoming wealthy through trading in wool. Today, Cotswold towns rely on tourism rather than the wool trade, and many of the most famous (and beautiful) ones are jam-packed every summer with sightseers, cars and coaches. The soft greens of the magnificent limestone hills, on the other hand, are usually empty save a few sheep, cattle and the odd farm-house.

THE COTSWOLDS

Facing page Several of England's most well-known rivers wind their way through the Cotswolds, including the Severn, Avon, Churn and the young Thames, which rises in the heart of the Cotswolds near Cirencester. Just as the water here is tranquil and still, this is not a stretch of countryside to rush through – there is too much to see, too many marvellous views to appreciate and too many places that beg to be explored.

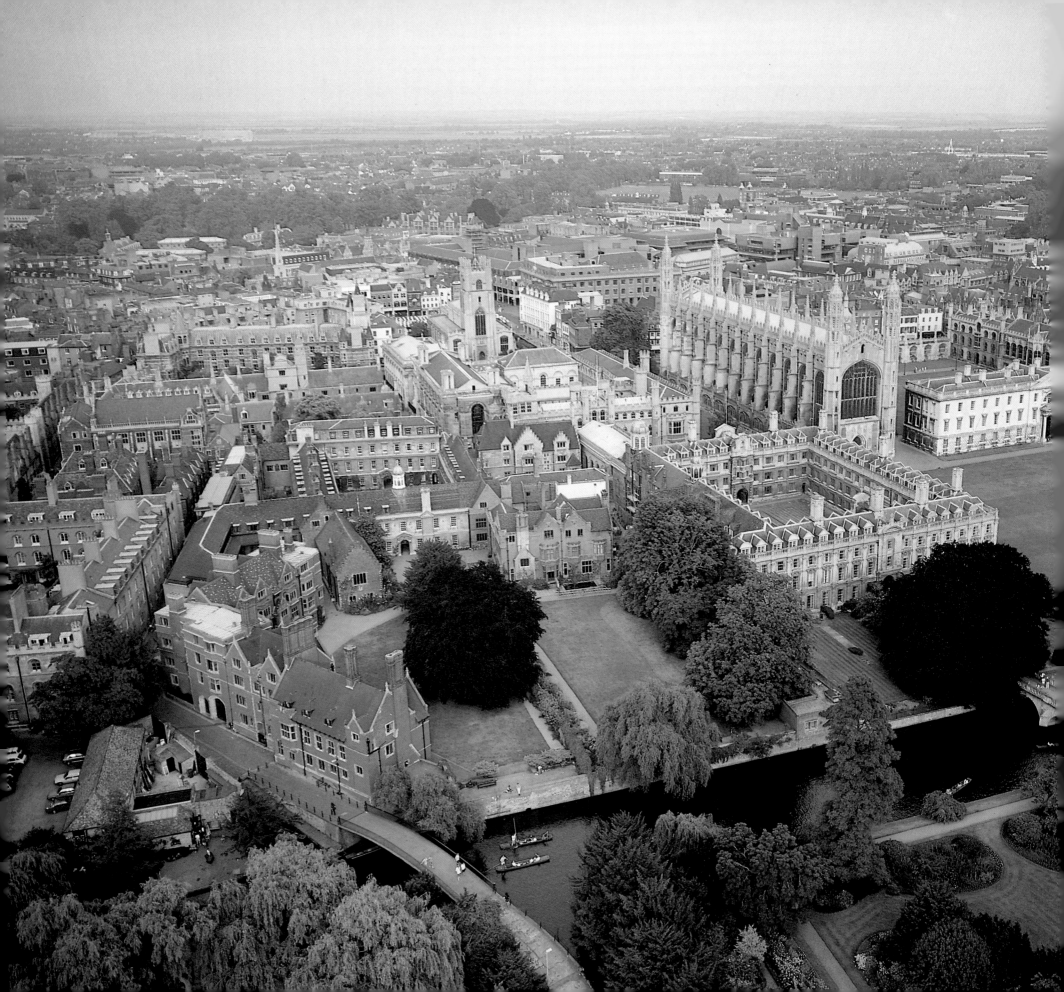

CAMBRIDGE AND EAST ANGLIA

CAMBRIDGESHIRE, ESSEX, NORFOLK AND SUFFOLK

Above Where it has been successfully drained, the damp, rich soil of East Anglia is ideally suited to agricultural use. These fields are farmed in neat strips which look particularly pleasing from the air.

CAMBRIDGE

Facing page Cambridge is a city ideally explored on foot. The different university buildings are jumbled together, each one providing an architectural feast for the eyes and an equally rich historical one for the mind. The Perpendicular towers of one of the city's most famous buildings, King's College Chapel (centre right), rise high above all else. Great St Mary's Church stands just behind it on the left, in front of the blue and white striped awnings of the stalls on Market Hill. In the foreground on the right the seventeenth-century Clare Bridge crosses the Cam, leading to the lawns known as The Backs where the townspeople once tethered their animals.

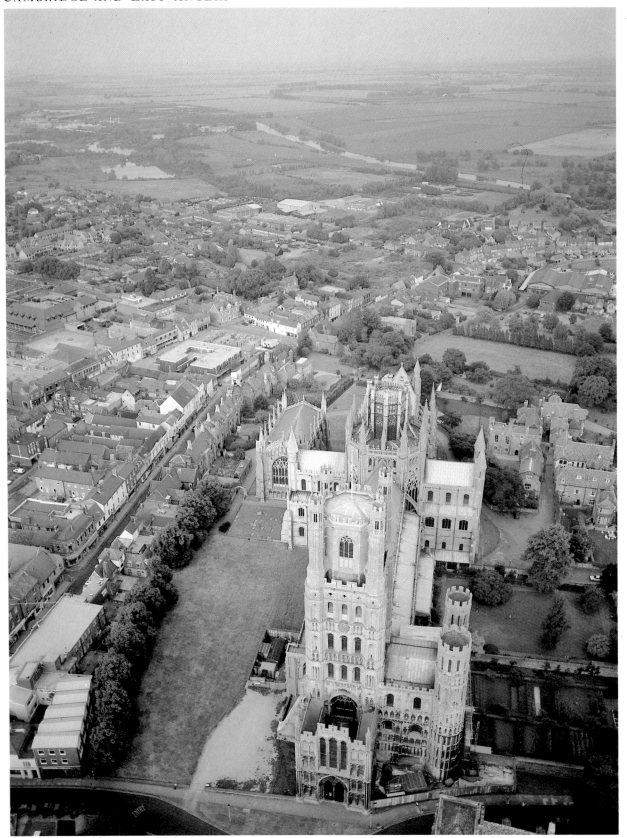

ELY CATHEDRAL

Left In the flat landscape of the Cambridge fens the Early English architecture of Ely Cathedral stands out from its surroundings like a pale golden beacon. Building began in the 1080s on the site of an earlier Benedictine abbey and was completed in 1200, but in 1322 the tower collapsed. Disaster was transformed into triumph when it was replaced by the octagonal lantern that is now considered to be one of the greatest masterpieces of medieval architecture in the world. The interior of the cathedral is equally spectacular, especially on a chilly winter's afternoon when it seems a haven of warmth and glowing light and the choir are practising for the evening service.

BURGHLEY HOUSE

Facing page When William III visited Burghley in the seventeenth century he is reputed to have said the house was 'too large for a mere subject'. The 'mere subject' he was referring to was John Cecil, 5th Earl of Exeter, who was the then owner of the house that had been built in the 1580s by William Cecil, Elizabeth I's chief minister and great friend. The King was hardly to be blamed for casting a beady and jealous eye on Burghley, for John Cecil spent a fortune on the Baroque decorations that still grace the interior of the house, making it one of the most beautiful stately homes in Britain. Antonio Verrio, the Italian painter, spent ten years working there on the George Rooms but made himself so unpopular (he would only eat food that was specially imported from Italy at vast expense) that the Earl was delighted to see the back of him. Capability Brown landscaped the gardens in the eighteenth century and created the artificial lake.

NORFOLK FIELDS

Following pages Some of Britain's loveliest gardens are to be found in Norfolk, as well as many commercial nurseries producing everything from alpines to the immense fields of poppies and lavender seen in these photographs. Although neither of these plants is native to Britain they have both earned a special significance in the national culture over the centuries. Poppies are irrevocably linked with the Flanders fields of the First World War, and lavender-scented cosmetics have long been sold as 'Old English lavender', even though there is no such thing in botanical terms.

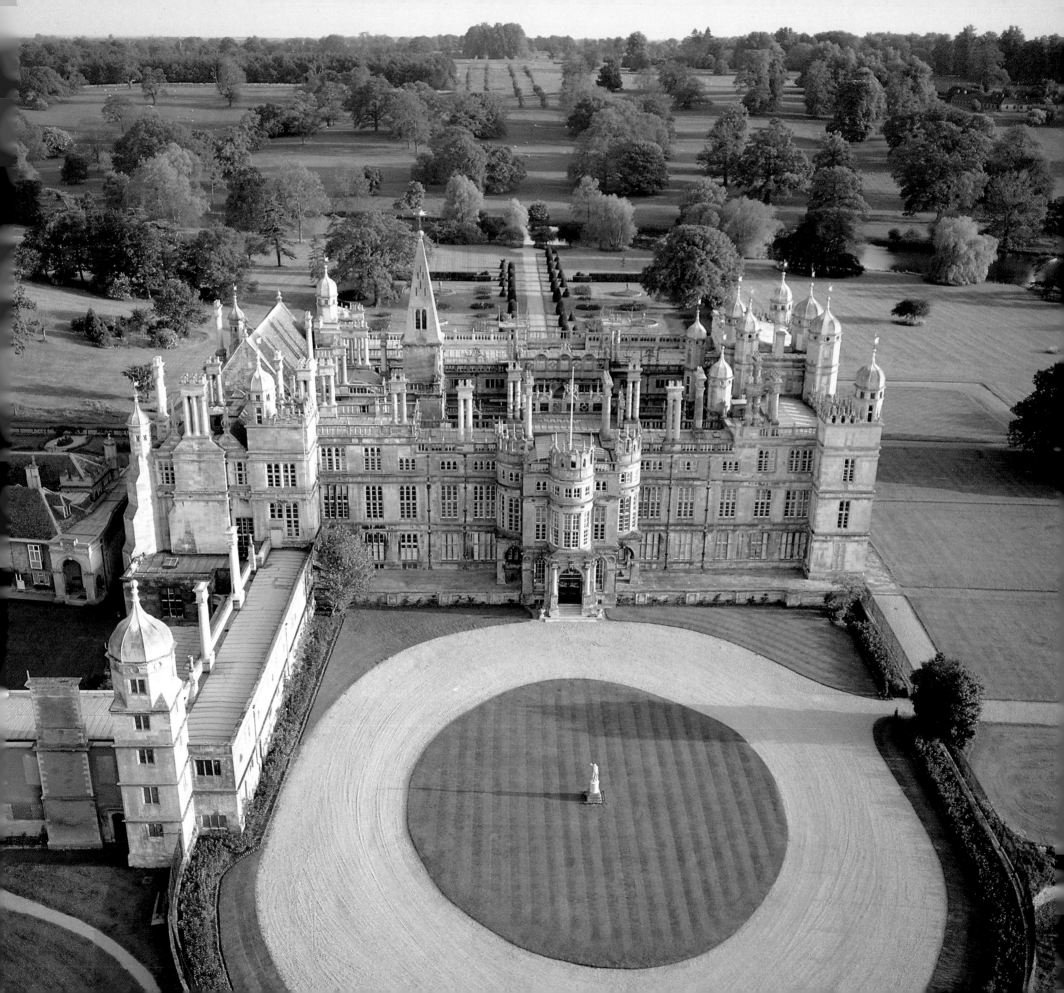

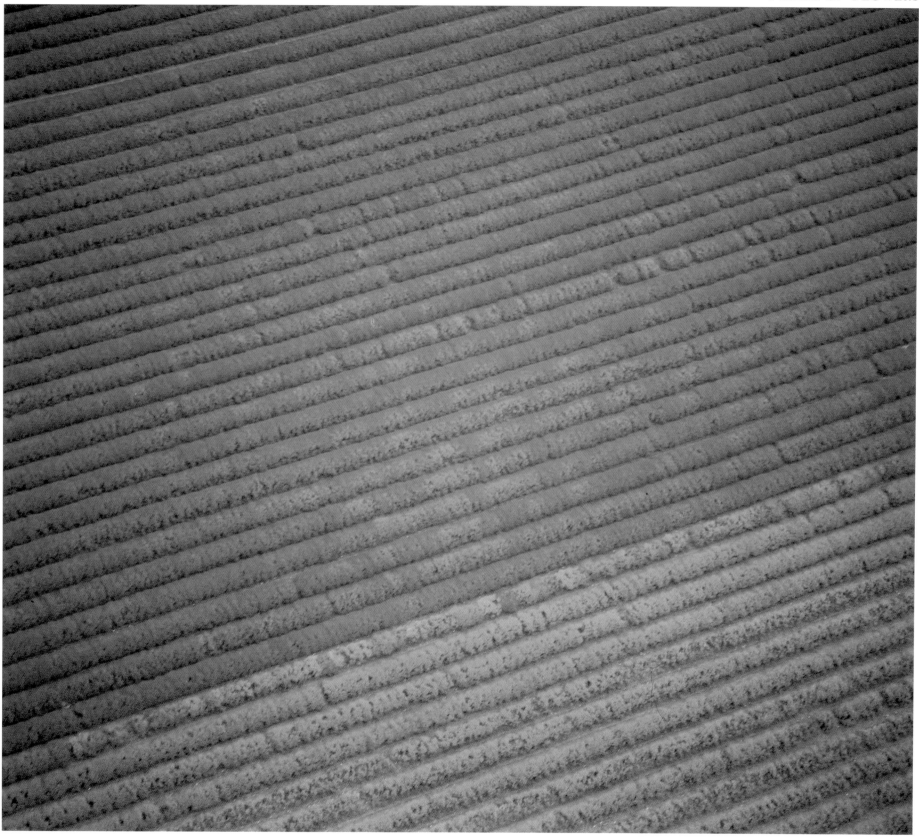

EAST ANGLIAN LANDSCAPE

A map of East Anglia reveals a landscape intersected in many places with a network of drainage ditches, dykes and rivers, and in this photograph the pancake-flat land resembles a green patchwork quilt. What the picture doesn't reveal is the dark side of East Anglia's history. During the late sixteenth and seventeenth centuries this part of England was bedevilled by superstition and a fear of witchcraft that led to hundreds of supposed witches being hanged. As well as the numerous stories of rigged trials at which innocent people were sentenced to death on a variety of trumped-up charges (especially when Matthew Hopkins, the Witchfinder General, presided), there are many tales of hauntings and strange happenings. There is the terrifying Brown Lady (complete with empty eye sockets) whose haunting seems to move from house to house, Borley Rectory in Essex (now destroyed by fire) which was once claimed to be the most haunted house in England, and the weird Jack o' Lanterns (also known as Will-o'-the-Wisps) whose flames used to lure lonely travellers to their deaths as they crossed the fens.

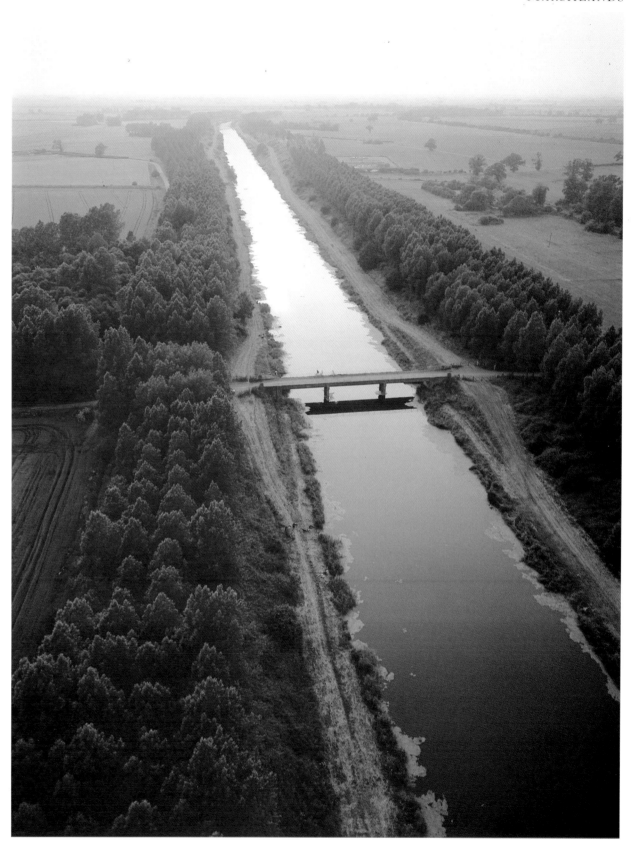

MARSHLAND FEN

For as long as people have lived in East Anglia they have tried to drain the waterlogged land. The Romans were the first to build causeways and construct drainage channels above the marshy ground of the fens, but after they left Britain their work fell into disrepair and it wasn't until the thirteenth century and onwards that any real attempts were made again. The landscape has changed drastically since the seventeenth century around Ely Cathedral, for instance, which was once part of the Isle of Ely and surrounded by swamps filled with the eels that gave the city its name. It was on this island that the Anglo-Saxon patriot Hereward the Wake held out against the invading Normans until 1071.

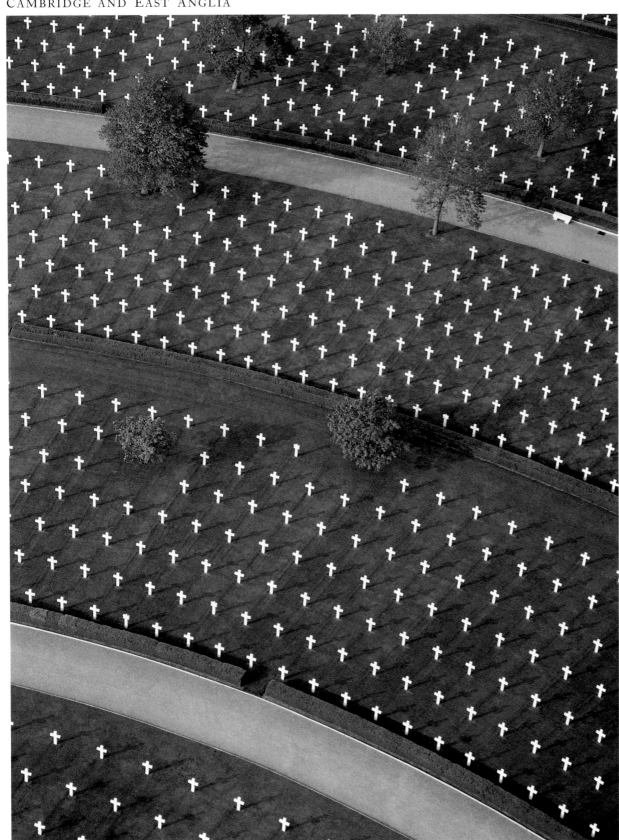

WAR CEMETERIES

Left Line upon line of graves, only interrupted by the occasional tree, lie peacefully in this war cemetery. It has the simple dignity common to all cemeteries, both in Britain and abroad, that commemorate those killed in action. The sheer number of the crosses found in any of these cemeteries carries a stronger anti-war message than words could ever do. As George V said when he visited the battlefield cemeteries in Flanders in 1922: 'I have many times asked myself whether there can be more potent advocates of peace upon earth through the years to come than this massed multitude of silent witnesses to the desolation of war.'

GREENHOUSES

Facing page At first glance it is almost impossible to fathom out what this is, but in fact the photograph shows thousands of panes of glass ranged in meticulous rows at a large nursery near Cambridge.

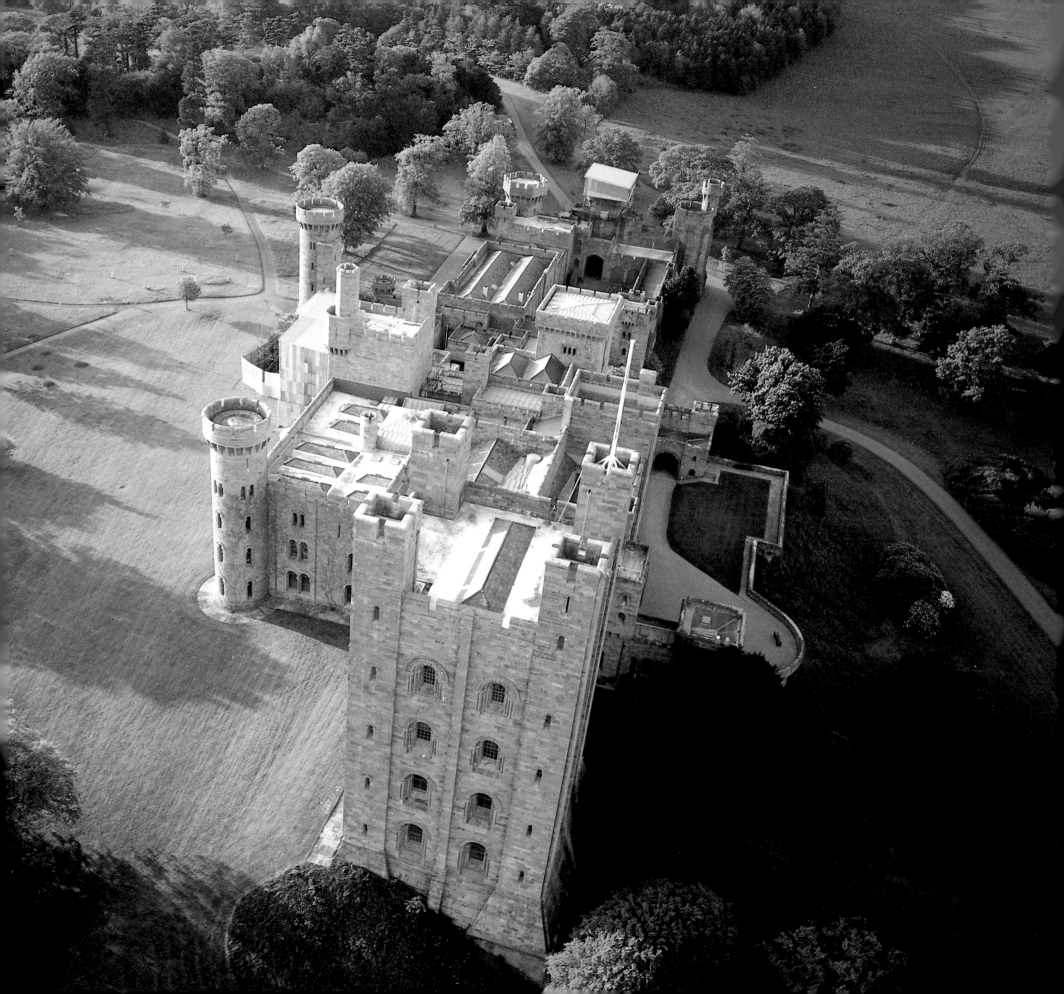

WALES

Gwynedd, Clwyd, West Glamorgan, South Glamorgan and Powys

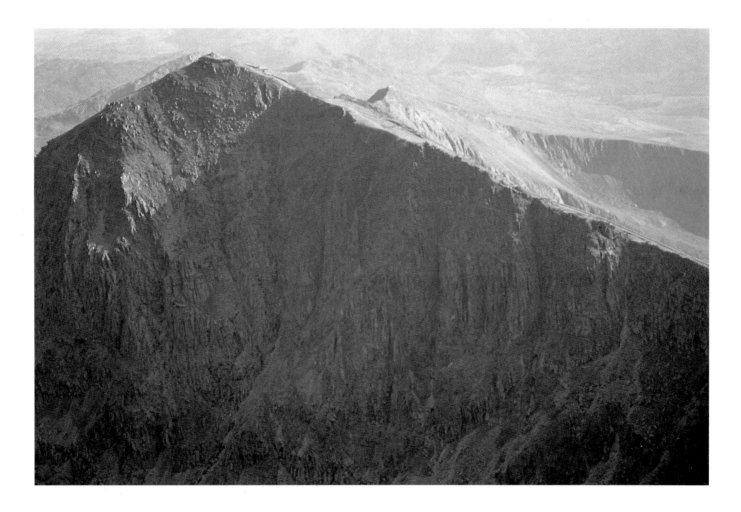

SNOWDON

Above The high peaks of Snowdonia are uncompromisingly barren, yet exert a magnetic power over the many people who revel in the breathtaking views that can be enjoyed from them on a clear day.

PENRHYN CASTLE

Facing page It looks like a beautifully preserved Norman castle – which is exactly what its architect, Thomas Hopper, intended when he drew up the plans for Penrhyn Castle in the early nineteenth century. He was commissioned by G H Dawkins Pennant, who wanted to build a Norman castle that suitably reflected his enormous wealth and local standing. Penrhyn's position near the ancient Isle of Anglesey (whose rocks were formed over 3000 million years ago) adds further weight to the happy fiction that the castle is Norman. The grounds spread for over 40 acres (16 hectares) up to the Lavan Sands in Conwy Bay.

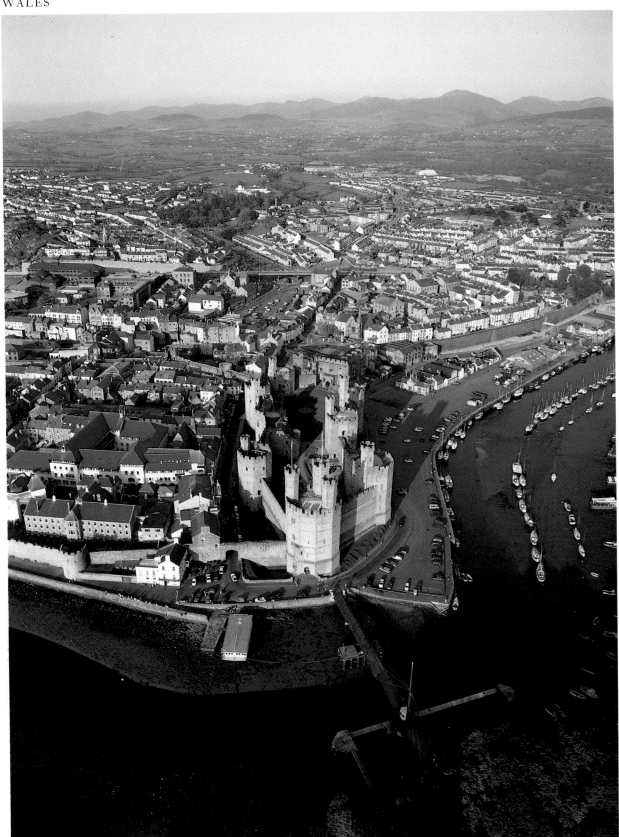

CAERNARFON CASTLE

Caernarfon Castle has stood guard over the southern end of the Menai Strait for over six centuries and remains one of Britain's greatest medieval military buildings. The castle, with a ground plan shaped rather like an hourglass, was designed to be the lynchpin of the string of defensive castles built by Edward I around North Wales, but it had to serve as a royal palace as well as a fortress. Indeed, Prince Edward, the eldest son of Edward II and his first wife Eleanor, was born here in 1284. He later became the first English Prince of Wales and, later still, the unpopular Edward II who was murdered in another castle, Berkeley in Gloucestershire. In 1911 the first royal investiture was held in the castle, when another ill-fated Prince Edward (later Edward VIII) became Prince of Wales; and the present Prince had his investiture here in 1969. The craggy peaks of Snowdonia rise up on the horizon.

RHUDDLAN CASTLE

Rhuddlan Castle is the second of the 15 castles built by Edward I with the intention of showing the Welsh who was in command after their ignominious defeat at his hands in 1282, and although it is in ruins today Rhuddlan still has an air of majesty. It is notable for its twin gatehouses although, having been partly destroyed during the Civil War, they are no longer as imposing as they once were. The castle stands at the head of the River Clywd, just before it runs into the sea at Rhyl on the North Wales coast, in a commanding position that was an excellent vantage point when the castle was a working fortress. Today, it is a focus for inquisitive holiday-makers rather than the warring Welsh, and is set in a particularly popular stretch of coastline.

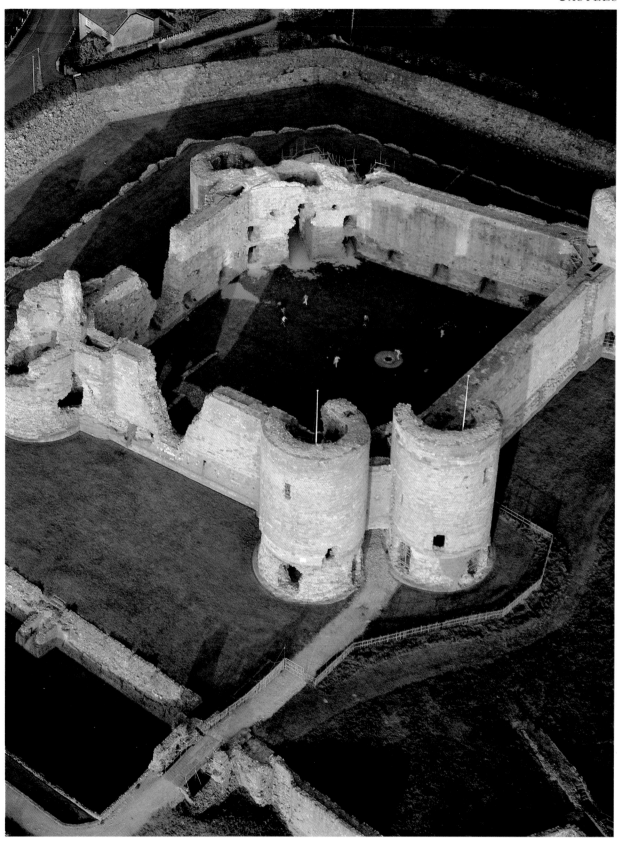

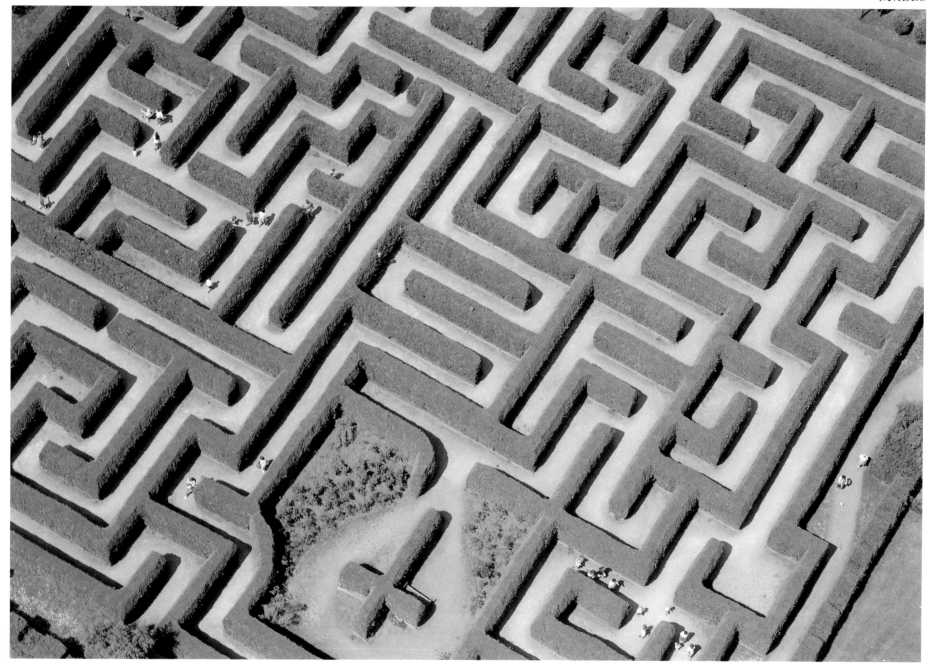

RHYL CARAVAN PARK

Facing page The neat rows of caravans at Rhyl's caravan park testify to this town's holiday attractions, which include funfairs and traditional seaside entertainments.

MARGAM ABBEY

Above The maze at the ruined Margam Abbey, with its 1-acre (0.4 hectare) grounds, is said to be the largest in the world. The abbey itself was turned into a country house after the Dissolution of the Monasteries in 1536.

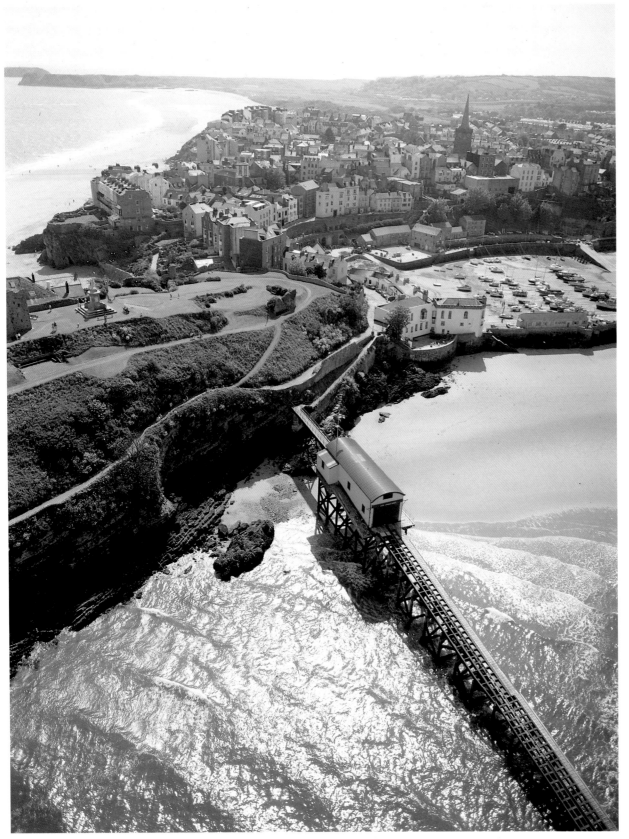

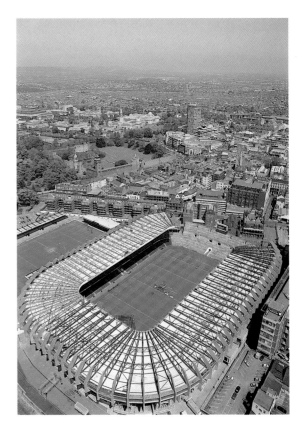

TENBY

Left Daniel Defoe described Tenby as 'the most agreeable town on all the south coast of Wales, except Pembroke', but it seems to have stood up well to the stigma of being considered second-best by him. In fact, the town became extremely popular during the early nineteenth century when the Napoleonic Wars meant foreign travel was impossible and the well-to-do had to take their holidays at home. A town first sprang up in Tenby during the fourteenth century, near the twelfth-century castle (just glimpsed on the far left of the photograph) that juts out into Camarthen Bay. The castle is now in ruins, having been bombarded during the Civil War, but the fourteenth-century town walls are the most complete in South Wales. The town's four sandy beaches attract many holiday-makers – the largest is South Beach, shown in the top left of the photograph.

CARDIFF ARMS PARK

Facing page, right Although rugby is played at national level by England, Ireland, Scotland and Wales, it could be considered to be much more the preserve of the three Celtic countries than of England. In Wales, the traditional home of rugby is found at Cardiff Arms Park, which is a place that arouses strong emotions in the hearts of all Welsh rugby fans. It is one of those sporting names that has earned a place in the national psyche, needing no further explanation whenever it is mentioned.

COLWYN BAY

Right The calm waters of Colwyn Bay glitter in the early evening sunshine, along the stretch of North Wales coast that is packed with popular holiday resorts, such as Llandudno, Rhyl and Prestatyn. The sandy beaches and the safe bathing bring holiday-makers flocking here, and on rainy days there are plenty of tourist attractions to be enjoyed inland, such as the Welsh Mountain Zoo on a hillside above Colwyn Bay or the magnificent Conwy Castle that lies to the west of the town. Water sports enthusiasts enjoy Colwyn Bay too, and in the summer the waters here are host to water-skiers, wind-surfers and yachtsmen. Behind the pier in the photograph is Rhos-on-Sea, which is the nearest town to the west, with its chapel, dedicated to the Welsh St Trillo, standing out against the darkening sky. The chapel itself, which dates from the sixteenth century and is minute, was once linked with a nearby monastery.

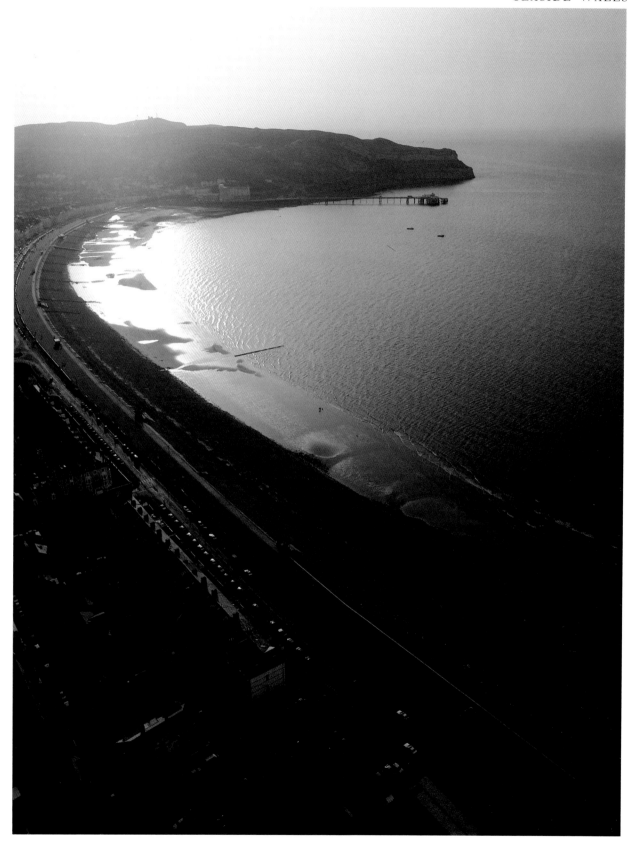

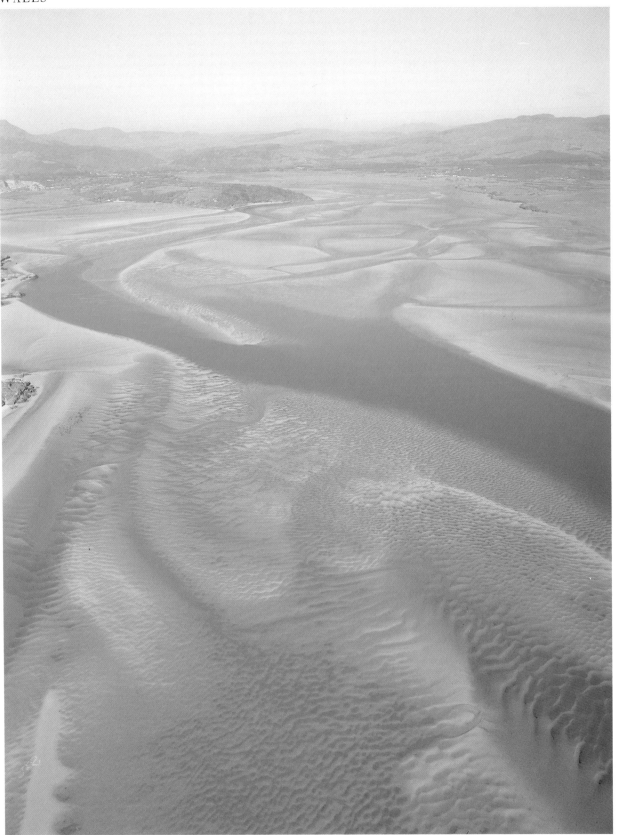

TREMADOG BAY

Left Deep Tremadog Bay, on the Lleyn Peninsula, is filled with sand banks but it is also the home of something much more ephemeral – a dream. In the 1920s the architect, Clough Williams-Ellis, became so enraptured by the Italian fishing village of Portofino that he decided to create a British version. It was serendipity that led him to find the perfect spot, having searched in vain for it, when he was asked to find a buyer for a derelict piece of land. The moment he saw the land he knew his search was over, and he set about creating his dream town, which he called Portmeirion. The warm waters of the Gulf Stream help to capture the requisite Mediterranean atmosphere, and the town is filled with Italianate buildings and architectural oddments that were rescued from British scrapheaps. During the 1960s the town became famous when the television series *The Prisoner* was filmed here.

CONWY

Facing page The inviting Conwy Sands stretch out in a generous semi-circle from the North Wales resort of Conwy, and are an irresistible attraction to holiday-makers, wind-surfers and sailors each summer. At low tide the sands almost join up with those of West Shore at Llandudno on the other side of Conwy Bay. On the opposite side of the estuary from Conwy, beside two bridges, sits the imposing medieval bulk of Conwy Castle. Even though it is now in ruins, it still dominates the town and the surrounding countryside, much as it must have done centuries ago when the English were trying to reinforce their newly won power over the Welsh. Anyone sailing over the waters of Conwy Bay might like to try spotting the lost land of Tyno Helig, which was submerged during the Dark Ages. Before the sea drowned it, the area was ruled over by Prince Helig ap Glannawg, whose daughter plotted with her penniless lover to kill a rich nobleman and marry on the proceeds. At their wedding a ghostly voice announced that the murder would be avenged on the fourth generation of the couple's descendants. Sure enough, four generations later, when the family were assembled together, the sea burst over the land and drowned them.

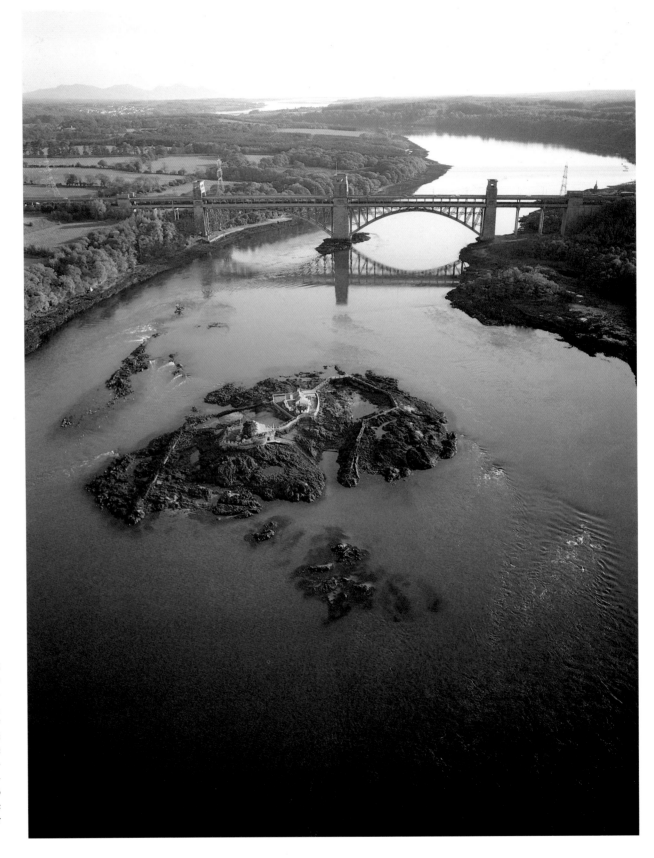

THE MENAI STRAIT

Only two bridges connect the Isle of Anglesey with the rest of Wales – the Menai Suspension Bridge, designed by Thomas Telford to carry his Holyhead Road and completed in 1826, and the smaller Britannia Railway Bridge, shown here in its post-1970 form. It was designed by Robert Stephenson and, when it was finished in 1850, the tubular design was such a success that Stephenson became famous in his own right and stepped out of the considerable engineering shadow of his father, George Stephenson. Sadly, the bridge's tubes that caused such a stir had to be removed in 1970 after a disastrous fire, and much of the bridge was rebuilt. It now carries the railway on its lower span and the road on its upper one.

BALA LAKE

Above The Dee begins its journey through Wales and into England at Bala Lake, or Llyn Tegid to give it its Welsh name. It is the largest natural lake in Wales and is set amid spectacular scenery in the Cambrian Mountains. The boats in the bottom left-hand corner of the photograph point to the enjoyable sailing on the lake. Below the water's surface lurks not only the gwyniad, which is similar to trout and has the distinction of living only in Llyn Tegid, but also the ancient town of Bala that, according to local legend, lies beneath these calm waters and was swallowed up because of the wickedness of its people.

VALE OF LLANGOLLEN

Left Acrefair in Clwyd is aptly named, for it is set in the beautiful Vale of Llangollen, where the salmon-filled River Dee twists its way through lush green land. Roughly 3 miles (4½ kilometres) west lies the town of Llangollen itself, where the world-famous International Musical Eisteddfod is held each June, but here at Acrefair the predominant sound is of water and the wind rustling through the trees. Between 1795 and 1805 that great engineer, Thomas Telford, built the Pont-Cyssllte Aqueduct, which dominates the photograph, to carry the Shropshire Union Canal. A short distance downstream and just visible through the thick ruff of trees lining the Dee is Bont Bridge, which was built by the Romans.

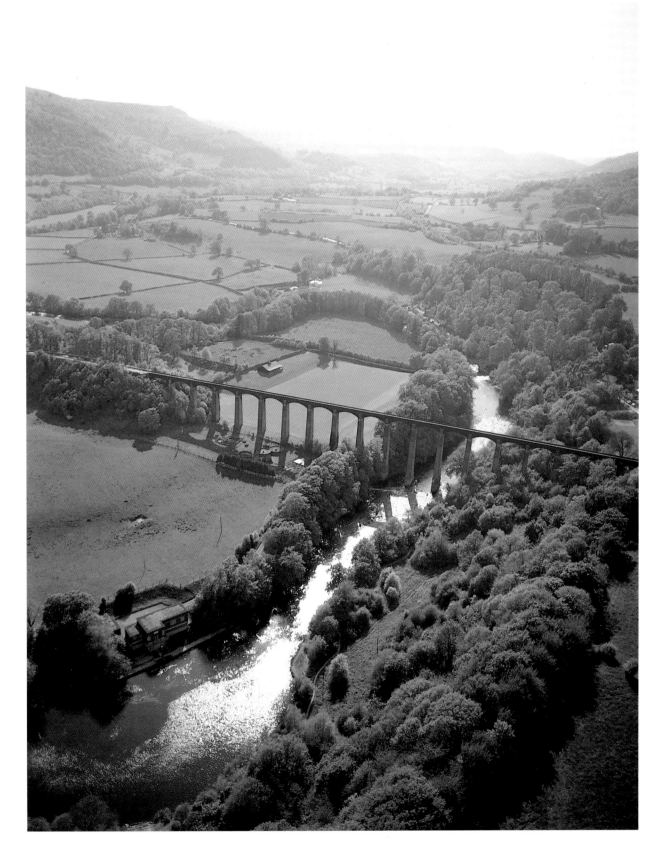

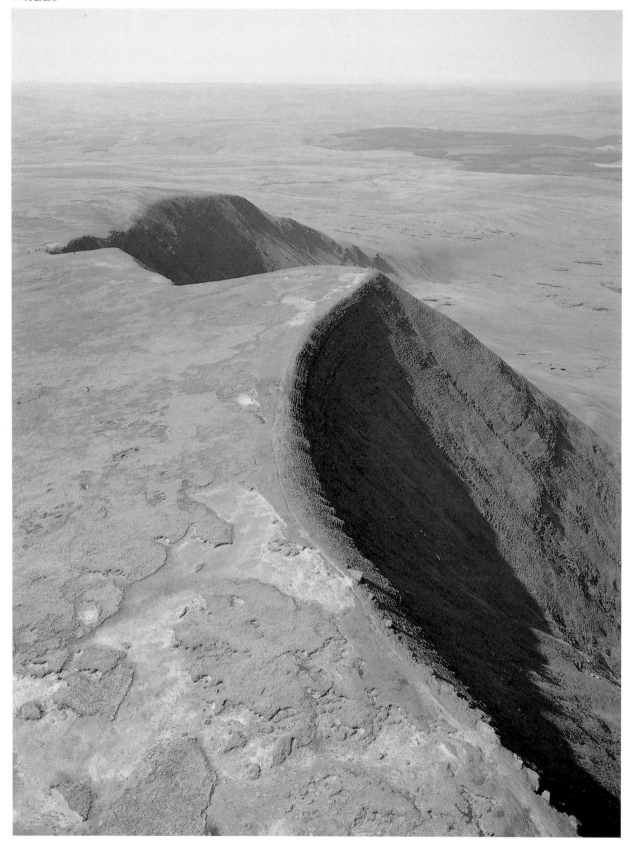

THE BLACK MOUNTAINS

Facing page, left and right Set in the Brecon Beacons National Park, which crosses the border between Wales and England, the Black Mountains are ages old. Some of the rocks in the Beacons were formed over 340 million years ago, and their weird, strangely smooth, shapes were scoured out of the Old Red Sandstone rocks by glaciers during the Ice Age. The layer of peat that covers the mountains is home to grasses, heather and, further down in the valleys, vast forests of conifers and woodlands of broad-leaved trees. It is a landscape full of surprises and mysteries, which is perhaps why many myths are associated with the Brecon Beacons. One such story says there is a secret door in the ground near Llyn Cwm Llwch lake, which used to open every 1 May to allow humans into fairyland. The door was closed to mortals forever after one human visitor stole a flower from the fairies although, as folklore abounds with terrible stories about what happens when humans become involved with fairies, perhaps that was just as well.

SNOWDONIA

Right Wales is also famous for another set of mountains – the range known collectively as Snowdonia National Park, in Gwynedd. This is an inhospitable, wild place that is steeped in history, from the relics of the Bronze and Iron Ages that have been found on the mountains, to the heroes who defended Wales against the invading English – the two Welsh-born Princes of Wales, Llywelyn ap Iorwerth (Llewelyn the Great) and his grandson Llywelyn ap Gruffydd (Llewelyn the Last), who was defeated by the armies of Edward I and killed in 1282, and Owain Glyndwr, who led an uprising against Henry IV between 1400 and 1410. Mount Snowdon itself, seen here, is the tallest mountain in Wales and England (it is 3560 feet (1085 metres) high). Although it was used in training by Sir Edmund Hillary and his men before they tackled, and conquered, Everest, there are several tracks, of varying difficulty, that are suitable for walkers. Anyone wishing to have a less energetic excursion can ride up to the summit and back on the little 5-mile (8-kilometre) railway that runs from Llanberis.

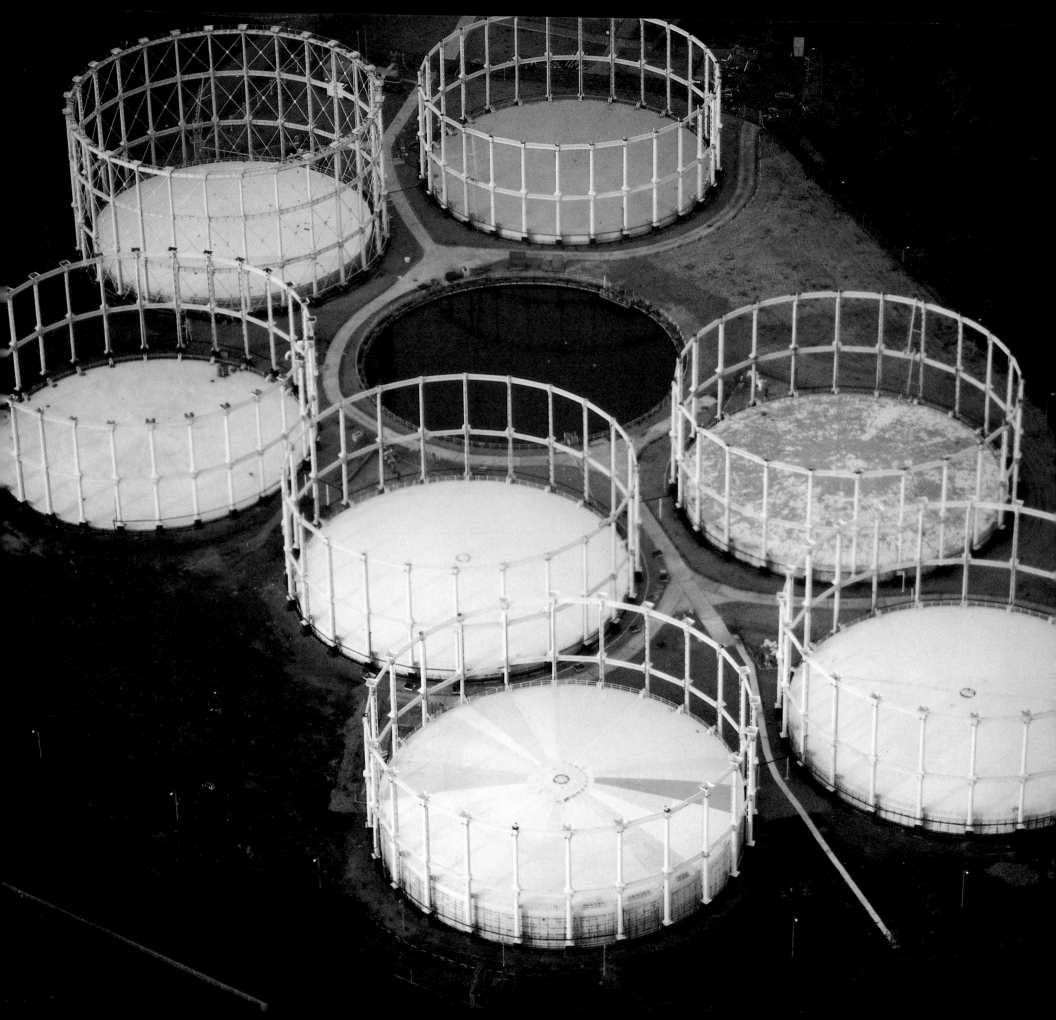

THE NORTH MIDLANDS

CHESHIRE AND DERBYSHIRE

The North Midlands are seen by many as the industrial heartland of Britain, but there are many areas of rural beauty to be enjoyed between the sprawling towns and cities. These thousands of bricks (*above*) are in a brickyard in Stoke-on-Trent, although the city and its environs (generally called the Potteries) are best known for the magnificent china that is produced in the factories of Spode, Minton, Copeland and Wedgwood. Much more prosaic are these gas tanks (*facing page*), yet even they have a strange, elegant beauty when viewed from this angle.

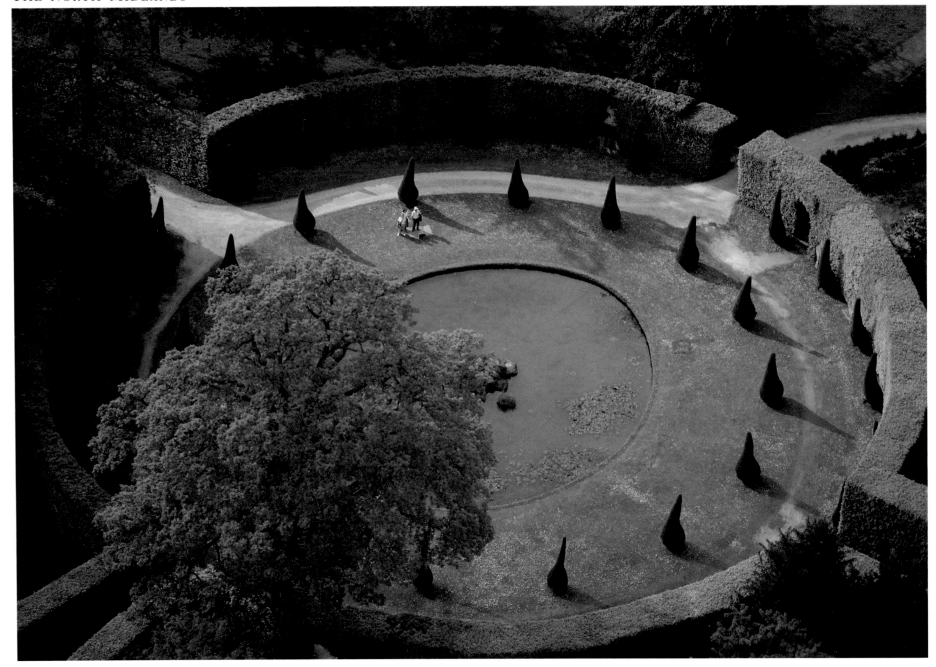

CHATSWORTH HOUSE

Above and facing page Looking at the Classical facade of Chatsworth House today it is hard to believe this was originally a Tudor mansion – the 1st Duke of Devonshire grafted the new building on to the original walls piecemeal whenever money and time permitted. Chatsworth House has remained home to the Cavendish family ever since and is a treasure trove of art and furniture. The gardens (*above*) are equally beautiful and in the past received the attentions of both Capability Brown, who diverted the River Derwent so it would flow in front of the house, and a young Joseph Paxton, who created the arboretum by bringing rare trees to Chatsworth from all over the world.

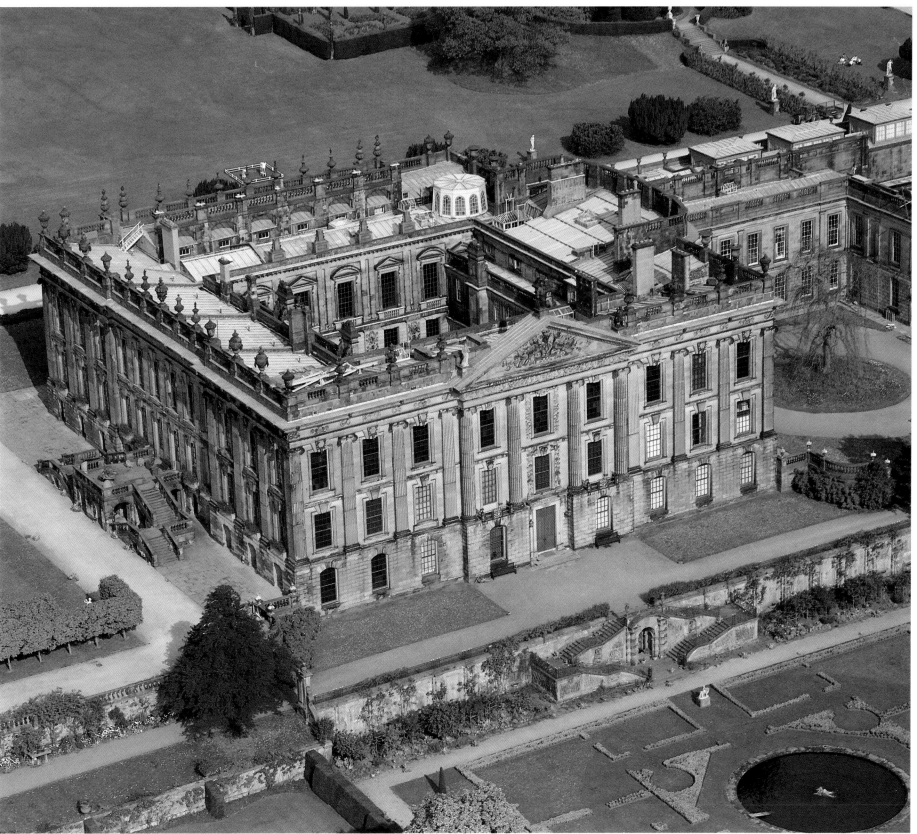

CHESTERFIELD

Local folklore says that the spire of St Mary and All Saints became twisted when it curved round to watch the last virgin bride enter the church, and it will only straighten up when the next one does so. The reality has nothing to do with the supposed morals of the women of the town but instead an architectural misalliance of wood and lead. The timber interior of the spire was encased in pieces of lead, arranged in a herringbone pattern, which were gradually warped by the heat of the sun. Although the spire leans more than 9 feet (2½ metres) from the perpendicular it is perfectly safe and has looked like this for over two centuries. The church itself was built in the thirteenth century and has a Norman font, Jacobean pulpit and plenty of Victorian and modern stained glass.

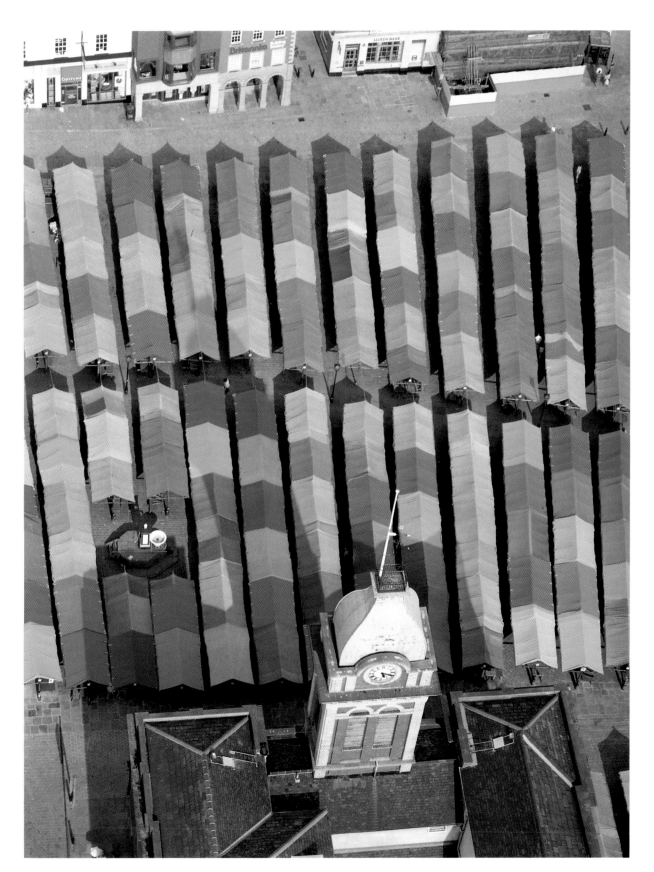

CHESTERFIELD MARKET

When he visited Chesterfield, the architectural historian Sir Nikolaus Pevsner loftily dismissed it as being 'singularly poor in noteworthy houses of any style'. Even so, the town has retained some flavour of its medieval past, including the tradition of an open-air market, although the current market hall only dates from 1857. When it was mentioned in the Domesday Book, Chesterfield was described as a hamlet of Newbold, but less than two centuries later the tables turned: Chesterfield had become a free borough and market town, and Newbold had so come down in the world that it was by then a suburb of Chesterfield. George Stephenson, the great engineer and inventor of the locomotive, lived near here and is buried in Holy Trinity Church.

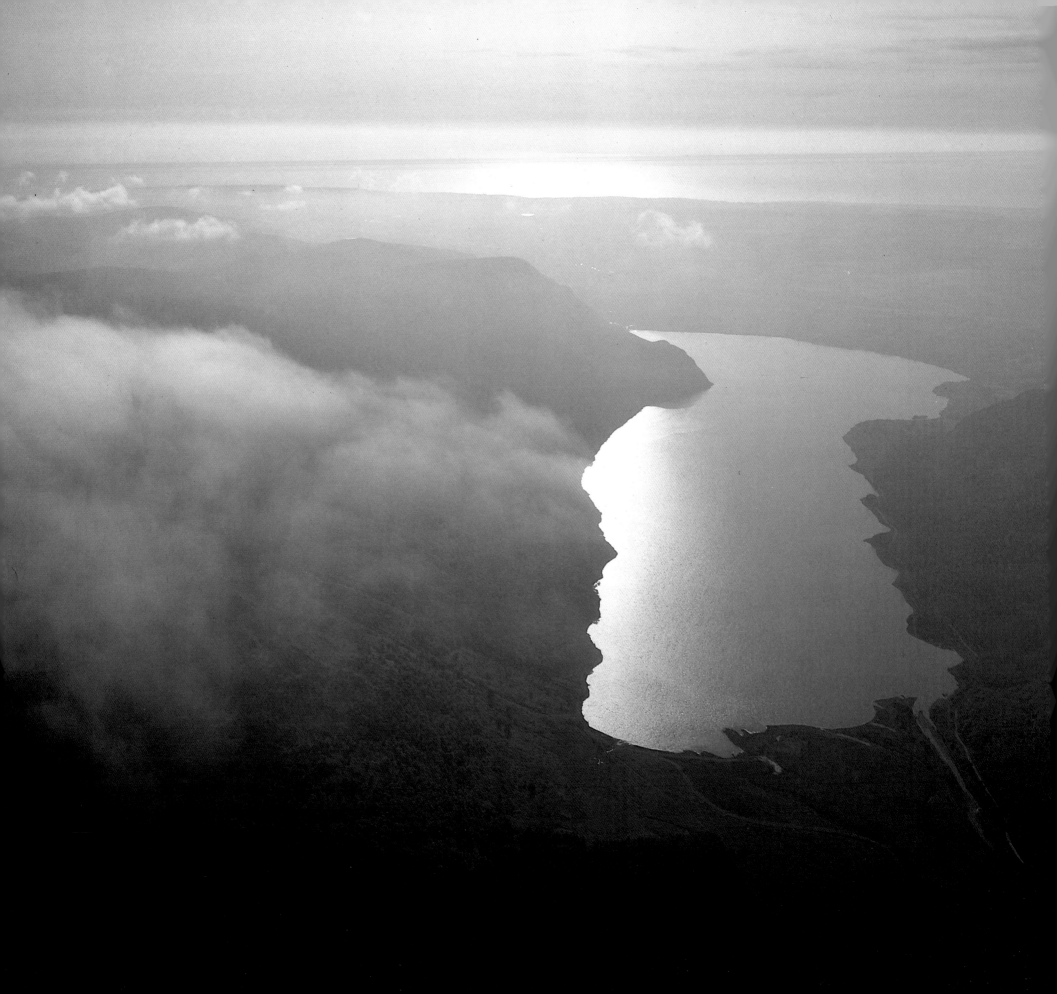

THE NORTH WEST AND THE LAKE DISTRICT

CUMBRIA

Above The brooding mountains of the Lake District have stood here for about 50 million years, although the lakes themselves are comparative newcomers to the landscape, having only been eroded by glaciers during the last Ice Age. Such has been their popularity over the past two centuries, since William Wordsworth's poems about the lakes captured the nation's imagination, that the land is now in great danger of being eroded by tourists.

ENNERDALE WATER

Facing page Visitors wishing to explore Ennerdale Water have to do so on foot, because it is the only one of the lakes not accessible by car. Perhaps it is this absence of any signs of twentieth-century transport that makes Ennerdale one of the most beautiful and unspoilt of all the lakes.

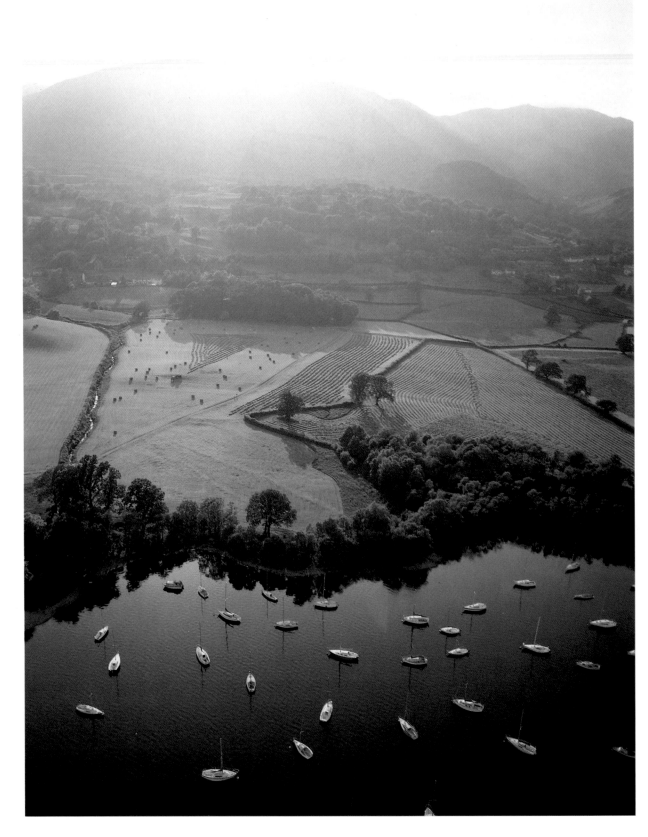

CONISTON WATER

The Lake District isn't all craggy mountains and low clouds, as this photograph shows. Here, yachts are moored in waters that are as calm as a millpond, but in the winter of 1966-7 the peace of Coniston was regularly shattered as Donald Campbell practised breaking the world water speed record in his speedboat *Bluebird*; sadly, he was killed in *Bluebird* in January 1967, while doing 328 miles (527 kilometres) per hour. He had first broken the world water speed record on Ullswater, also in the Lake District.

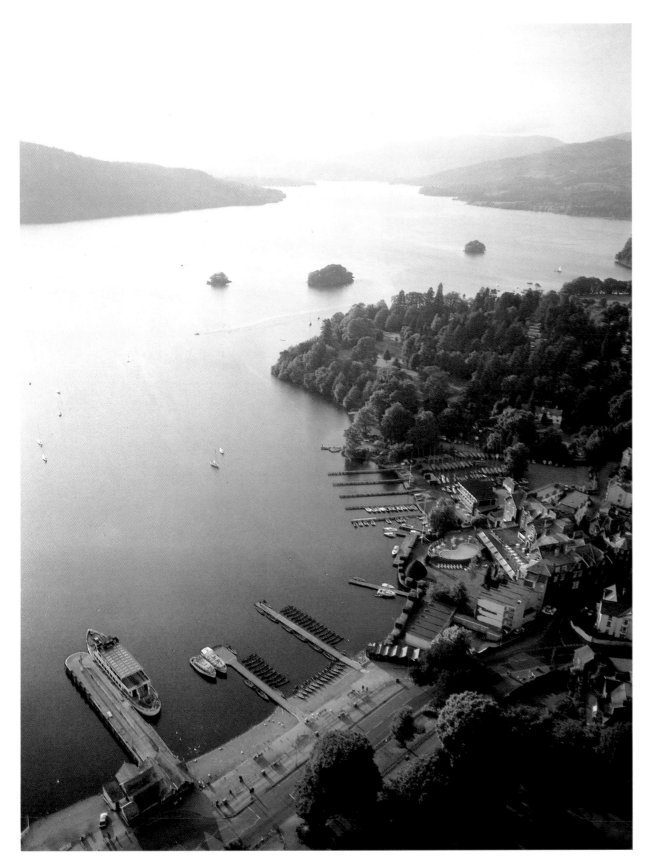

BOWNESS-ON-WINDERMERE

Left Windermere is England's largest lake and is more than 10 miles (16 kilometres) long. It is also one of the Lake District's most popular tourist centres. The large wooded island near Bowness in the middle of the lake, bears the appropriate name of Belle Isle. The lake yawns out to Troutbeck Bridge, Waterhead and Ambleside, but in the foreground is the little town of Bowness-on-Windermere, home of the Royal Windermere Yacht Club. Some of those yachts can be seen here, moored on piers in the tiny harbour.

ENNERDALE WATER

Following pages Ennerdale Water is redolent of peace and seems to belong to a different, more tranquil, age. There are walks of varying degrees of difficulty around its shores, with wonderful views of the surrounding landscape. Virtually all of the land to the south of Ennerdale Water is owned by the National Trust, who own more than a quarter of the entire Lake District National Park.

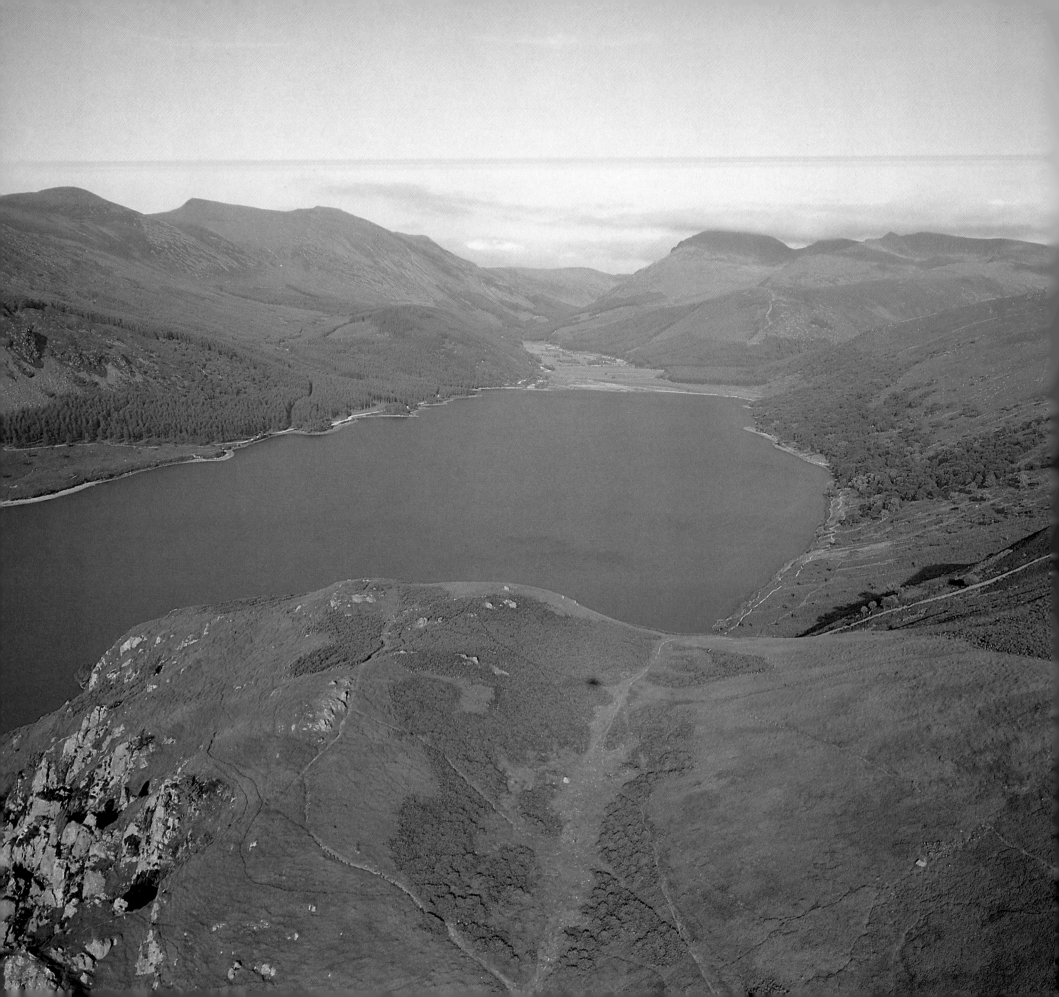

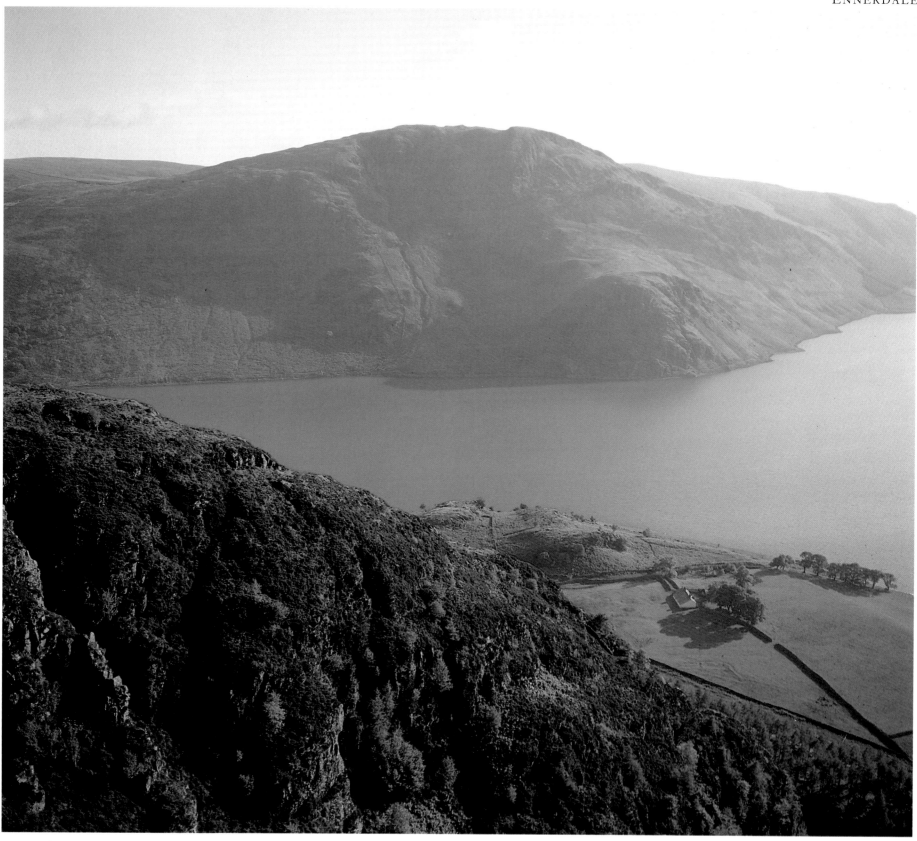

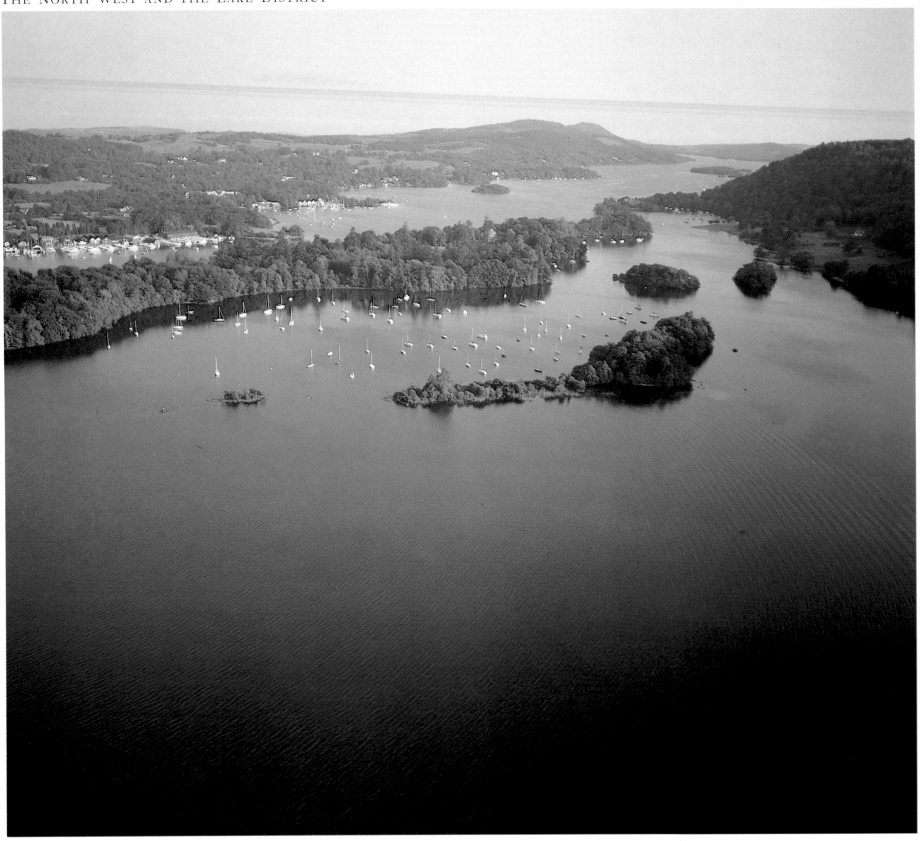

WINDERMERE

Facing page The wooded expanse of Belle Isle stretches diagonally across Windermere, surrounded by smaller islands. The island was home to the Romans and later to Norsemen, and was even a Royalist stronghold during the Civil War. Since 1774, however, Belle Isle has been best known for the completely circular house that was built there, which can be seen peeping through the trees rather like a giant's rhubarb forcer. The town of Bowness-on-Windermere, surrounded by boats, lies on the furthest bank of the lake.

CONISTON WATER

Right Coniston Water lies to the west of Lake Windermere, amid some of the most beautiful scenery in the whole of the Lake District. Many artists and writers have been associated with this area over the centuries, the most famous being William Wordsworth who was born in Cockermouth, and Beatrix Potter and the painter John Ruskin, who both have particular links with Coniston Water. Beatrix Potter owned Tarn Hows to the north of Coniston, while Ruskin lived on the shores of the lake, in a house called Brantwood, between 1872 and 1900. Looking at this photograph, it is not hard to understand why the Lakes have always exerted such a strong attraction.

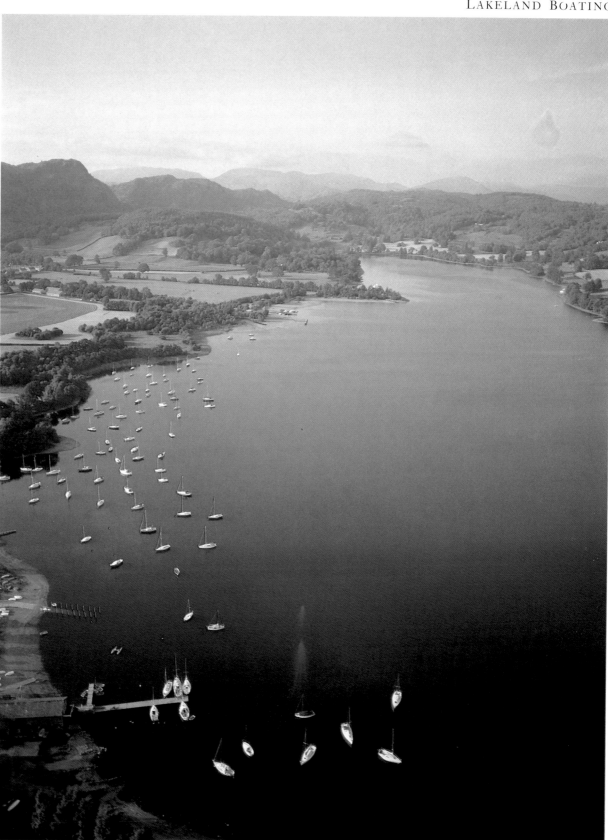

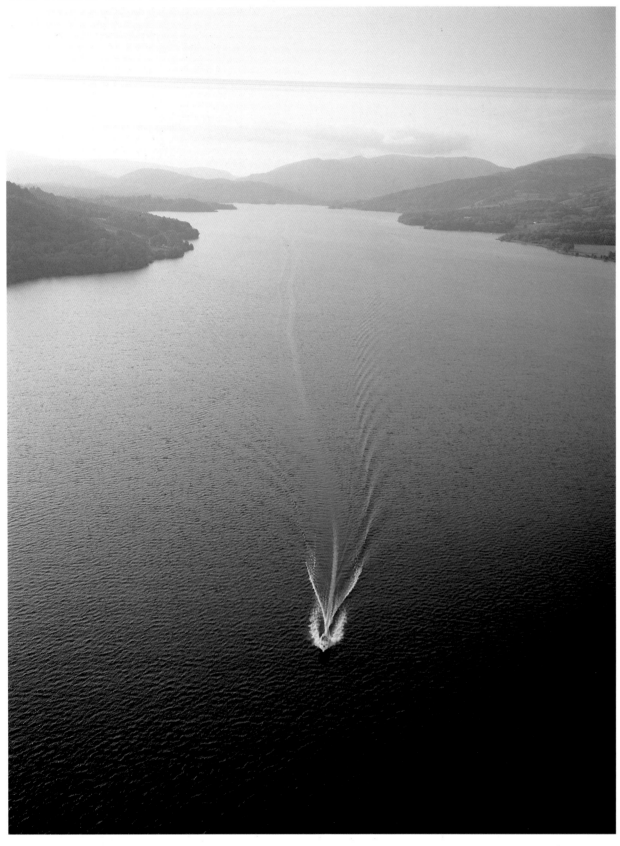

WINDERMERE

Left Boating in the Lake District usually conjures up images of leisurely trips in a yacht, or perhaps an organized pleasure cruise intended to take in all the sights. Roaring up and down Lake Windermere in a speedboat (the only lake on which this sport is now allowed) is another matter, albeit an extremely exhilarating one. The scenery around each lake is spectacular when viewed from the water, and the mountains around Windermere are particularly beautiful. They are the youngest mountains in the Lake District, despite being about 430 million years old, and were formed from Silurian slate which has much softer outlines than the sharp crags around Borrowdale.

TOWARDS RYDAL WATER AND GRASMERE

Facing page This part of the Lake District is indissolubly linked with William Wordsworth, who not only wrote much of his finest poetry about the scenery, but also had two homes here. The small Dove Cottage in Grasmere was the first, where he lived with his sister, but he later moved to a much larger house, Rydal Mount, where he lived with his wife, their three children and his sister. Wordsworth lived here until his death in 1850, and is buried in the churchyard at Grasmere. Both Grasmere and Rydal Water are small, a quality which appealed strongly to Wordsworth, who wrote that the best lakes were not very large and had opposite shores that were clearly visible. Anyone viewing a vast lake, he wrote, 'has the blankness of a sea-prospect without the grandeur and the accompanying sense of power'.

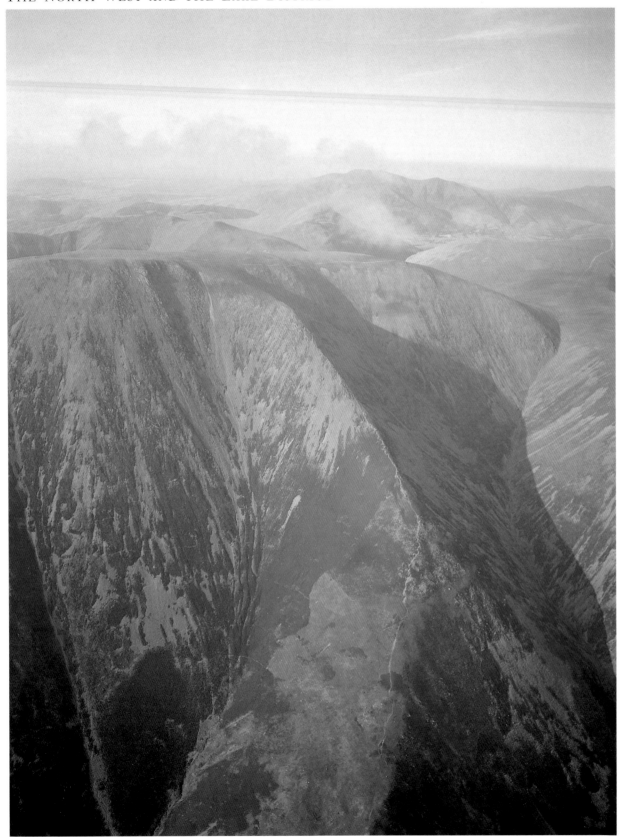

SKIDDAW

Left The mountain of Skiddaw is set in Skiddaw Forest, just north of Keswick. It is made of Skiddaw slate, which is the oldest rock in the Lake District and was formed about 530 million years ago. It seems appropriate, then, that this part of Skiddaw looks rather like the bony back of some prehistoric monster. The rock weathers into smooth curves and steep-sided drops. Skiddaw's highest point is 3053 feet (930 metres) above sea level and, although it is not the tallest mountain in the Lake District, it neverthe-less towers above everything else in the area, providing magnificent views of the surrounding valleys and peaks.

SKIDDAW

Right When viewed in shadow, Skiddaw has a very different atmosphere. Instead of smooth sides and clear shapes, this side of the mountain has a much more blurred outline. The thickly wooded valley on the left of the photograph is part of Skiddaw Forest, with a glimpse of the huge Bassenthwaite Lake (which forms the border between the Skiddaw and Thornthwaite Forests) in the background. Higher up are the deep gouges left by winter streams which have probably trickled their way down the mountain for thousands of years, gradually carving out deeper and deeper clefts in the Skiddaw slate.

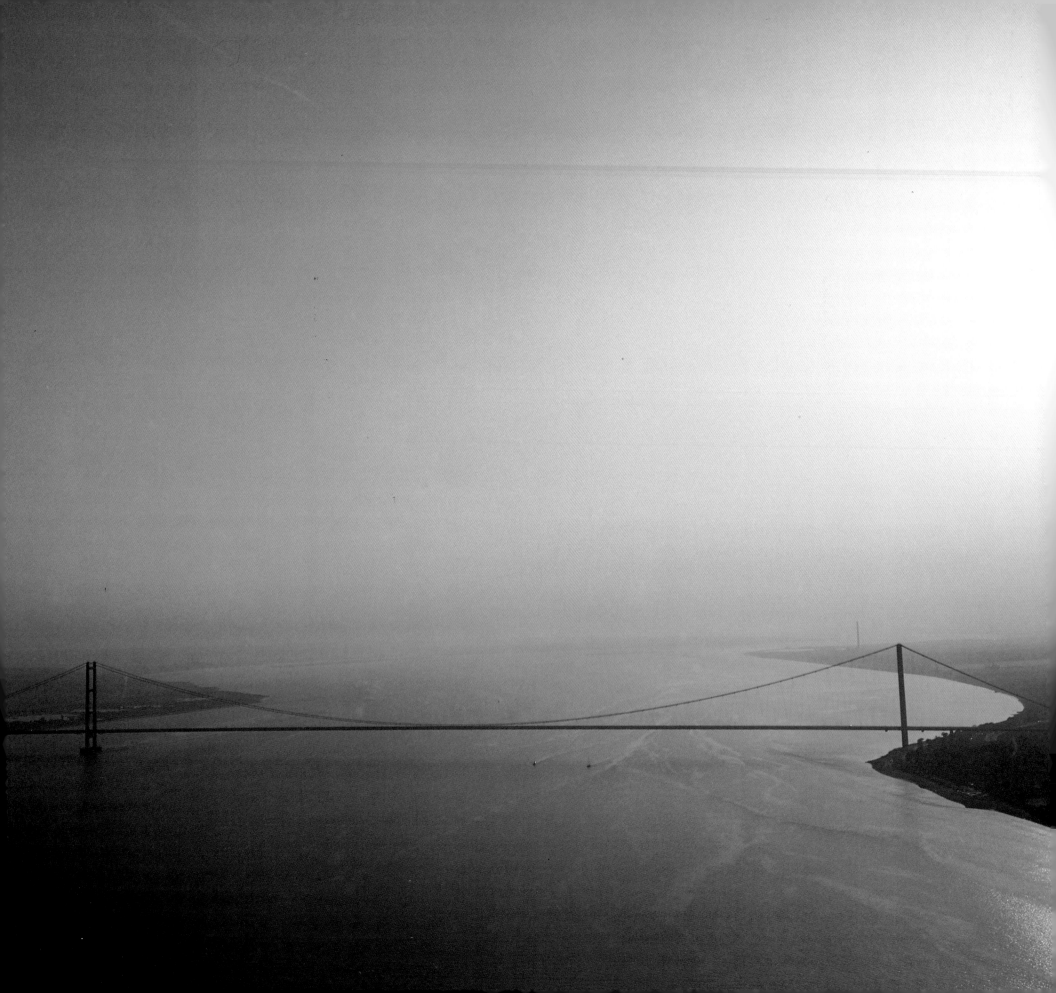

THE EAST COAST AND YORKSHIRE

HUMBERSIDE, LINCOLNSHIRE AND NORTH YORKSHIRE

Above Flecked with spume and feeding ground for numerous sea gulls, the waters of the North Sea crash on to the east coast of England. These sands have witnessed bloody battles between the inhabitants and the invading Vikings centuries ago, the retreat of the Romans before the Dark Ages, hand-to-hand fighting between the fierce Border raiders of the north and the hapless folk they were trying to pillage, the busy trading conducted on the North Sea and a host of unrecorded and long-forgotten acts of bravery and treachery.

HUMBER BRIDGE

Facing page The elegant Humber Bridge (1981) is the longest single-span suspension bridge in the world, even longer than the Golden Gate Bridge in San Francisco. So long, in fact, that the towers are wider apart at the top of the bridge than at the bottom to allow for the curvature of the earth. The main span is 4626 feet (1410 metres) long, and its total length is 7283 feet (2220 metres). If all the wire in the two main cables were unravelled it would go round the Equator one-and-a-half times. The bridge straddles the mighty River Humber, linking Grimsby with Hull on the north bank of the Humber.

THE RIVER HUMBER

Above The Humber has given its name to the county of Humberside, and a glance at a map of this area of Britain shows just how deeply the river carves its way through the east coast and out to the North Sea. The Humber itself is the estuary of the Trent and Ouse rivers and is 40 miles (64 kilometres) long, stretching from the port of Goole out to the major fishing town of Grimsby and the North Sea. The River Hull, dykes and huge drains also flow into the Humber, and the estuary is a haven for wildlife. The most important city on the Humber is the thirteenth-century port of Kingston upon Hull, which is better known in its abbreviated form of Hull. By the fourteenth century Hull stood on an island which was created by a defensive moat built to link the Humber and Hull rivers. Parts of the moat were widened during the eighteenth and nineteenth centuries to create Hull's enclosed docks. Today, the city's docks stand on the edge of the River Humber and Hull is a major container port.

HUMBER BRIDGE

Left The two main cables of the Humber Bridge measure 27 inches (68 centimetres) across, with each one containing over 14,500 separate wire filaments. Anyone driving over the bridge, however, is likely to forget about its vital statistics and instead gaze at the panoramic view of the River Humber.

THE INDUSTRIAL FENS

Cooling towers belch out plumes of smoke near Lincoln, hinting at the industrialization that is so prevalent west of this point. Through the smoky mists can be seen neat fields in all shades of green, with pretty rows of broad-leafed trees forming the boundaries between them. The eastern half of Lincolnshire is flat fenland, but to the west is a ridge of limestone, known as the Lincoln Edge, which runs from the Humber down to the town of Stamford.

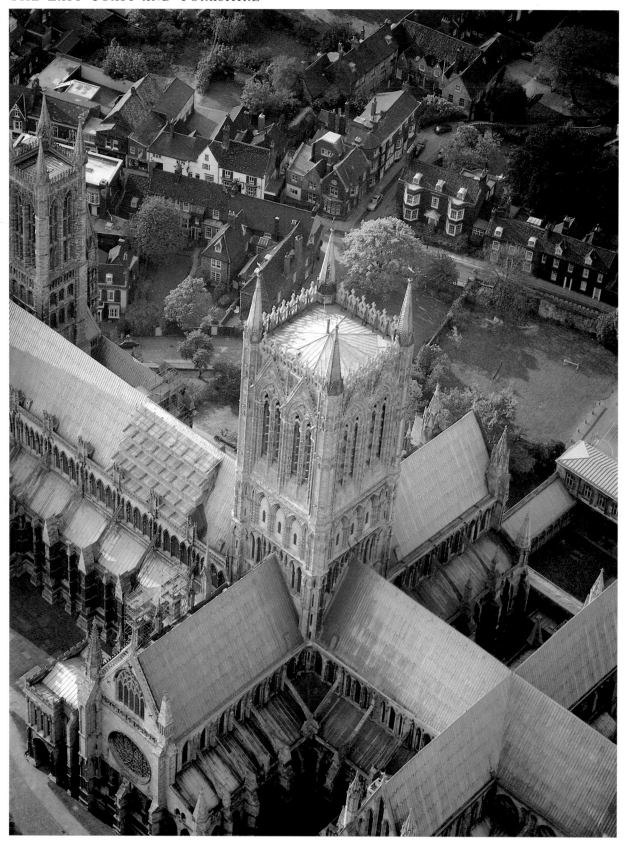

LINCOLN CATHEDRAL

Left Earthquakes are relatively rare in Britain, but in 1185 Lincoln was shaken by an earthquake severe enough to destroy its original Norman church. The Cathedral Church of St Mary was built in its place during the following two centuries, using local honey-coloured limestone in the Early English architectural style. It is the third largest cathedral in Britain, and its position on a limestone ridge ensures it is visible for miles around. The cathedral is also notable for having three spires (plainly visible in the photograph on the facing page). It is not always easy to admire the pointed Gothic arches and delicate tracery of the medieval stonemasons' work from the ground without getting a cricked neck, but this bird's-eye view shows off the stonework in all its beauty, even if it has been blackened with time.

THE CITY OF LINCOLN

Facing page Lincoln is a deceptive city – although the surrounding area is quite flat, Lincoln itself has some steep climbs leading up from the lower part of the city, with one street actually called Steep Hill. The twin spires of the cathedral's wide west front are clearly visible here, towering above the surrounding buildings. In front of the cathedral in the photograph is Lincoln Castle, which was founded by William the Conqueror in 1068.

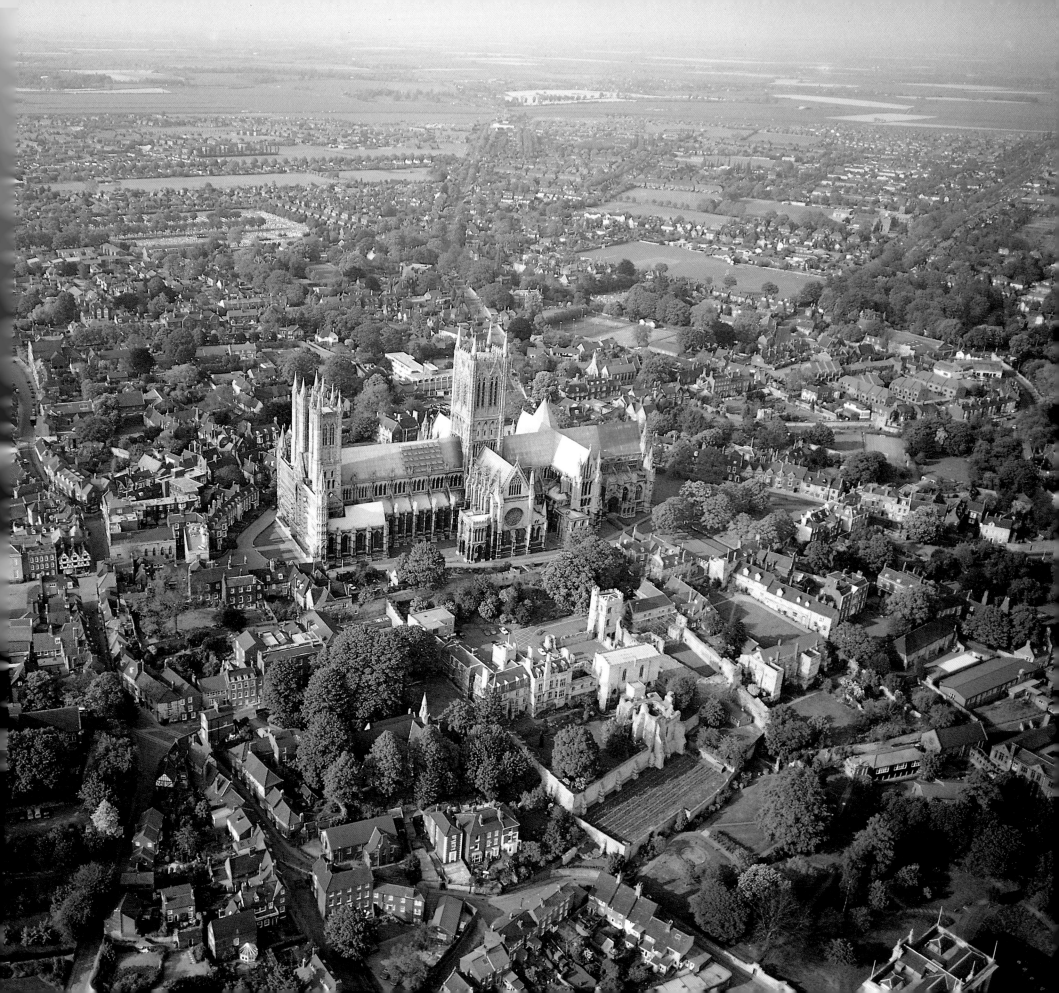

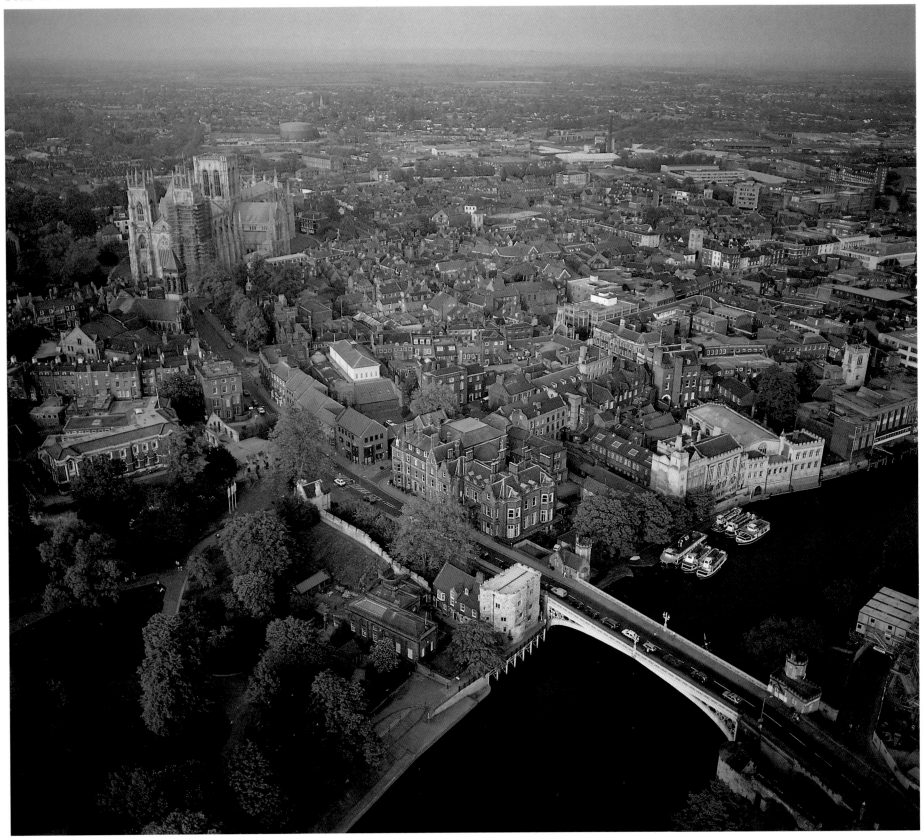

EMLEY MOOR

Above A few miles south east of Huddersfield lies Emley Moor, an area that has put itself on the map with this gigantic television transmitter. It is the tallest free-standing building in Britain, which is why it is dotted with red lights – to act as a warning to low-flying aircraft. It makes an odd contrast with the unspoilt Yorkshire countryside lying all around.

YORK

Facing page and right Even at first glance, the city of York seems to have virtually everything – one of the most magnificent cathedrals in Europe, a host of ancient and medieval buildings, a castle, Roman walls, a railway museum complete with original steam trains, two riverfronts (the Rivers Ouse and Foss flow through the city), and even its very own gasworks. George V said 'The history of York is the history of England', and any visitor to York will be able to trace the city's pedigree through a Roman tower, a Viking museum, many medieval buildings and even some Georgian squares. York Minster is the largest cathedral in Northern Europe and is the fourth cathedral to stand on this site. Work began on it in 1220 and continued for more than 250 years before the cathedral was finished. However, as the photographs show, even now work continues on the cathedral – the restoration of the south transept, after it was severely damaged by a bolt of lightning in 1984, has been meticulously carried out.

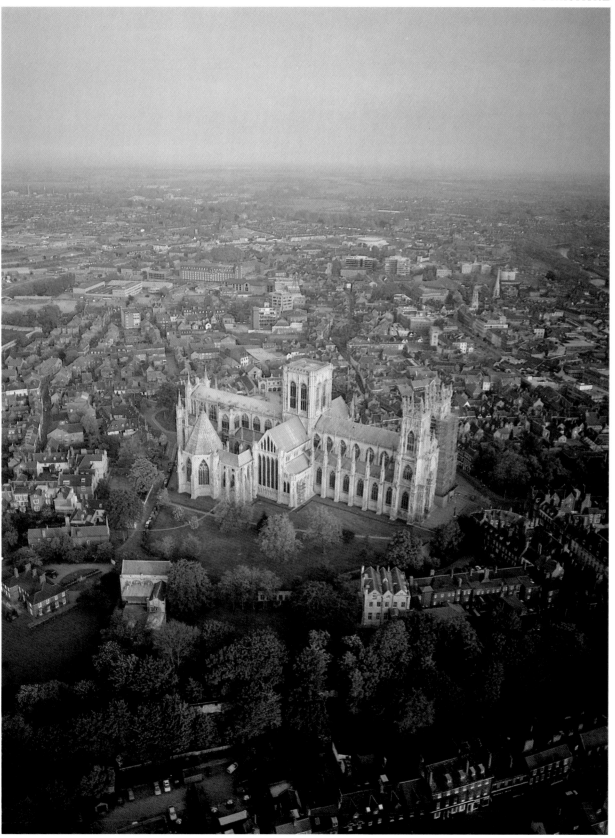

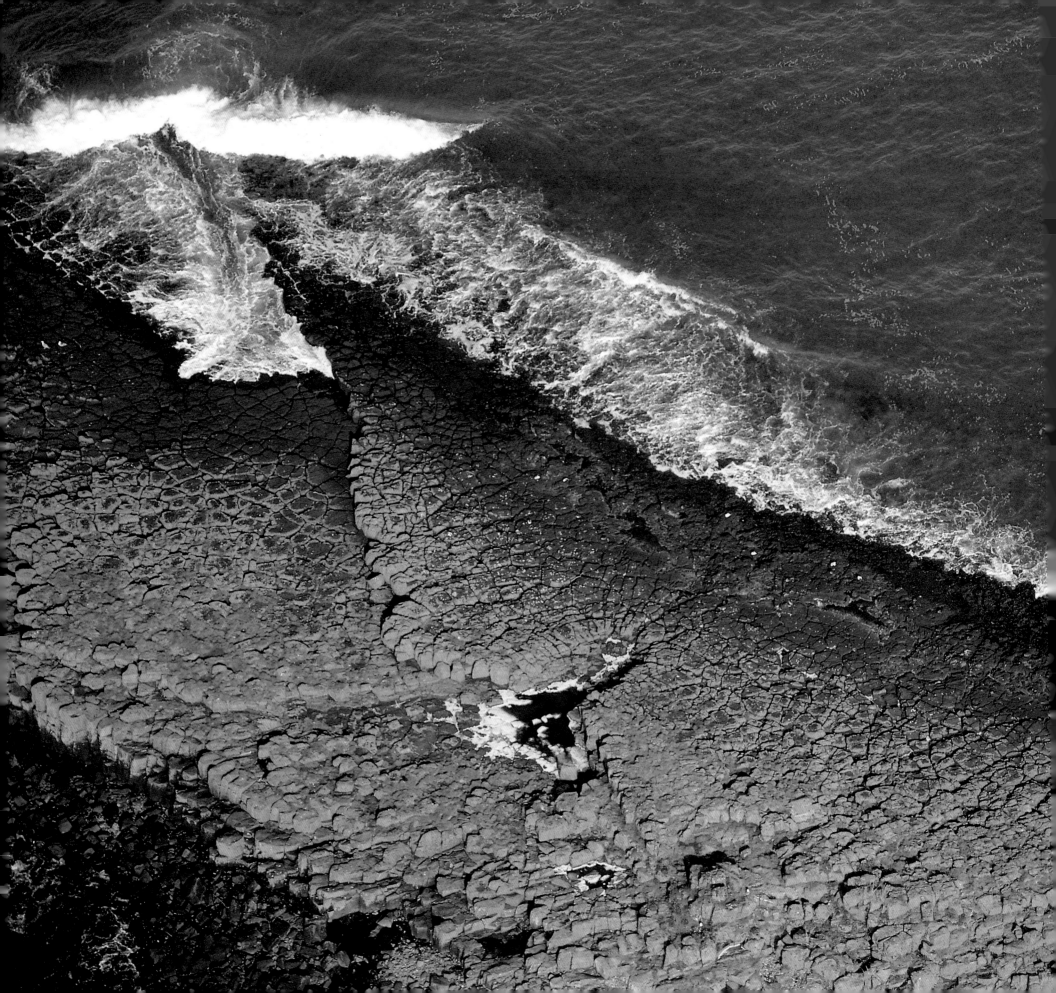

THE NORTH EAST

NORTHUMBERLAND, TYNE AND WEAR, BORDERS AND LOTHIAN

HOLY ISLAND

Facing page and above It is the sea that dictates the way of life on Holy Island, or Lindisfarne as it is also known, because for five hours at each high tide the causeway which links the island to the mainland at Beal is submerged and Lindisfarne becomes a true island. When the tide recedes, it reveals a wide sandy peninsular that is the perfect feeding ground for many species of wildfowl and wading birds. Emmanuel Head, on the north east corner of Holy Island, is a spectacular viewing point from which to observe the teeming bird life, ranging from puffins to short-eared owls.

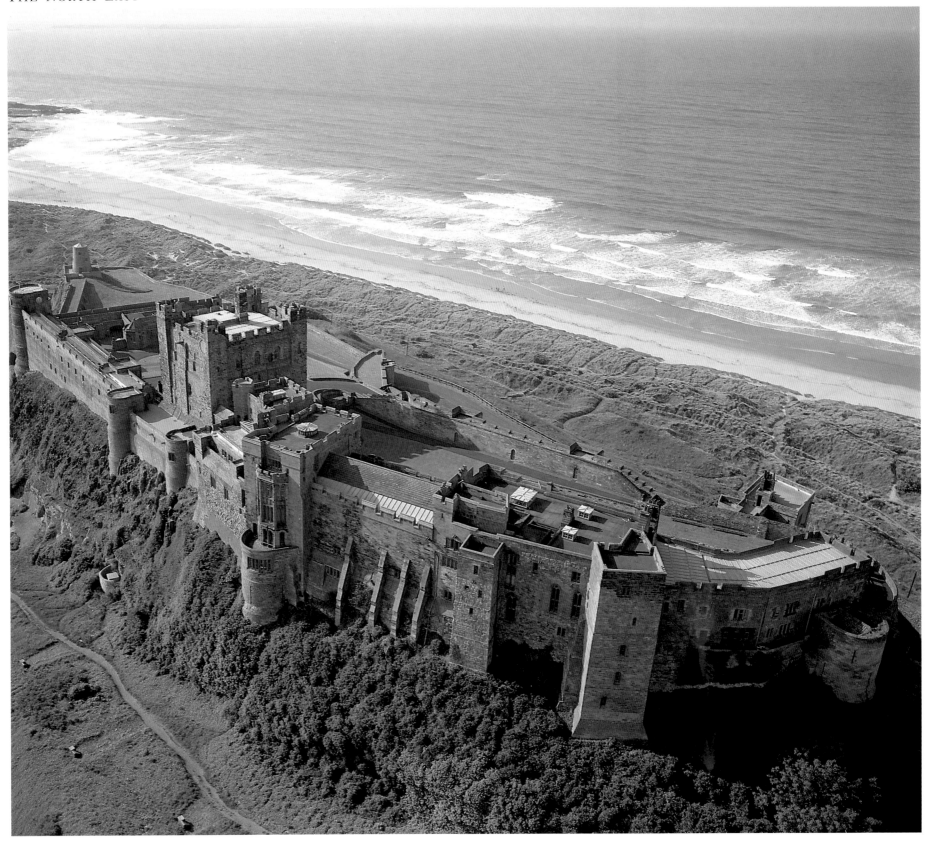

BAMBURGH CASTLE

Facing page The solid fortifications of Bamburgh Castle show how closely guarded the Borders have been over the centuries – there was always the danger of invasion, whether from over the sea or across the Scottish border. On a clear day, Bamburgh commands a magnificent view of the surrounding coastline, with the Farne Islands and Longstone Lighthouse in the North Sea perfectly visible. There has been a castle here since the Dark Ages, when Bamburgh was the capital of Northumbria (one of the five kingdoms of England) and the home of the kings who ruled here. It survived three separate attacks by the Vikings, and the Saxon castle that was built here was besieged by William II at the end of the eleventh century. The Norman castle that survives today was built over the following hundred years, although a good deal of the building is much newer than that and dates from the nineteenth century, when the castle was restored from the dilapidated state into which it had fallen.

TANTALLON CASTLE

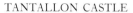

Right The remains of Tantallon Castle stick up like a jagged tooth from the surrounding flat coastline and, as this photograph shows, the castle still occupies an important vantage point along the Scottish Firth of Forth. Tantallon was built in the fourteenth century by the Red Douglases who were busy pursuing a protracted feud with the Black Douglases, not to mention a host of other intrigues, plots and sieges. The promontory on which the castle stands doesn't look very high from a helicopter but, at 100 feet (30 metres), it was considered quite lofty enough to deter any invaders arriving by sea, and the deep defensive ditches that were dug in front of the castle took care of anyone approaching by land. Despite its strong defensive position, Tantallon was badly damaged during an artillery siege at the end of the Civil War in 1651, and had been abandoned entirely by the end of the seventeenth century. In this photograph, the coast stretches away to the east, with the fishing harbour of Dunbar visible in the background.

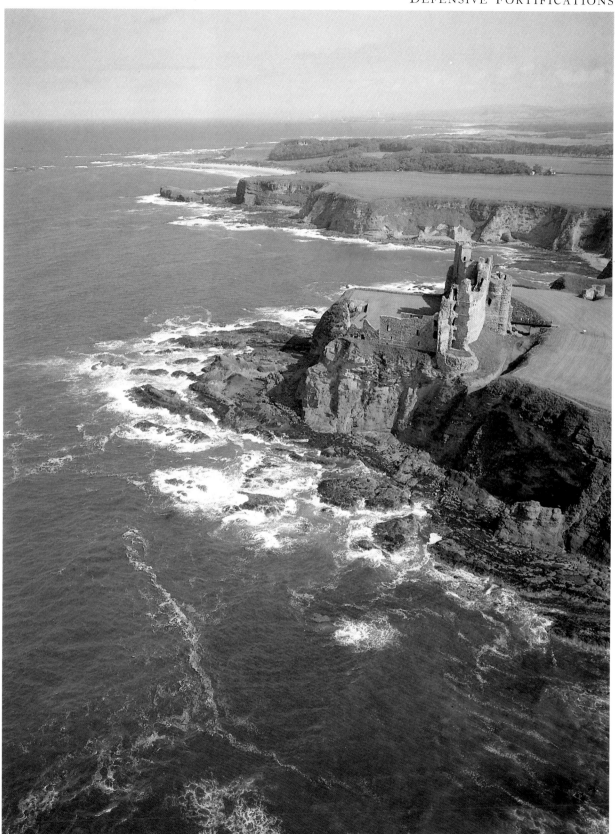

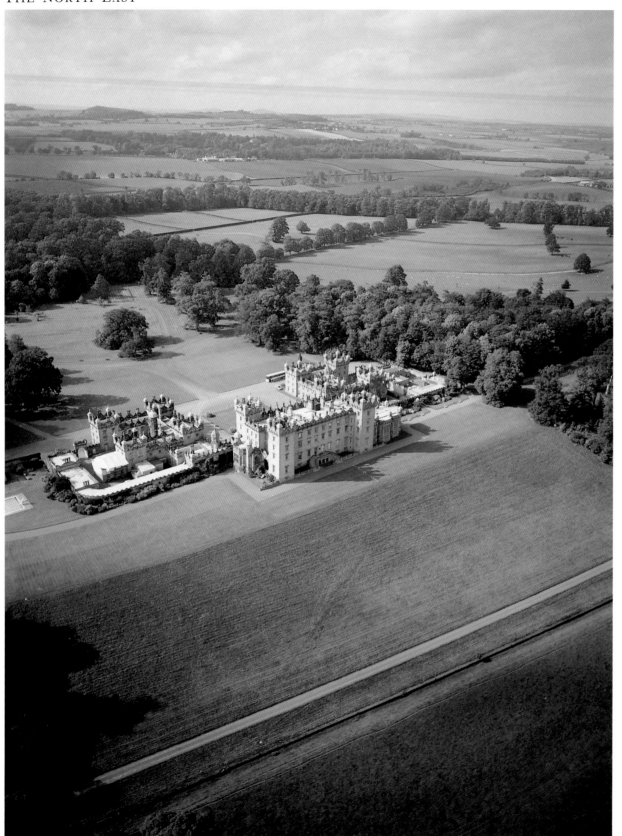

FLOORS CASTLE

It looks like an architectural fantasy, and in fact Floors as it stands today is a Victorian version of an idealized castle. The central block was built, in a much plainer style, for the 1st Duke of Roxburghe between 1721 and 1726. It is not known whether the architect was William Adam or Sir John Vanbrugh, but the latter seems the more probable. Just over 100 years later, in the 1840s, the 6th Duke of Roxburghe commissioned William Playfair to embellish the house by building the two wings, increasing the number of rooms and smothering the finished work in castellated parapets, pepperpot chimneys and anything else that took his fancy. The Georgian-cum-Jacobean result, with its many turrets, beautiful grey stone and elegant architecture, makes Floors Castle unlike most of the castles to be found in Scotland. They are usually built in the style of Scottish Gothic, or in an earlier, plainer design. The interior of the castle is lavishly furnished, and one room is dedicated entirely to stuffed birds. The castle is open to the public and lies just outside the town of Kelso, in the soft, green wooded countryside of the Borders, near the River Tweed.

WARKWORTH CASTLE

'A moth-eaten hold of ragged stone' is how Shakespeare's Henry IV described Warkworth Castle in Northumberland, although 'fascinating historical ruin' would be more polite – and more accurate. The siting of first a Saxon stronghold and then a twelfth-century castle here was an obvious choice, because not only was there an excellent view up and down the coast, but the River Coquet forms a horseshoe bend here that encloses the town in its very own moat. The castle became an important military base, and in 1332 Edward III sold it to the Percy family, who improved it considerably and even turned the keep into a palace. The 3rd Lord Percy, who was created Earl of Northumberland, plotted here with his son 'Harry' Hotspur to overthrow Henry IV (an ironic twist of fate since it was Hotspur's plotting that had put the King on the throne in the first place), but the plan failed and Warkworth Castle was besieged by the furious Henry in 1403. It was a rather ignoble defeat, as the castle is believed to have surrendered after only seven shots had been fired at it. A later member of the Percy family plotted against Elizabeth I in 1572, was beheaded for his trouble and the castle began falling into disrepair. A less blood-soaked remnant of the Middle Ages is the large expanse of green land behind the castle which is divided into long strips, known as stints, that are cultivated by the local inhabitants. Other survivors of those far-off days are the ruined fortified tower, and the medieval bridge at the northern end of the town. Alnmouth Bay and Seaton Point can just be discerned in the background.

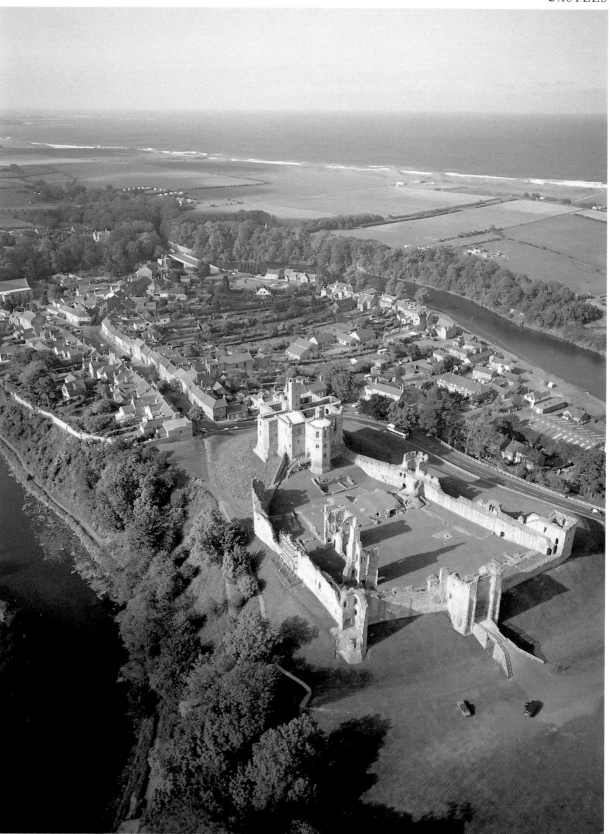

NEWCASTLE UPON TYNE

Over a quarter of a million people now live in Newcastle upon Tyne – a city which has changed immeasurably since its days as a Roman frontier station called Pons Aelii – and so housing continues to spread outwards from the city centre, as this photograph shows. The city centre itself underwent an enlightened redevelopment in the 1830s thanks to the combined work of a builder, Richard Grainger, an architect, John Dobson, and the town clerk, John Clayton. Together they created the elegant area around Grainger Street and Grey Street, and Dobson also designed the Central Station (opened by Queen Victoria in 1850) which heralded the arrival of the railway (and the prosperity that came with it) in Newcastle.

NEWCASTLE UPON TYNE

Right Six bridges cross the Tyne at Newcastle, varying considerably in size and importance. In the foreground is the famous New Tyne Bridge (1928), Newcastle's principal road bridge. Next as the eye follows the Tyne up its course, crouching low, is the red and white Swing Bridge (1876), whose central section pivots through 90 degrees to allow ships to pass by. The High-Level Bridge was built by George Stephenson in 1849 to carry the railway across the Tyne while allowing tall ships to sail underneath with room to spare. Railway passengers get a good view of the Norman castle keep, which was built in 1172 (to defend the city against the Scots) and gave the city its name. It is just visible in the photograph, standing in front of the Central Railway Station at the fork in the lines. The pale grey Queen Elizabeth Bridge (1981) carries the new Metro city railway, followed by the King Edward VII railway bridge (1906) and, lastly, the Redheugh Bridge (1981), which was built to carry traffic.

SHIPPING ON TYNESIDE

Below The shipyards of Tyneside were once world-famous, and Newcastle itself enjoyed its heyday as a shipbuilding centre as well as an important port – the classic liner *Mauretania* was built here by Swan Hunter for Cunard in 1907. The Great Depression of the early 1930s helped to sound the first death knells of Tyneside's shipbuilding industry, and matters have gone from bad to worse ever since. Even so, other forms of boating have survived in Tyneside, as can be seen from this photograph. Sailing clubs proliferate up and down the coast and there are still plenty of local fishermen.

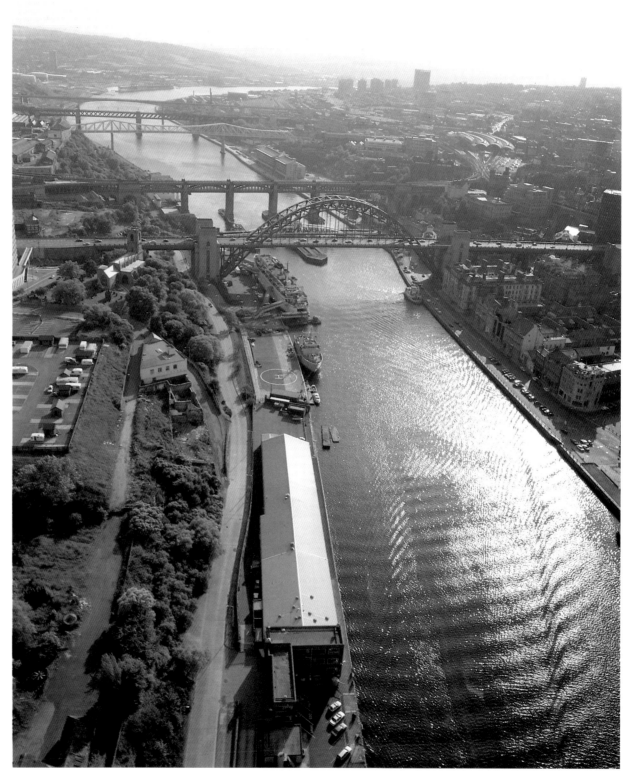

THE CHEVIOT HILLS

The line of the Cheviots in Northumberland closely follows the border between England and Scotland, and here both countries can be seen from their tallest points. The Cheviot itself is the highest point, at 2677 feet (816 metres), and it has given its name to a famous breed of sheep. At one point the Cheviots are crossed by the Pennine Way as it ploughs across the border into Scotland.

THE CHEVIOT HILLS

Unlike the Pennine Way, which can have a rather blurred outline, the Cheviots stand out clearly against the sky. They are captured here on a misty atmospheric day, which makes it all the easier to picture this land's history – the Saxon kingdom of Northumbria (made up of present-day Northumberland, Durham and Yorkshire) was the most important of England's seven kingdoms and a centre of learning and spirituality that was renowned throughout Europe. Later, these peaceful, gently undulating hills were the scene of bloodshed and desperate battles during the Border wars, when Northumberland was a no-man's land between England and Scotland.

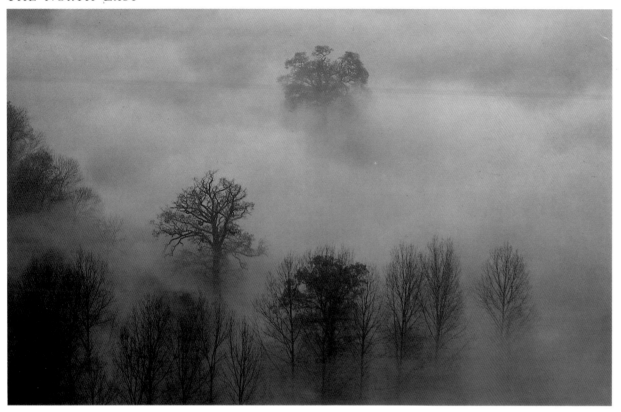

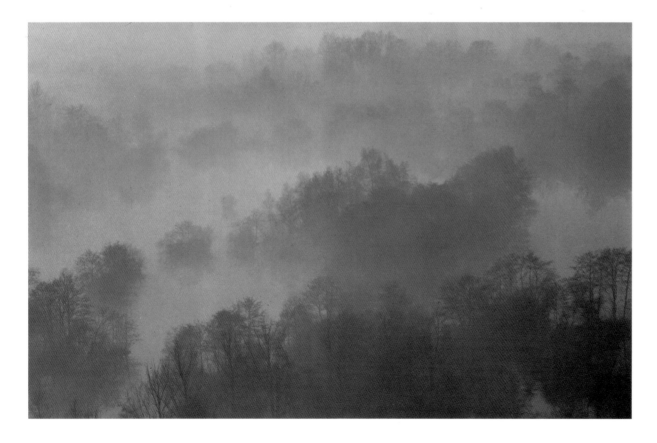

KIELDER FOREST

Left, above and below The southern hills of the Cheviots are covered by part of the Border Forest – a massive enterprise that began in 1926 when the Forestry Commission began to plant what would become the biggest man-made forest in western Europe. Taken together with the nearby Redesdale Forest, the Kielder Forest forms the largest part of the Border forest, and is adorned with the huge Kielder Water Reservoir, which holds another record, being the largest man-made stretch of water in Britain. The 145,000 acres (58,680 hectares) of forest are planted with Sitka spruce, Norway spruce, Scots pine and larch to supply timber for industry.

KIELDER FOREST

Early morning mist blankets the trees in the forest, creating a hauntingly romantic image of ancient Britain. The forest has a castle, which was once a hunting lodge belonging to the Dukes of Northumberland, and it also encloses some of the county's most remote countryside. There are special walks through the forest and on to the moorland, covered with purple grasses and home to hares and other wildlife.

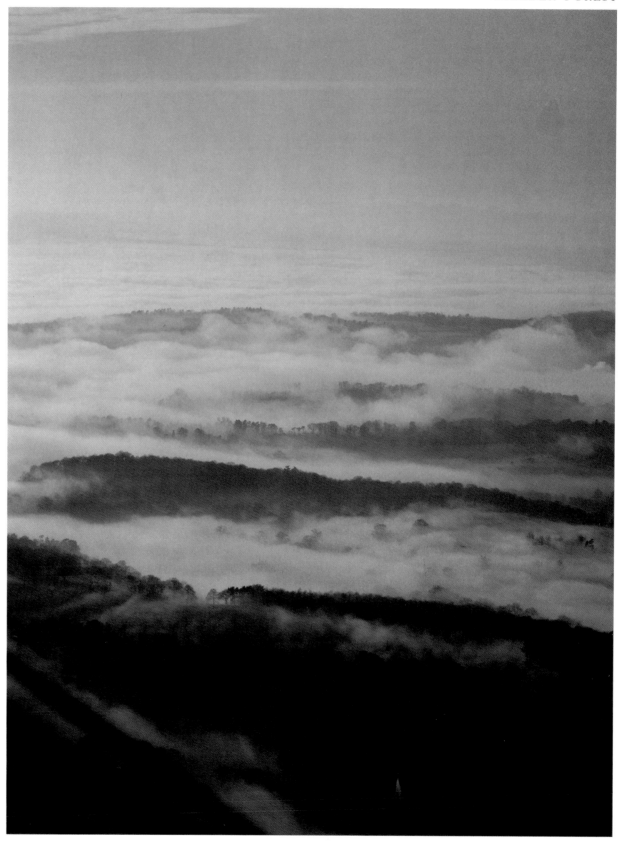

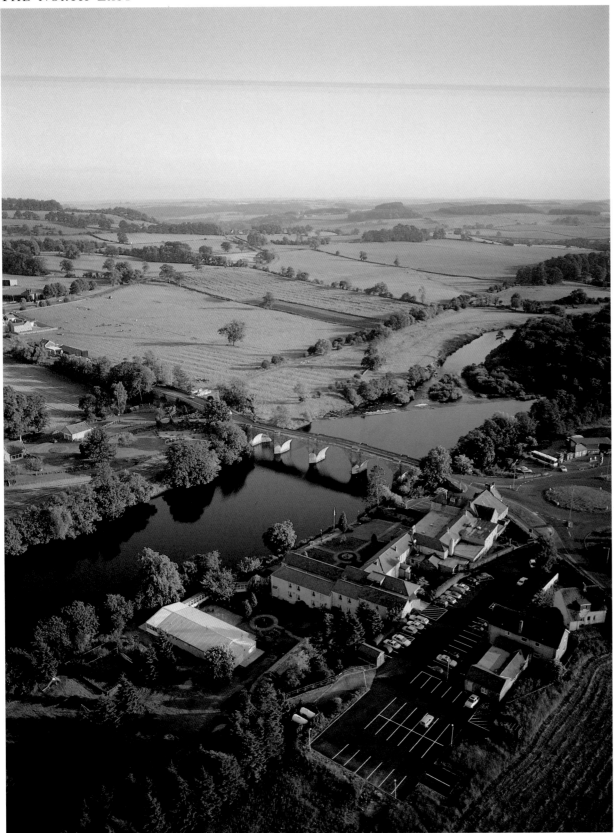

HADRIAN'S WALL

Facing page, left As this photograph shows so well, the wall was built on high ground whenever possible to provide a good vantage point for the defending troops, with deep ditches which the invaders would have to cross while also coping with missile fire. Watchtowers, milecastles and forts were evenly spread along the length of the wall to ensure a solid defence and also a good communications network, so any news could be spread quickly up or down the line. The wall was 80 Roman miles long, which translates today as about 73 miles (117 kilometres), and ran right across the country, from Bowness on the west coast to Wallsend on the east. This shows a section of Hadrian's Wall about 20 miles (32 kilometres) east of Carlisle.

LOW BRUNTON

Left Near Hexham in Northumberland is the village of Low Brunton, which stood near Hadrian's Wall. The pretty little bridge in the photograph crosses the North Tyne River, which runs from its source in the Border Forest to the outskirts of Hexham. There it is joined by the South Tyne, West Allen and East Allen rivers to become the Tyne, which then flows east through Newcastle and out to the North Sea. The soft countryside around Low Brunton is ideal for walkers.

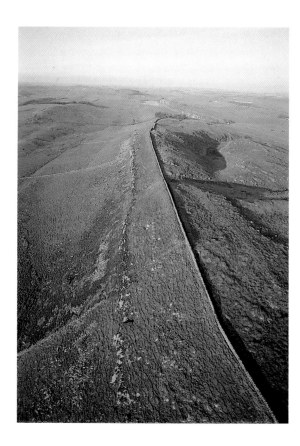

HADRIAN'S WALL

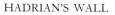

Right Most relics of Roman Britain were destroyed when Britain was invaded by the Vikings, but Hadrian's Wall survived. It is believed to have been inspired by travellers' tales of the gigantic Great Wall of China, and was built from AD 122-8 on the orders of the Emperor Hadrian. The wall served two purposes, not only marking the northernmost point of the Romans' occupation of Britain but also acting as a defensive rampart against the fearsome Caledonians (as the Romans called the Scots) and other Border tribes. The tribes living in Scotland had already slain at least one Roman legion when they advanced as far as the Tay and built a fort there, so the Emperor Hadrian wasn't taking any chances when he ordered that the wall be built between the Tyne and the Solway Firth. In fact, so worried were the Romans about the threat from the hostile tribes to the north that they built another, smaller, wall between the Forth and the Clyde, and called it the Antonine Wall after the Emperor Antonius Pius. However, the wall was attacked so often that the Romans retreated again to Hadrian's Wall and an uneasy truce prevailed.

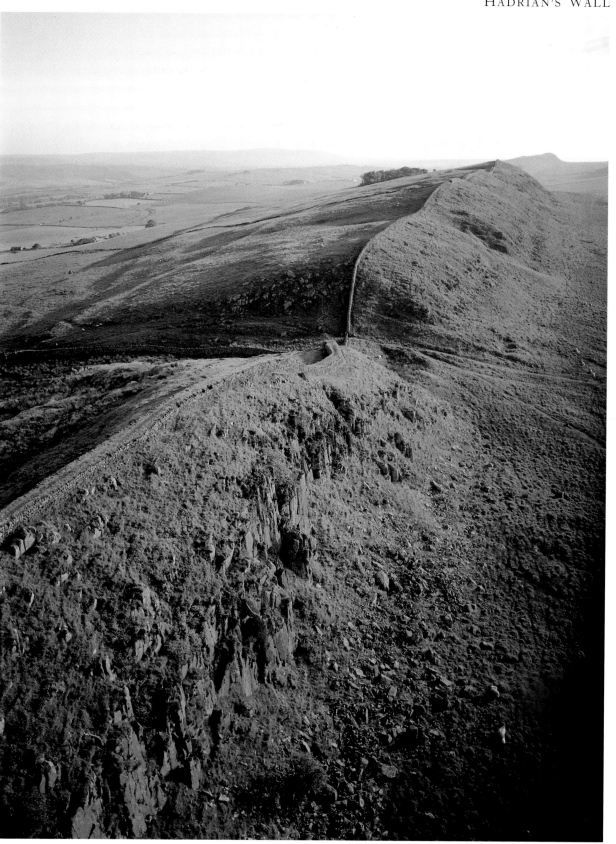

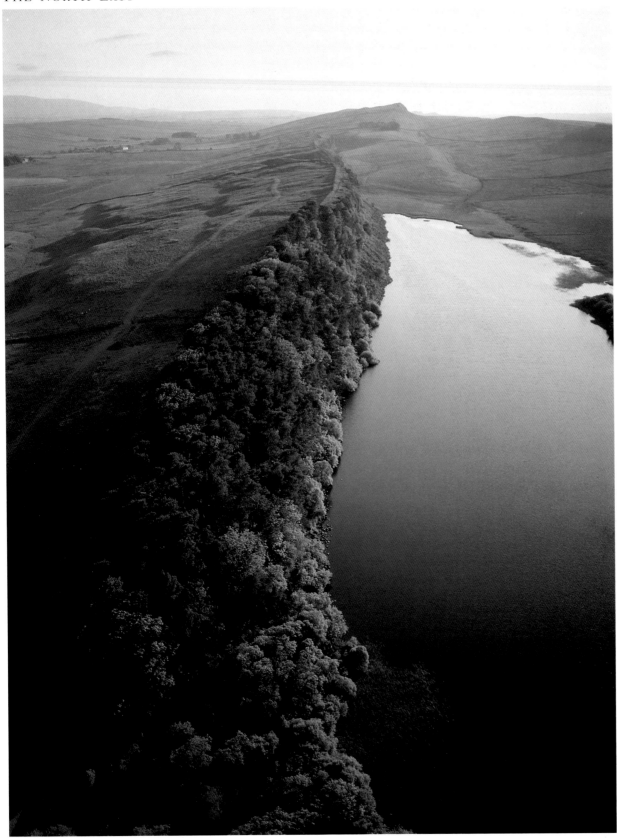

HADRIAN'S WALL

Left Whenever possible, the builders of the wall took advantage of natural features in the landscape to increase their defensive position and create as many problems for the attacking tribes as possible. For present-day inhabitants and visitors to Cumbria and Northumberland that means much of the remaining wall runs spectacularly along rocky outcrops or beside loughs, as here near Housesteads. The lake, of course, is on the Scottish side of the wall and would have acted as a natural moat. Hadrian's Wall originally stood nearly 15 feet (4.5 metres) high and so ensured that friendly tribes living north and south of it wouldn't be able to join forces in a common cause against the Romans.

HADRIAN'S WALL

Facing page It would be difficult to shin up this outcrop of rock while clutching a hefty sword in one hand and defending yourself with the other, which is why Hadrian's Wall runs along the top of it. The rock is known as whinstone or dolerite, and is fine crystal that cooled into hexagonal columns after it was forced up out of the earth. It runs across much of the land covered by Hadrian's Wall, and is also found on the Farne Islands and parts of Lindisfarne.

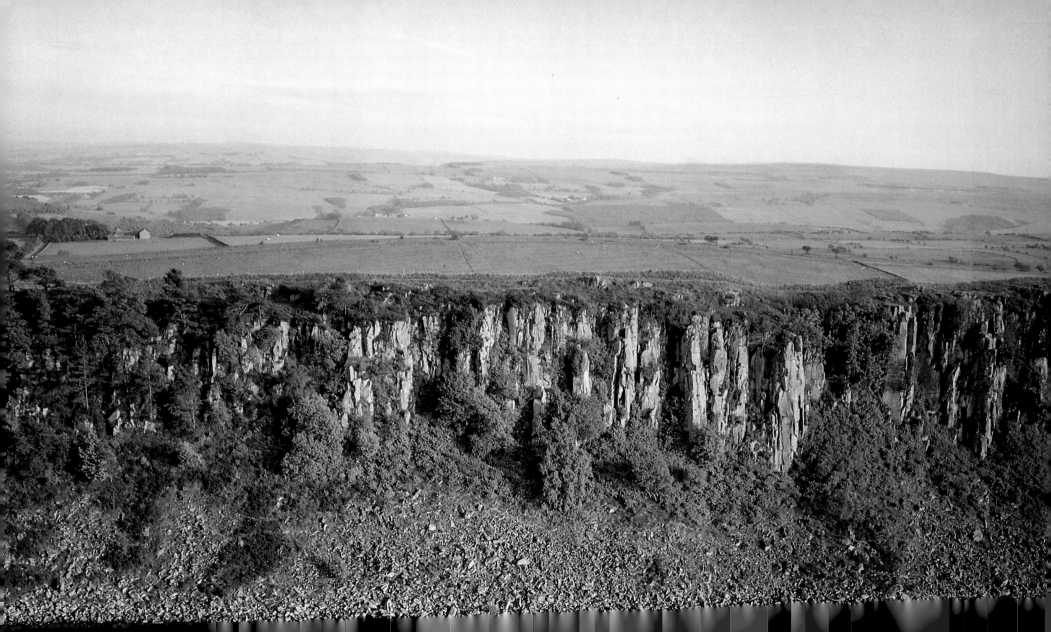

SCOTLAND

Lothian, Fife, Tayside, Borders and Strathclyde

THE FIRTH OF FORTH

Above Scotland seems to have the best of both worlds – inland is some of the most beautiful countryside in Britain, while parts of the coastline are spectacularly wild and craggy. This section of coast has strange square slabs of rock for a shoreline. *Facing page* The Firth of Forth runs for over 50 miles (80 kilometres) from Stirling to the North Sea, and is a working estuary as well as a stunning feature of the Scottish landscape.

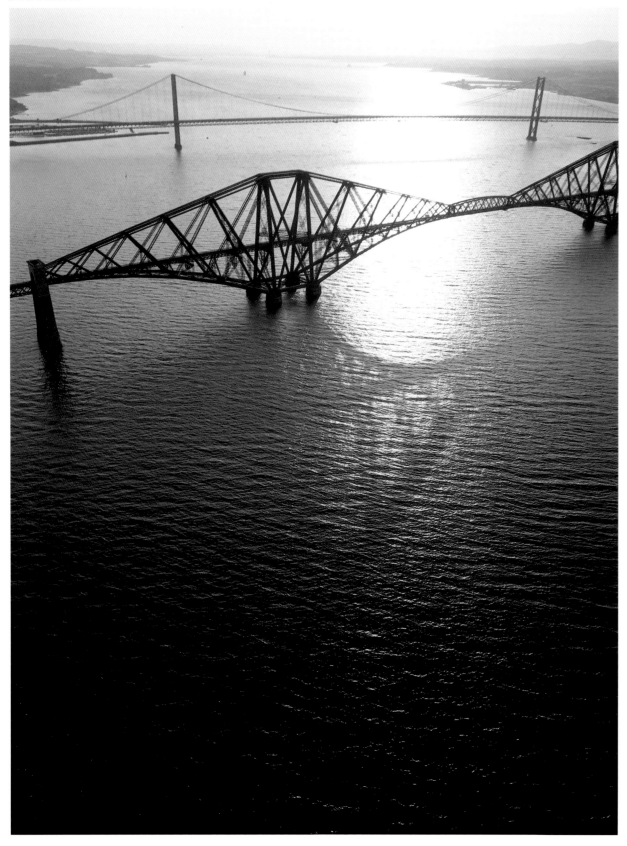

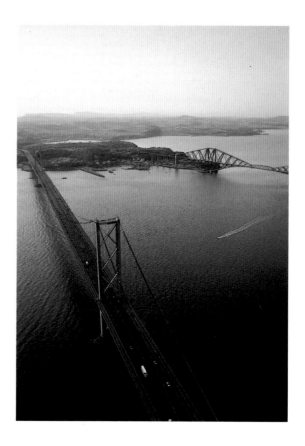

NORTH QUEENSFERRY

Above The town of Queensferry (named after the eleventh-century Queen Margaret of Scotland who used to take the ferry that sailed across the Forth) is divided in two by the mighty estuary, with North Queensferry (shown here) being by far the smaller of the two sections. The town nestling in the bay behind North Queensferry is the old royal burgh of Inverkeithing, which once held an important market.

THE FIRTH OF FORTH

Left Two magnificent feats of engineering span the Firth of Forth. The Forth Bridge, with its intricate spiders' webs of girders, was opened in 1890 to take the railway across the Forth and such is its fame that it has entered the English language, with 'like painting the Forth Bridge' being used to describe any endless task. That is not just a clever turn of phrase – at any given moment, some part of the bridge's surface, which covers 135 acres (54 hectares) in all, is being covered with red-oxide paint. The elegant Forth Road Bridge was opened in 1964.

THE TAY AT DUNDEE

Right Two bridges cross the Firth of Tay, linking the ancient royal burgh and seaport of Dundee on the north bank with Newport-on-Tay and all points south. Travellers on either the road or rail bridge are treated to magnificent views of the river, with ships and boats passing by, old abbeys and castles in the distance and Dundee, the capital of Tayside, shining on the north shore. Before Britain's county boundaries were altered and many of the counties given banal new names in the 1970s, Dundee was the capital of the county of Angus, a place-name rich in history and thoroughly evocative of mountainous Scotland, including the hornless Aberdeen Angus cattle that come from here. For 800 years a ferry plied its profitable trade across the Tay from Newport-on-Tay, but the completion of the Tay toll road bridge (in the foreground) in 1966 put paid to that. The rail bridge in the background is considerably older, having been built between 1883 and 1887 to carry the railway between Aberdeen and Edinburgh. When it was first built, passengers were no doubt rather wary of using it because it replaced a previous rail bridge that had been blown down during a gale while a train was crossing it. The nineteenth-century poet William McGonagall, who lived in Dundee and is now renowned for his awful verse, commemorated the disaster with these immortal lines:

> *Beautiful railway bridge of the Silvery Tay,*
> *Alas, I am very sorry to say,*
> *That ninety lives have been taken away*
> *On the last Sabbath day of 1879.*

THE COAST AT DUNBAR

Following pages, left Visitors to Scotland for the first time are often astonished at the beautiful sandy bays and gentle views that abound. Perhaps they expect the countryside to be continually blanketed in a thick Scotch mist and heavy drizzle. The reality is often quite different, as here at Dunbar – a town on the east coast of Lothian that is flanked on both sides by vast expanses of sand in Belhaven Bay to the west and White Sands to the east.

THE HOWE OF FIFE

Following pages, right Until the huge bridges were built over the Firths of Forth and Tay, the kingdom of Fife was a somewhat isolated peninsula that jutted into the North Sea. The Howe of Fife, as it is called, is a valley rich in agricultural potential, as this abstracted view of its land reveals, with the produce bought and sold in the inland town of Cupar.

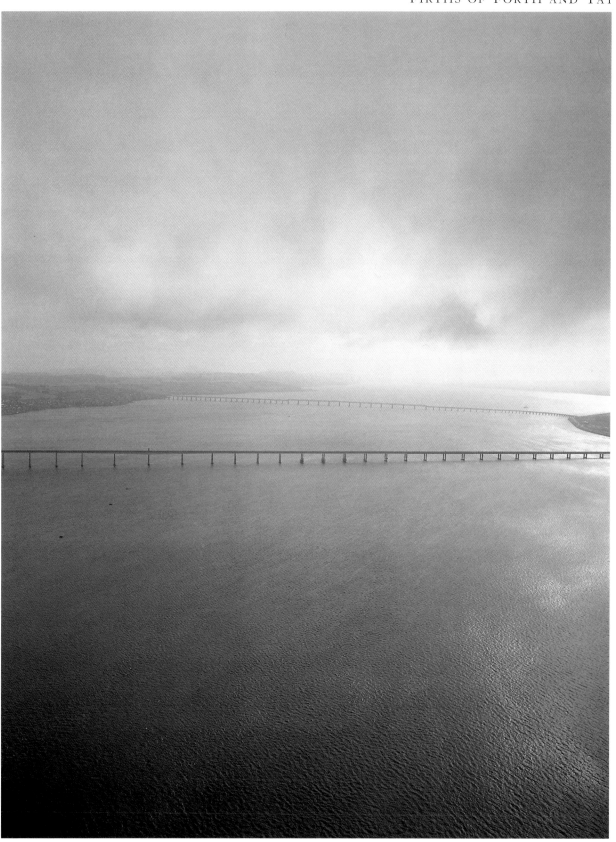

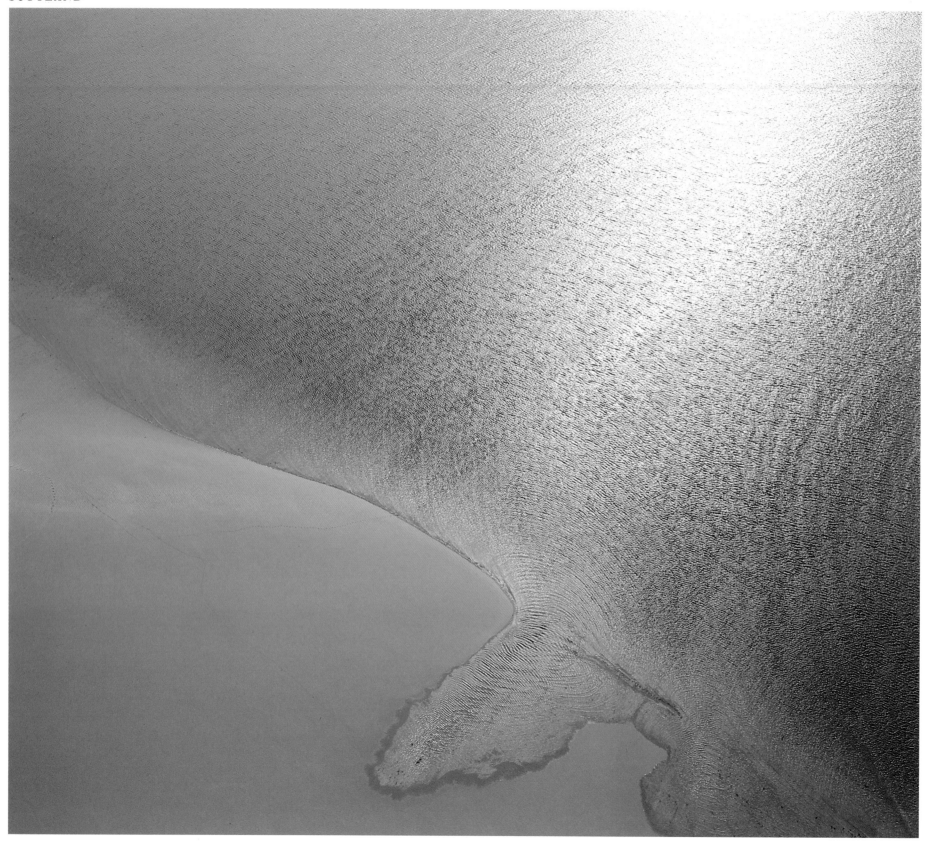

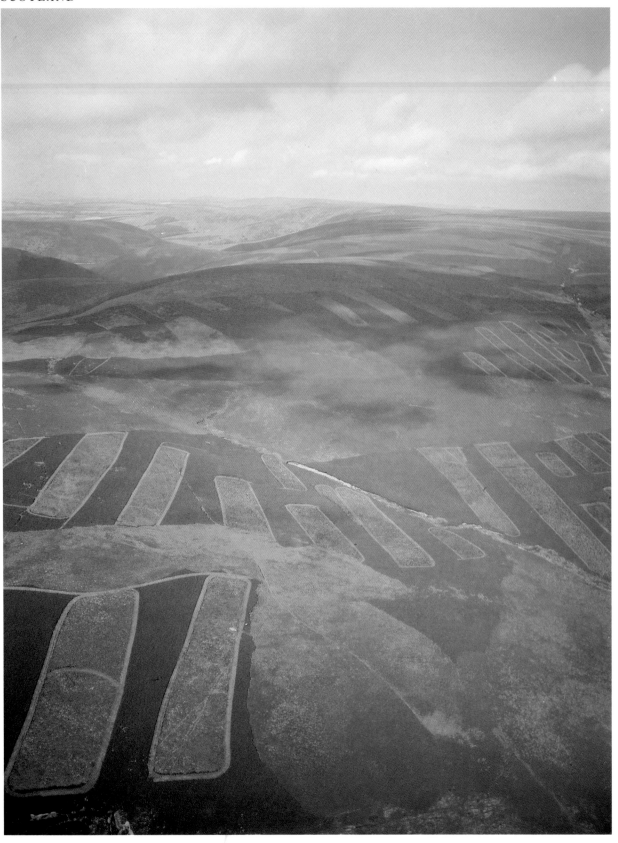

THE LAMMERMUIR HILLS

Left The rich moorlands of the Lammermuir Hills, which lie on the boundary between the counties of Lothian and the Borders, are wild and virtually empty. These strange brown patches on the landscape mark the places where peat is being cut out of the ground. Beyond them, in the valley on the left of the photograph, is a little patch of blue – one of the several reservoirs to be found in this area. This is lovely land for walkers, with few inhabitants, fewer tourists and plenty of attractive views. One walk near the village of Primrosehill goes past Edinshall, which is the remains of an Iron Age *broch* (a tall, circular tower built of stone and used for sheltering from attacks by other tribes).

THE LAMMERMUIR HILLS

Facing page The place names in these hills conjure up images of blood-stained Scottish history, such as the many battles and intrigues that have taken place in and around the Lammermuir Hills. This is partly due to their close proximity to the border between England and Scotland – a boundary that has shifted so often that Berwick-upon-Tweed to the south has changed nationality 14 times (it has been English since 1482).

THE LAMMERMUIR HILLS

One of the relatively few villages in the Lammermuir Hills is revealed here through a gap in these cumulus clouds. The road snakes through the valley bottom, running past small farms and large uncultivated fields which are doubtless home to flocks of Scottish sheep. Before the farmers in the Lammermuir Hills fenced off their grazing lands, they used to let their sheep wander about at will. Twice a year they would organize 'gathering holds' in which all the straying sheep would be herded together, sorted out and returned to their proper homes ready to be inspected, counted and sent off to market. Then away the remaining sheep would go again, to roam wherever they wished for another six months.

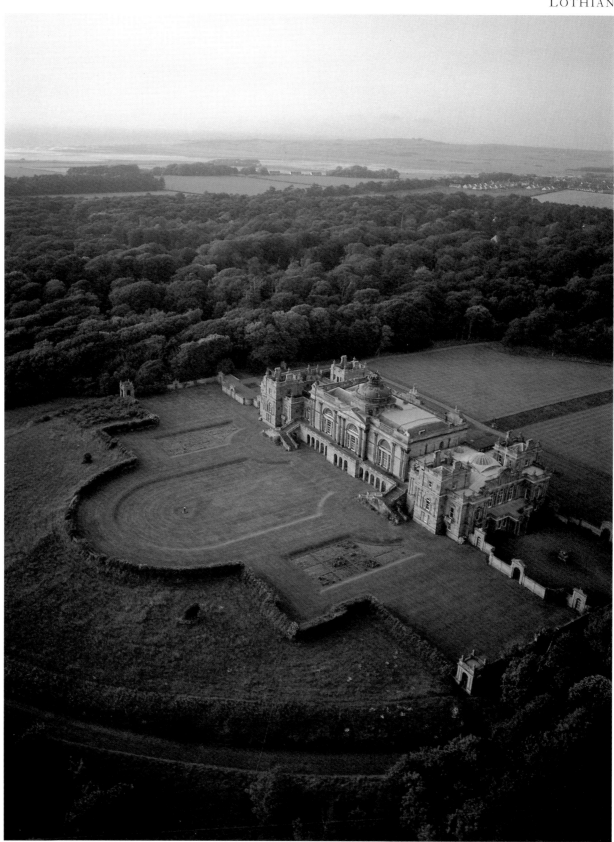

GOSFORD HOUSE

Anyone walking along the seashore near Aberlady Bay, Longniddry or Gosford Sands by the Firth of Forth may well wonder what lies behind the thickly wooded parkland that is enclosed by a high brick wall. It is Gosford House, one of the seats of the Earl of Wemyss, which was built in the Neo-Classical style in stages during the nineteenth century. Robert Adam designed the central section of the house which was built after his death in 1800, and William Young added the north and south wings in 1890. The formal sunken garden was designed to be viewed from above. The waters of the Forth, and the sandy reaches of Craigielaw Point and Aberlady Bay, can be seen in the background.

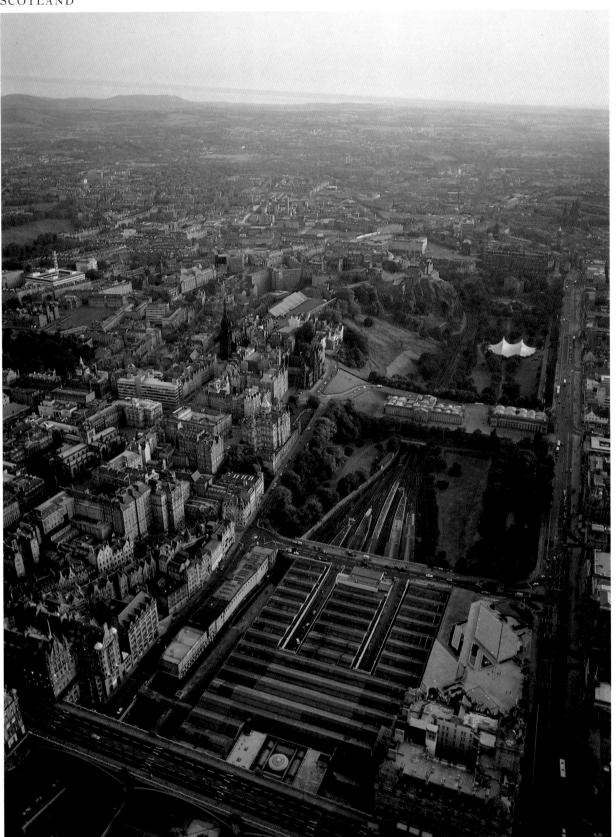

ARTHUR'S SEAT

Facing page, left The weird, lumpy outline of the extinct volcano known as Arthur's Seat looms over one of Europe's most elegant cities, yet its brooding presence only enhances the historic atmosphere that pervades so much of Edinburgh and seems to have seeped into the very stones of its buildings. At its summit Arthur's Seat is 823 feet (250 metres) high, and it deserves to be climbed for the panoramic views it offers of Edinburgh itself, the Firth of Forth beyond and the Pentland Hills to the south. The inevitable question is, who was Arthur? The legendary king of the same name has many associations in Scotland, but in this case Arthur's Seat is believed to be a corruption of the Gaelic *Ard-na-said*, which rather disappointingly refers to the height arrows can reach at a shooting ground.

PRINCES STREET GARDENS, EDINBURGH

Left The dark green swathe cut by Princes Street Gardens through the heart of Edinburgh has made them one of Scotland's most famous sights. They didn't exist until the late eighteenth century; until then, the area now filled by the gardens was an unpleasant stretch of dirty water known as Nor' Loch. Today, the gardens are the perfect place for the weary traveller to rest while gazing up at the many different buildings clustered around their edges. The long straight street on the right of the photograph is Princes Street itself, named after the sons of George III. The railway lines cutting straight through the centre of the gardens lead to Waverley Station (the name of which was taken from Sir Walter Scott's novel, *Waverley*). Lying across the centre of the gardens is the road called The Mound, which links Princes Street with the Old Town. Its name suggests it is one of the many pieces of volcanic rock to be found in Edinburgh, but its origins are much more prosaic – it is the heap of debris and rubbish left after the draining of Nor' Loch. As such, it must be the most elegant rubbish dump in the world, with two beautiful buildings to adorn it – the Royal Scottish Academy (nearest Princes Street) and the National Gallery of Scotland.

EDINBURGH CASTLE

Right Today, Edinburgh Castle perches on its volcanic crag at the end of Princes Street Gardens with a benevolent air, but the site has a past that is inextricably woven into the rough and bloody history of the Scottish people. Castle Rock, on which the castle stands, has been a defensive strongpoint since the seventh century when Edwin, King of Northumbria, built a wooden fortress here and in doing so gave the city its name – Edwin's burgh. All traces of that fortress have vanished, and the oldest remaining building is the tiny Chapel of St Margaret which dates from the eleventh century. Other buildings in the castle precincts include the palace itself (where Mary Queen of Scots gave birth to her son, the future James VI of Scotland and James I of England), the banqueting hall underneath which French prisoners were kept in the Casemates during the Napoleonic Wars, and the modern Scottish National War Museum which commemorates Scots soldiers killed during the First World War. The world-famous ancient streets collectively called the Royal Mile culminate in the vast castle esplanade, easily identified here by the tall terraces of seats that rise either side of it, ready for the spectacle of the Edinburgh Military Tattoo that will take place once the sun has set and the castle is floodlit.

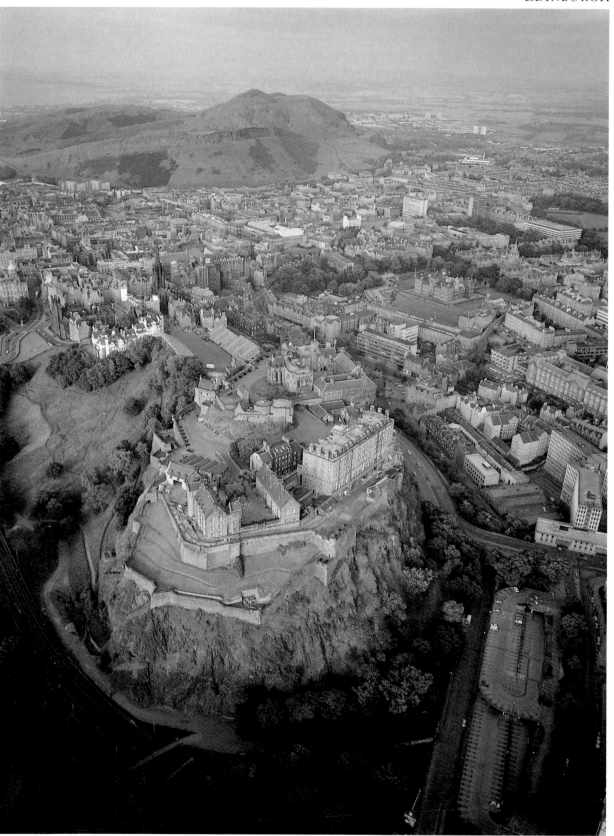

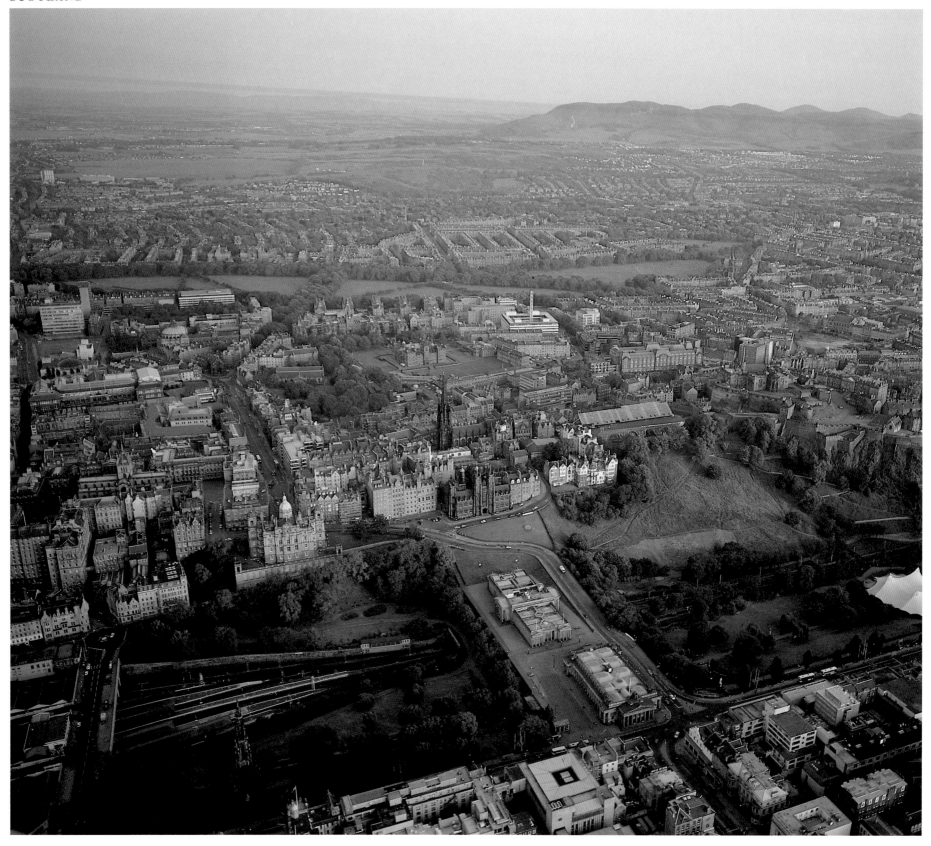

AULD REEKIE

Facing page The blackened stone of the buildings in the old part of Edinburgh bears testament to its nickname of Auld Reekie, or Old Smoky, which refers to the days when fires burned in every grate and a pall of smoke hung over the city each evening like a suffocating blanket. The name also conjures up some of the atmosphere of this part of the city – of the narrow streets and dark courtyards overshadowed by tall buildings that have stood here since the Middle Ages, the wynds (narrow paths) that lead through the closes that lie behind the main streets and the people and events that have become part of the city's past. The High Kirk of Edinburgh, better known as St Giles Cathedral, is on the left of the photograph and can easily be identified by its crown-shaped tower and the large rectangular courtyard in which the church stands. On dark and shadowy winter days another aspect of Edinburgh's history springs to mind. This is the city of Burke and Hare, those strong-stomached grave robbers who sold the exhumed corpses for medical research in the 1820s; when demand started outstripping supply they took to murder. These are also the streets through which Deacon Brodie (model for R L Stevenson's *Dr Jekyll and Mr Hyde*) conducted his campaign of terror during the late 1780s – he was a pillar of the kirk during the day and a cat-burglar and murderer by night.

ST ANDREWS

Right If you want to trace the history of Scotland's patron saint, the city of St Andrews is named after him and is said to have been the place where his bones were washed up after a shipwreck in AD 347. If you want to play golf in Scotland, St Andrews has five courses on offer, including the oldest one in the world – the Old Course, which begins on the far right of the photograph. To the left of the golf course, standing alone in the corner of the furthest bay, is Martyrs' Monument. Designed in 1842, this commemorates Protestant martyrs from the fifteenth and sixteenth centuries who were burned to death when they refused to embrace the Catholic faith. When people weren't burned at the stake they were imprisoned in the notorious Bottle Dungeon, which still survives in the otherwise ruined thirteenth-century castle (foreground) and is shaped like a bottle; no one ever escaped from it alive. The street known as The Scores leads from the castle back to the Martyrs' Monument and is edged with many buildings that belong to St Andrews' University. Founded in 1412, it is the oldest university in Scotland and the third oldest in Britain after Oxford and Cambridge.

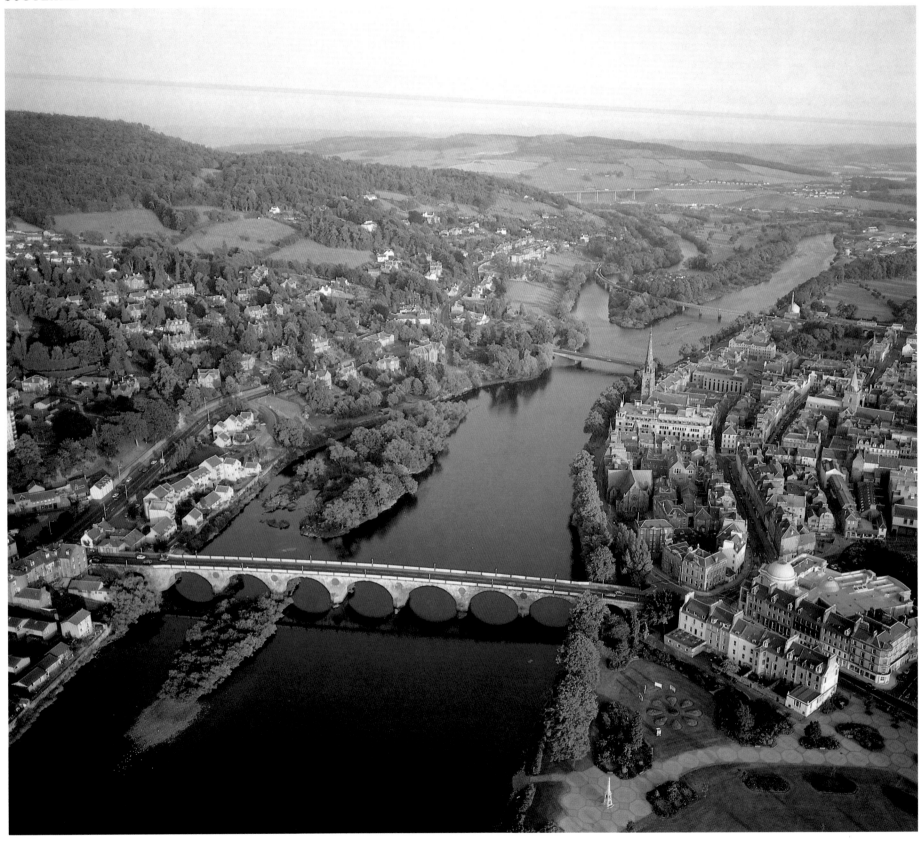

PERTH

Facing page Looking at this photograph, it is easy to see why Perth is called the Fair City. The Tay and Almond rivers converge here, and the River Earn runs past the south of the city, but they all meet south east of Perth at the beginning of the Firth of Tay. The two road bridges are the arched Perth Bridge and the simpler Queen's Bridge in the background, with the railway bridge curving around towards Dundee in the right of the photograph. Perth was the capital of Scotland until the court moved to Edinburgh in 1437, after James I had been murdered here in the Monastery of the Preaching Friars (where he was later buried) on the orders of the Earl of Atholl, who believed himself to be the rightful king. The city surrendered to Cromwell in 1651 and was occupied by the Jacobites during the hapless uprisings of 1715 and 1745. Little remains of medieval Perth today, although Sir Walter Scott's book, *The Fair Maid of Perth*, reawakened an interest in the city's history and helped to preserve and restore the great St John's Kirk. It was here, in 1559, that John Knox preached a sermon against church idolatry which led to a spate of church vandalism throughout the nation.

GLASGOW

Right People visiting Glasgow for the first time are often surprised by the city they discover – there is a much lighter and more beautiful face to Glasgow than the visions conjured up by the tales of street after street of grim tenements and graffiti-covered tower blocks. Some of these places that earned Glasgow such a bad name for social conditions are still there, of course, remnants from the Industrial Revolution and the boom of the nineteenth century when the quality of Glasgow's housebuilding suffered in its bid to keep up with the rapid growth of industry. The city also has many magnificent buildings, and Greater Glasgow has over 100 parks and gardens open to the public. The one shown here is Kelvingrove Park, which is not only a lovely wooded park in its own right but also home to Glasgow's Art Gallery and Museum, and the University of Glasgow. The university was founded in 1451, but this magnificent Gothic building was built more recently, by Sir George Gilbert Scott in 1865. The semi-circular rows of houses, known as Park Circus, lie directly ahead.

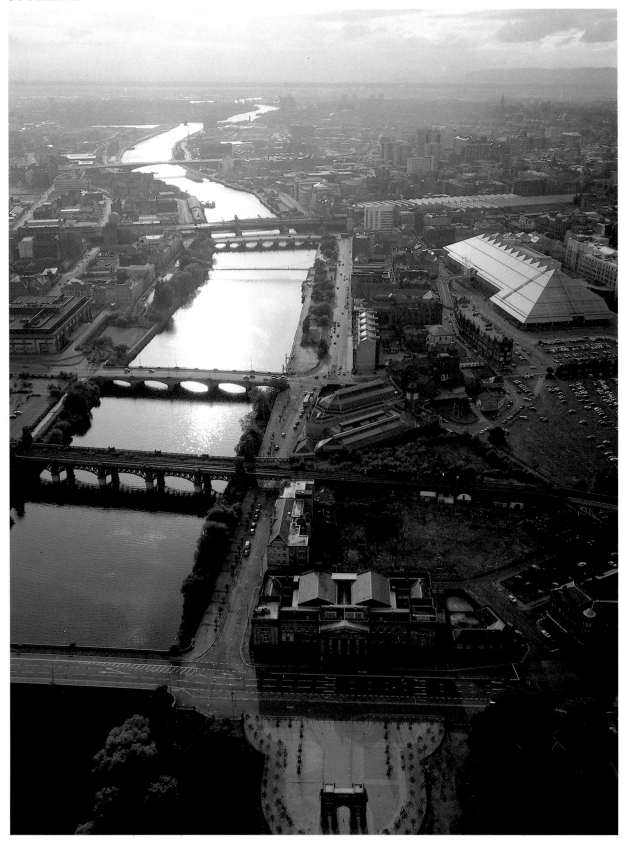

GLASGOW AND THE CLYDE

Left and facing page The mighty Clyde runs like an artery through the centre of Glasgow, linking the city to Port Glasgow further west at the mouth of the river, and past it to the Firth of Clyde and the open sea. The Clyde was widened to take more river traffic and increase Glasgow's potential as an important Scottish port and industrial city during the nineteenth century, from which point onwards it became known for its heavy engineering and, most romantically, its ship-building. During the industry's heyday, such famous liners as the *Queen Mary*, *Lusitania* and the *Queen Elizabeth* and *Queen Elizabeth II* were all built here. In the photograph on the left, Albert Bridge, in the foreground, marks one of the boundaries of Glasgow Green (some of the trees can be seen at the bottom of the photograph). Next comes a railway bridge and then, predictably enough, Victoria Bridge. The huge glass-topped building to the far right is the new St Enoch Centre – the largest shopping centre to be found under glass in Europe. The next bridges are the narrow suspension bridge, then Glasgow Bridge, then the railway bridge taking trains in and out of Central Station and, just behind the white ship, Kingston Bridge. The rectangular stretch of water on the left of the Clyde past Kingston Bridge is Prince's Dock, with further docks lying upriver. The photograph on the facing page shows gasometers by the Clyde.

TENTSMUIR FOREST

Following pages Two very different images of Tentsmuir Forest are shown here. The forest itself stands on the tip of the southern bank of the Firth of Tay, near Tayport, and is owned by the Forestry Commission. Part of it is a nature reserve, but the rest is a working forest, planted with thousands of conifers.

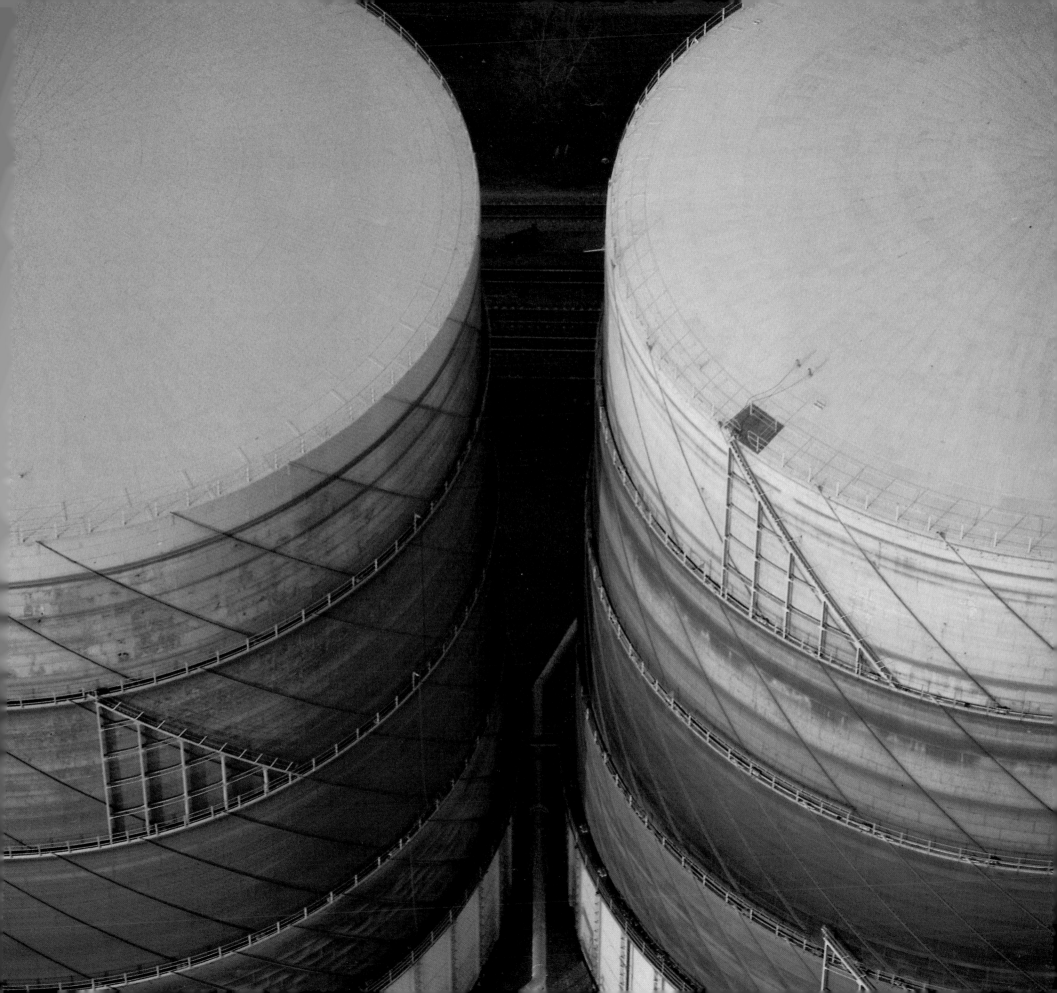

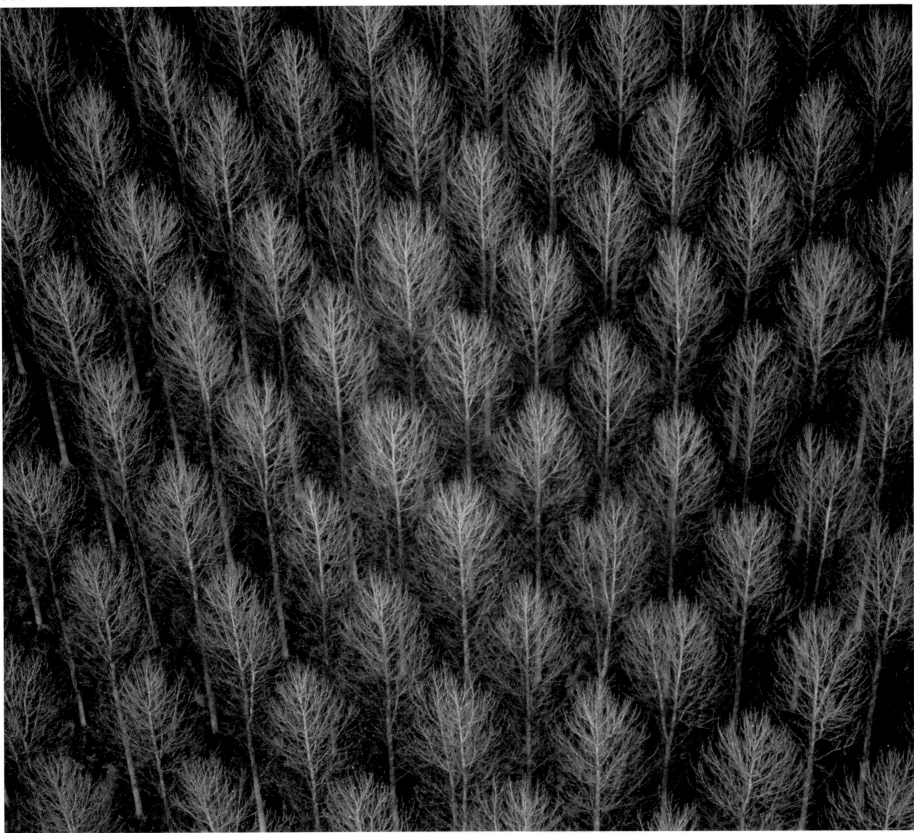

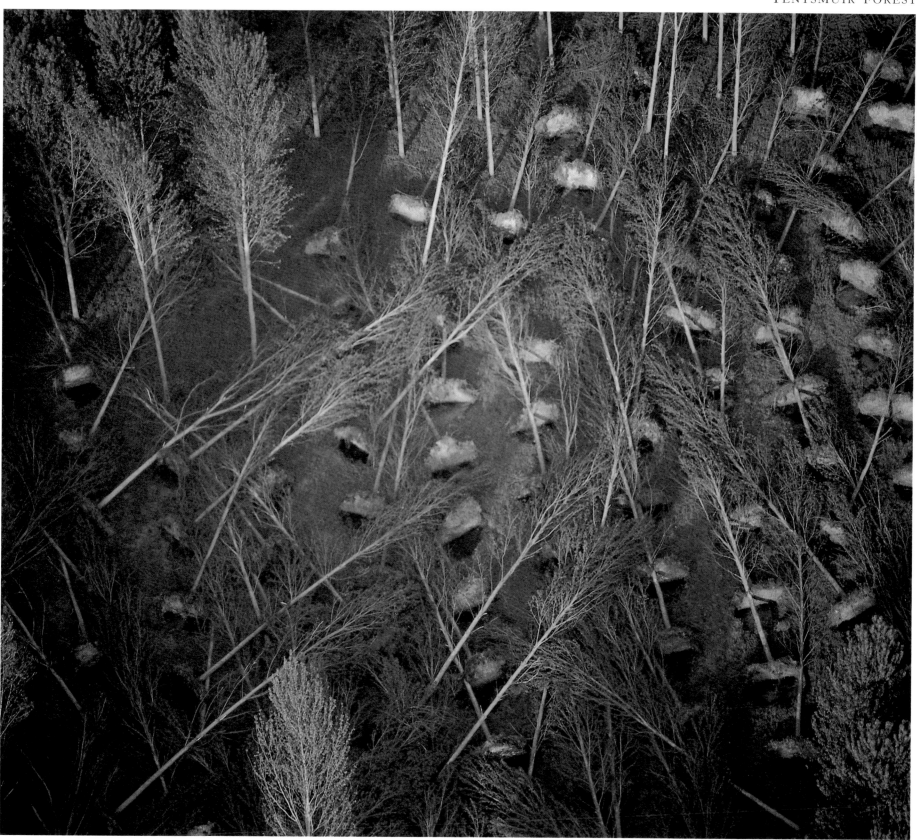

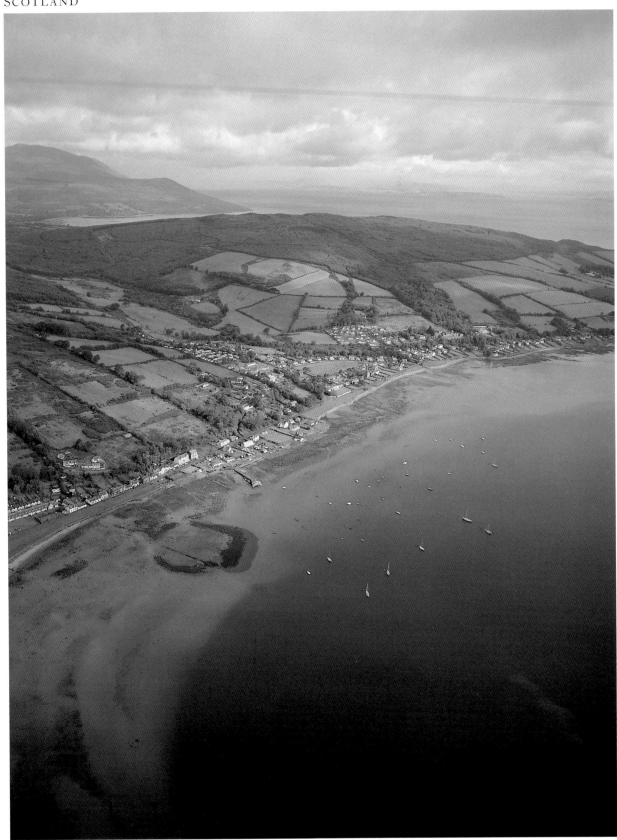

LAMLASH

This is the largest village on the Isle of Arran, on the eastern shore of the island and overlooking Lamlash Bay and Holy Island beyond it. Lamlash is a haven for keen sailors and fishermen; one of the most notorious voyages from here was that of Robert the Bruce, who set sail in 1307 at the beginning of his seven-year campaign to win Scotland's independence from England. A hint of the towering mountains in the north of the island can be glimpsed near the top left of the photograph, looming down over the deep curve of Brodick Bay. Brodick is the unofficial capital of Arran, and is the main port of the island.

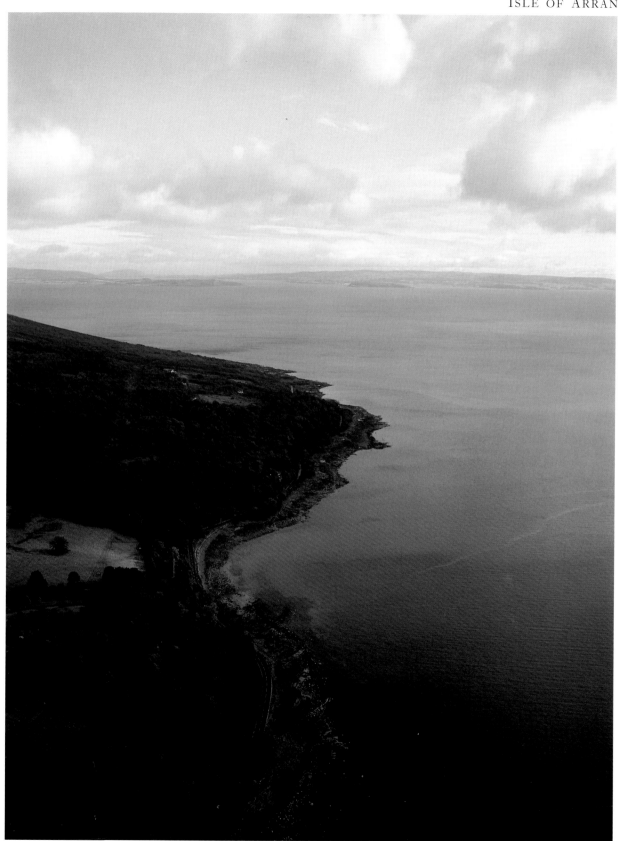

ISLE OF ARRAN

The main road on the Isle of Arran provides a spectacular tour of the coast because it runs right round the island. There are magnificent views of the waters surrounding the island and the other islands and mainland beyond. The small lake and formal garden in the bottom left of the photograph are part of the grounds of the stark-looking Brodick Castle. Among the islands visible on the horizon are Little Cumbrae Island, with Great Cumbrae Island lying behind it, and the southernmost tip of the Isle of Bute stretching across from the left of the photograph. Beyond, on the horizon, is mainland Scotland.

KINTYRE

Kintyre is only joined to the mainland of western Scotland by a tiny stretch of land at Tarbert in the north. If you look at it on a map, Kintyre is pointing south in a long straight strip in the North Channel, with the Sound of Jura to the west and the Kilbrannan Sound, which separates Kintyre from the Isle of Arran, to the east. At the southernmost point of Kintyre, Ireland lies only 15 miles (24 kilometres) away. There are two forests and several woods on Kintyre, as well as the lovely moorland shown here, covered with soft green grass and pools of the purple heather that is the familiar emblem of Scotland.

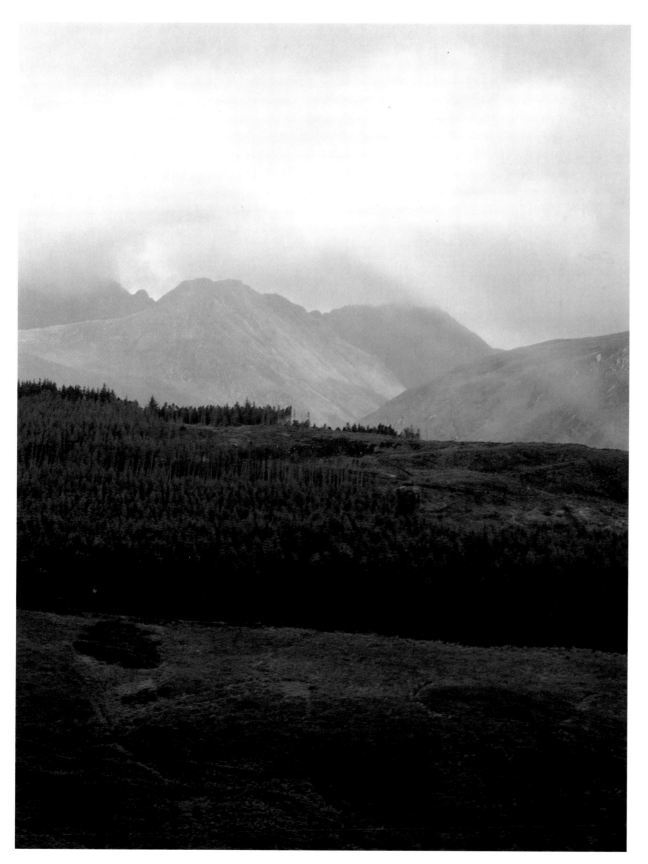

THE ISLE OF ARRAN

There are two distinct characters to Arran – the gentle landscape of the south and the wild craggy mountains of the north. The mountains rise to more than 2800 feet (853 metres), and one of them, Goat Fell, towers high above Brodick Bay on the east coast of the island. Keen walkers will enjoy the lower slopes of the mountains, while experienced climbers can attempt the peaks. Although there is no one to be seen in this photograph, Arran is often home to visiting geologists who revel in exploring the Arran Dyke Swarm – a group of softer rocks that have somehow become incorporated into the granite of the mountains.

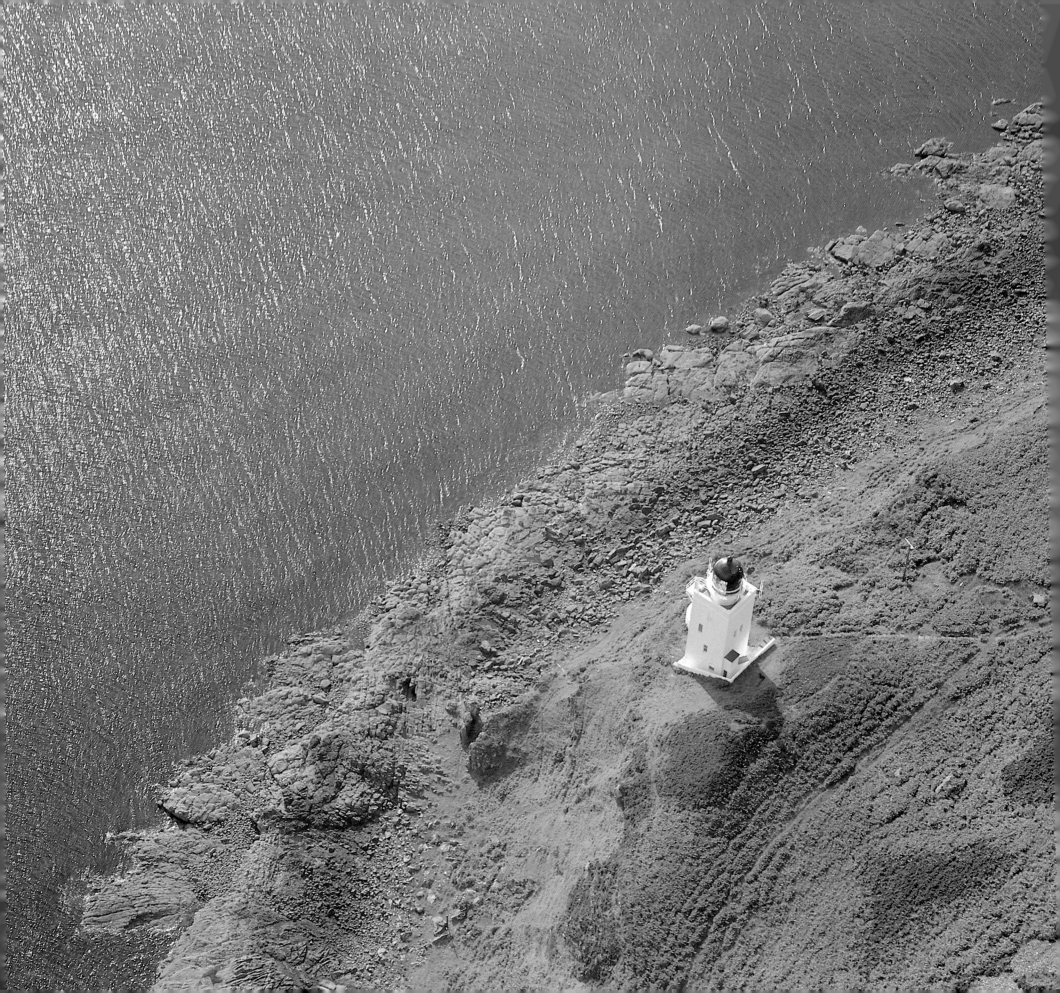

HOLY ISLAND

Facing page The lighthouse on the south east point of Holy Island, off the Isle of Arran, looks like a child's toy with its square white body and shiny black top, but it still plays a very important role in ensuring the safe passage of ships around its waters. There are many legends and myths associated with the sea throughout Britain, involving everything from mermaids, strange sea monsters called kracken and ancient lands lost beneath the sea, to smugglers, wreckers and phantom ships. There are even stories told about lighthouses. For example, in 1900 it was reported that the lighthouse on the Flannen Isles, in the Outer Hebrides, wasn't showing a light. Eventually investigators reached the lighthouse and found everything in order, with the lamp prepared and ready to be lit. But the three lighthouse keepers had vanished, leaving no trace behind them, and not one of them was ever found.

HOLY ISLAND

Right The Holy Island off the Isle of Arran on the west coast of Scotland shares its name with the island that lies off the east coast of Northumberland. The fact is that all islands were holy to the Celts, and were especially so if they had once been inhabited by saints. This Holy Island was so-named in honour of St Molaise who is said to have lived to 120 years old, despite taking on 30 diseases in one go instead of being sent to purgatory after his death. St Molaise (whose name may well be linked with the word 'malaise') lived, with his many diseases, in a cave on the western side of the island. Over 600 years after his death, in 1263, the cave was decorated with runic graffiti by some Norwegian sailors who were gathering in Lamlash Bay before a big sea battle with the Scots. The Vikings had first invaded the Western Isles in the ninth century, and the islands (including Kintyre) were officially handed over to them in 1093. However, the sea battle of Largs in 1263 ended in the Vikings' defeat, and Alexander III of Scotland regained control of the islands.

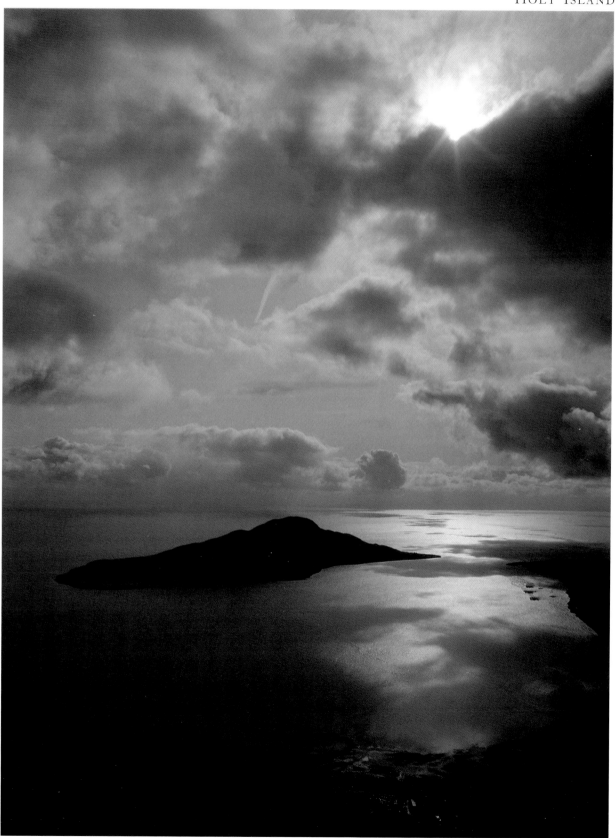

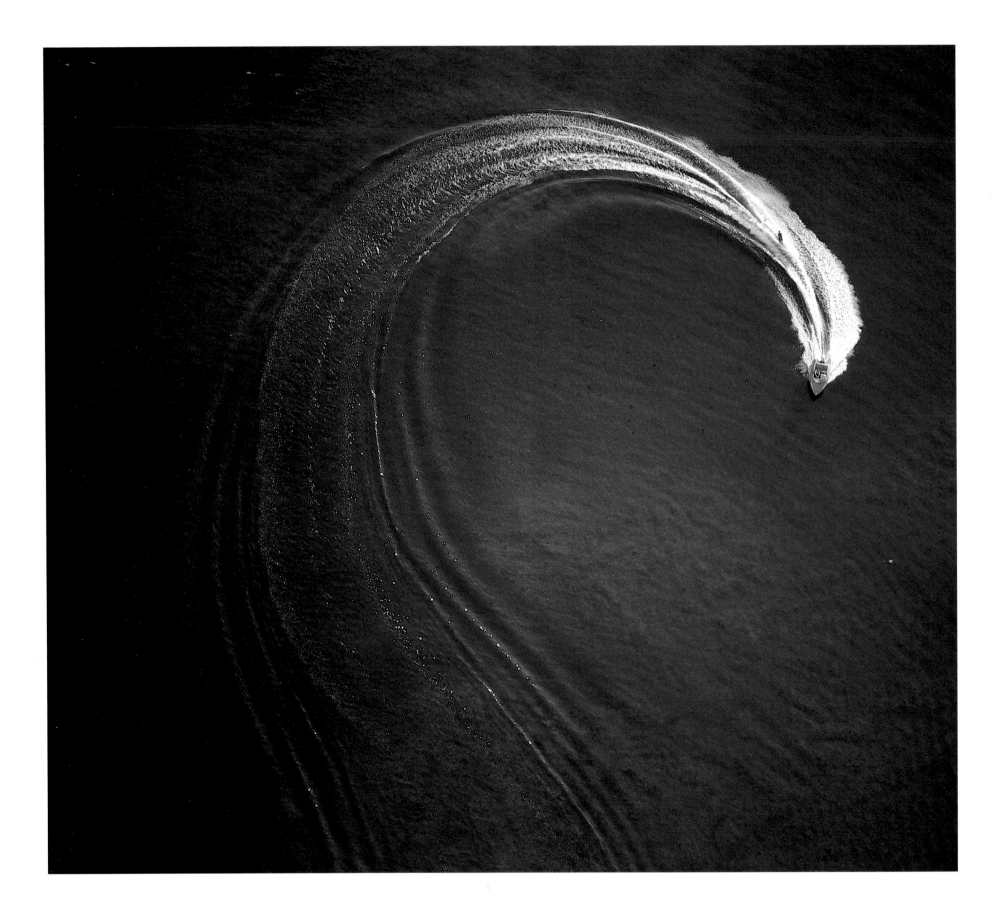

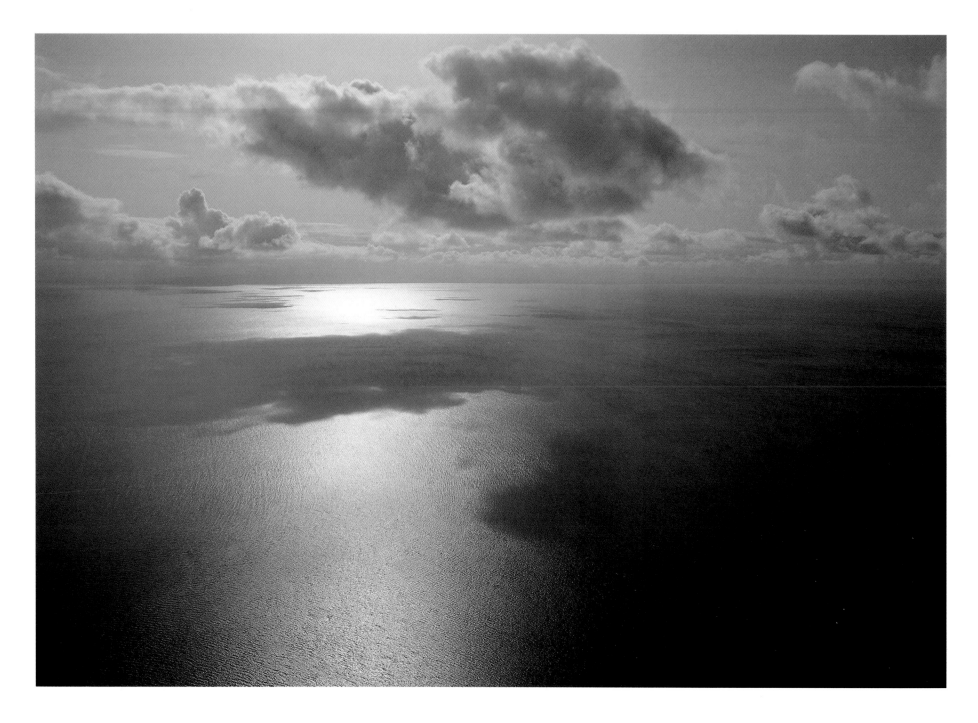

A ship, an isle, a sickle moon –
With few but with how splendid stars
The mirrors of the sea are strewn
Between their silver bars.

JAMES ELROY FLECKER